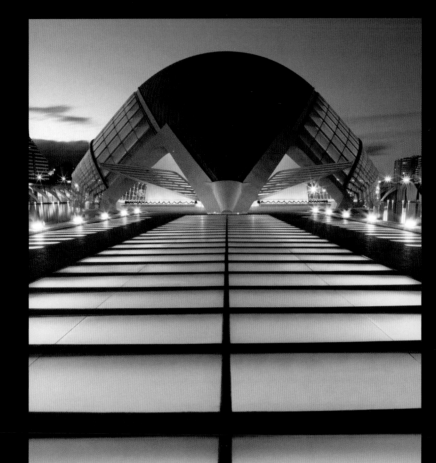

the ART of DIGITAL
PHOTOGRAPHY

JOHN HEDGECOE

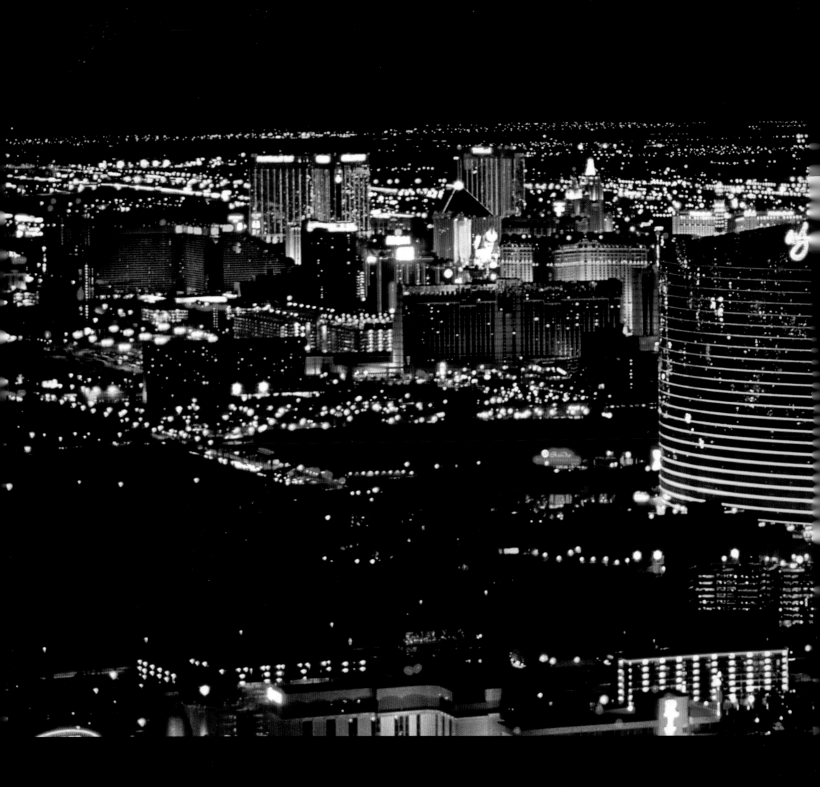

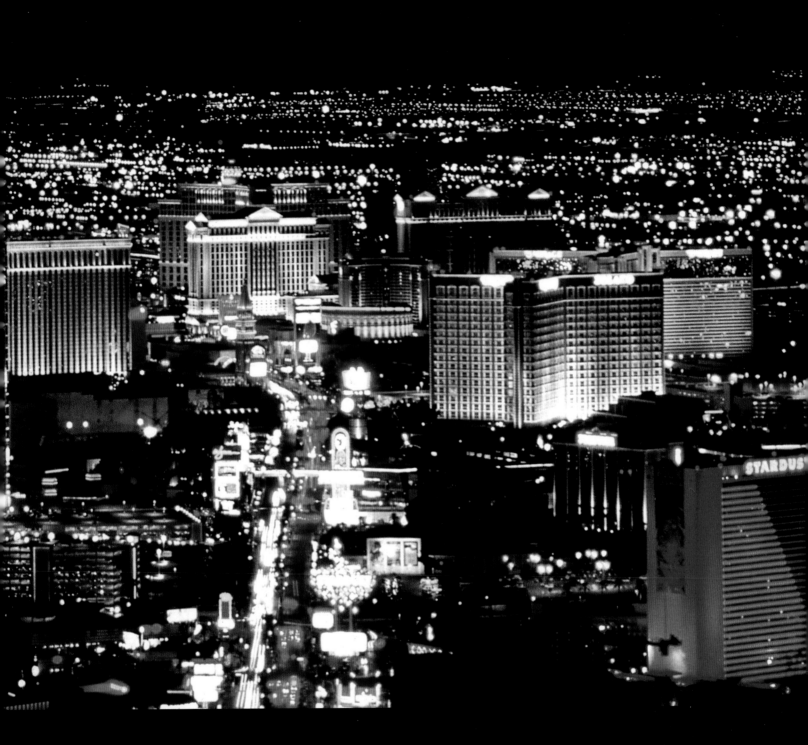

the ART of DIGITAL PHOTOGRAPHY

JOHN HEDGECOE

London, New York, Munich,
Melbourne, Delhi

Project Designers **Michael Duffy, Victoria Clark**
Project Editor **Letitia Luff**
Managing Editor **Stephanie Farrow**
Managing Art Editor **Karen Self**
DTP Designer **Vânia Cunha**
Production Controller **Melanie Dowland**

Associate Writer **Chris George**

First American Edition, 2006
Published in the United States by
DK Publishing, 375 Hudson Street,
New York, NY 10014

06 07 08 09 10 10 9 8 7 6 5 4 3 2 1

A Cataloging-in-Publication record for this book
is available from the Library of Congress.

ISBN-13: 978-0-7566-2354-8

DK books are available at special discounts for bulk
purchases for sales promotions, premiums, fund-
raising, or educational use. For details, contact: DK
Publishing Special Markets, 375 Hudson Street,
New York, NY 10014 or SpecialSales@dk.com

Color reproduction by Colourscan
Printed and bound in China by Hung Hing

Discover more at
www.dk.com

contents

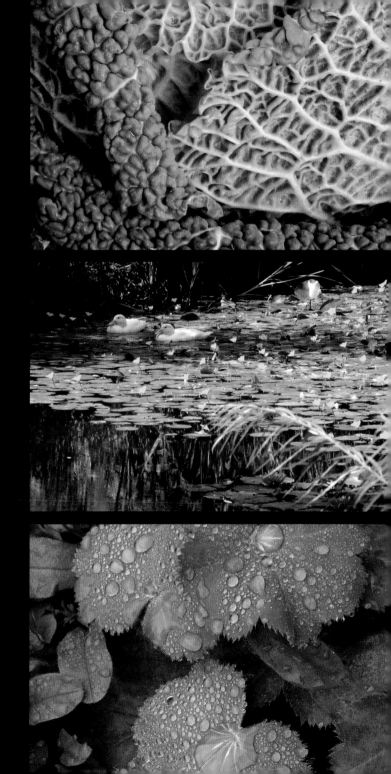

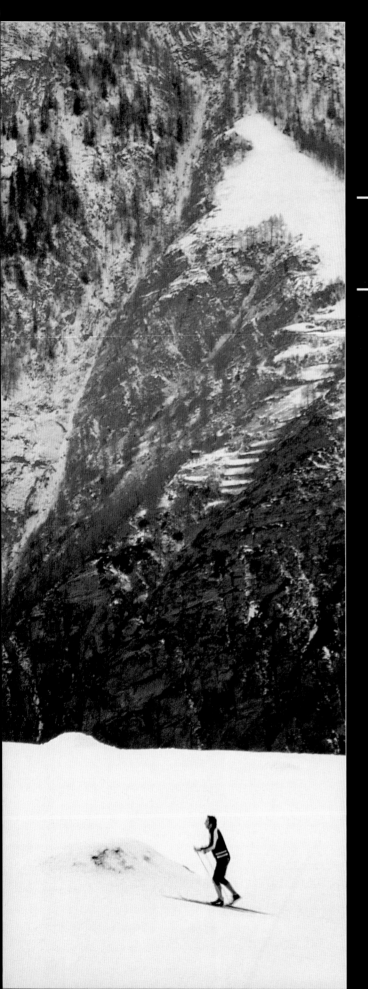

D

igital imaging has done far more than just modernize photography. Its arrival has given the person behind the camera more creative control over the picture-producing process than at any time in history.

The ease with which a picture can be viewed immediately after it has been taken on a digital camera allows you to learn from your results—and improve upon them. You can experiment freely, and unlike with film where you had to wait to see the outcome, you get near-instantaneous visual feedback. Furthermore, these "wasted" shots no longer cost anything—and can be deleted to free up space before anyone else has the chance to see them.

Then there is the simplicity with which the digital files can be manipulated after they are taken. This new postproduction stage brings highly skilled darkroom techniques to anyone with access to a basic computer. The sophistication of programs like Photoshop brings a new level of artistry and craftsmanship to photography.

Without the need for a physical printed form, digital images can also be shared with a wide audience at little cost. Through email and the Web, your photographs can be sent to anyone in seconds—or displayed in virtual galleries to a global audience.

However, digital imaging is not all plain sailing. The extra control available at the picture-taking stage, and the myriad ways that any image can be enhanced in postproduction, mean that photographers must learn many new skills. Photography has continued to evolve over its 200-year history, but with digital imaging, things change faster than ever before. New advances in electronics and programming mean it is not just a matter of catching up, it is a matter of having to keep moving forward.

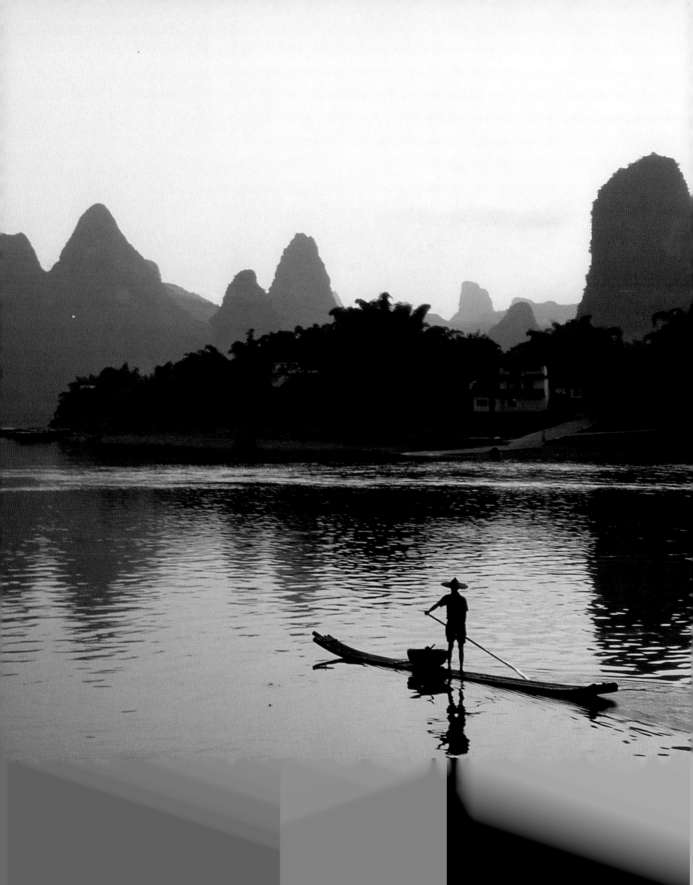

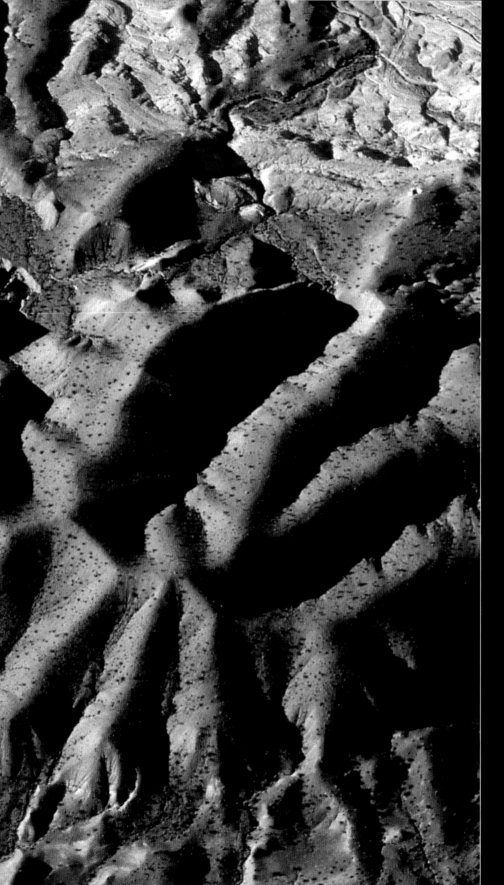

◄ VIEW FROM ABOVE
Photography is often about
capturing objects and scenes in
unusual ways and from new angles.
Taking pictures from a plane lets you
see a familiar landscape with fresh
eyes. Here, mountains in Arizona
are transformed into an abstract,
textured pattern.

► FLEETING MOMENTS
The digital camera is superb at
recording details that you may not
otherwise notice, and capturing brief
moments in time. The frost on this
tractor tire will soon disappear in
the morning sun.

D espite the ever-evolving hardware and software, it is still essential to master basic photographic skills and techniques. Just as artists and artisans have been discovering for centuries, tools alone cannot make a great work of art. With photographs, it is the person behind the camera that really counts. You choose what to shoot, where to shoot it from, and when to fire the shutter.

Even with the latest digital cameras, you still need to understand how to "see" as a photographer—and to know how to turn what you see into a successful image. In the era of the CCD and CMOS chip, therefore, it is as important as ever to understand how to use lighting, shutter speed, aperture, composition, and other elements in a creative way. Even with instant results and reusable memory, as a photographer you still need to develop a feel for how color, form, shape, texture, and pattern can be sought out and accentuated. You still need different approaches when tackling different subjects, such as landscape, portraiture, or sports. This book aims to show how to learn these old skills using the latest digital equipment.

work. Most of the images were taken on Olympus E1 and Hasselblad H1D digital cameras. A few scanned from slides are used—to show that even old shots can enjoy new life in the digital era.

I have broken the book up into three sections. The first looks at composition—how to arrange the subject within the confines of the photograph. The second section looks at how lighting can turn a mundane subject into a work of art. Finally, we look at the core subjects and styles that are most commonly tackled by photographers.

▼ TECHNICAL ADVANTAGE
In the days of film, you could shoot a whole roll of a snowboarder's acrobatics, only to find later that all were out of focus or badly exposed against the bright sky. With digital, you see your mistakes and can take corrective action immediately.

► SETTING UP THE SHOT
The digital camera's LCD screen is a perfect tool for checking composition—taking the place of the Polaroid proof used in the days of film. In this shot I used the display so I could place the model so the setting sun appeared to be sitting on her outstretched hand.

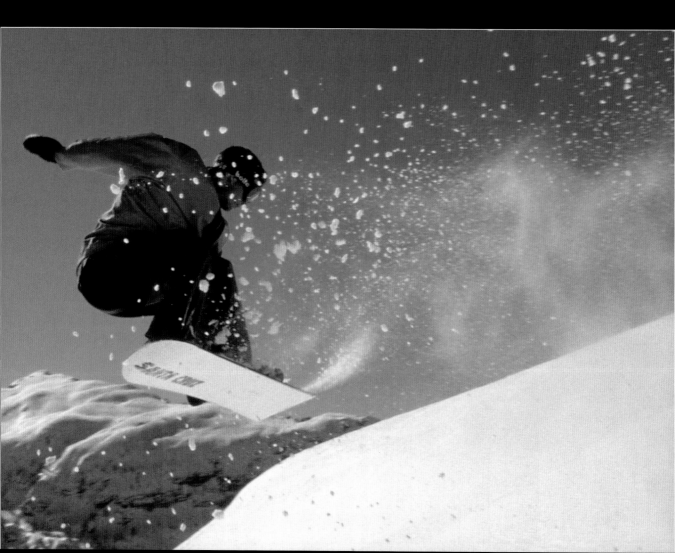

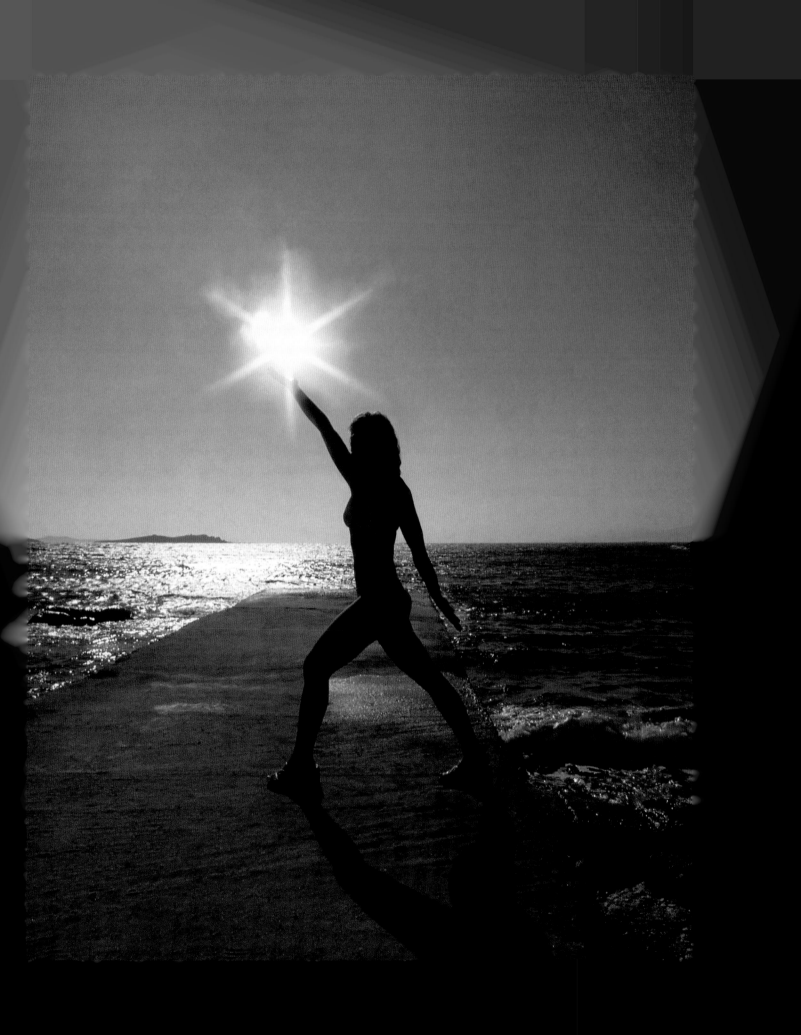

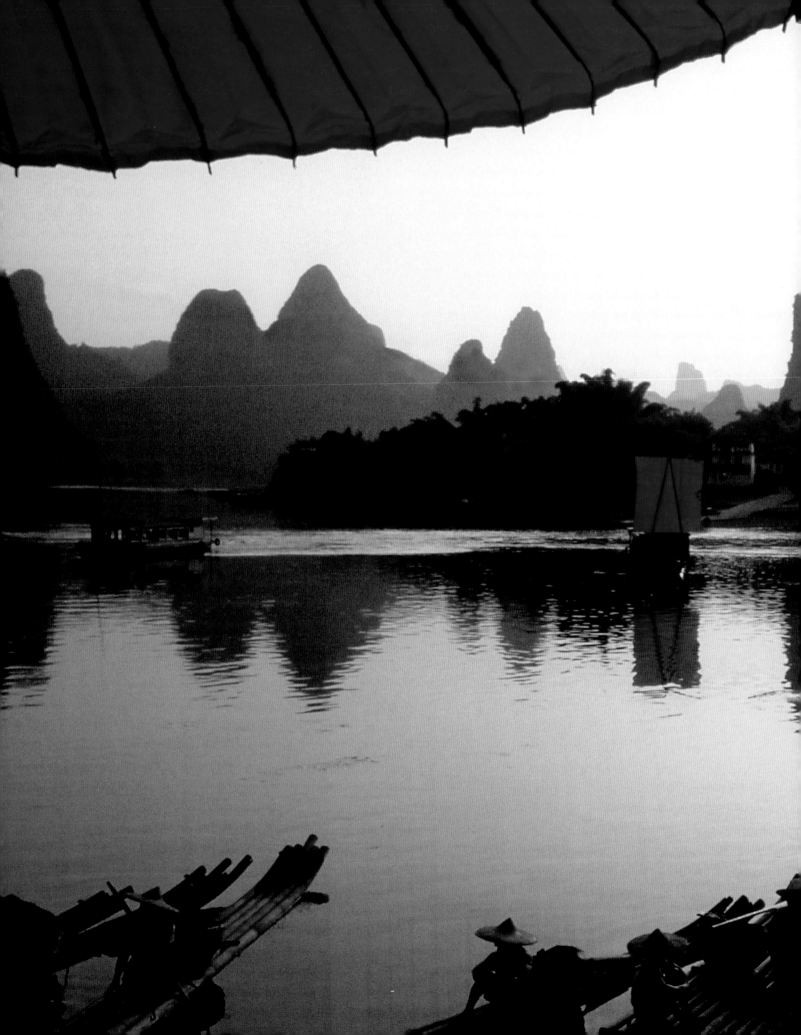

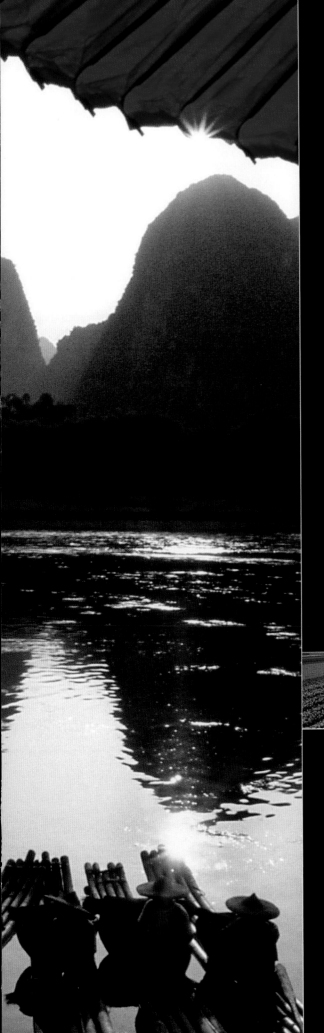

composing the image

1

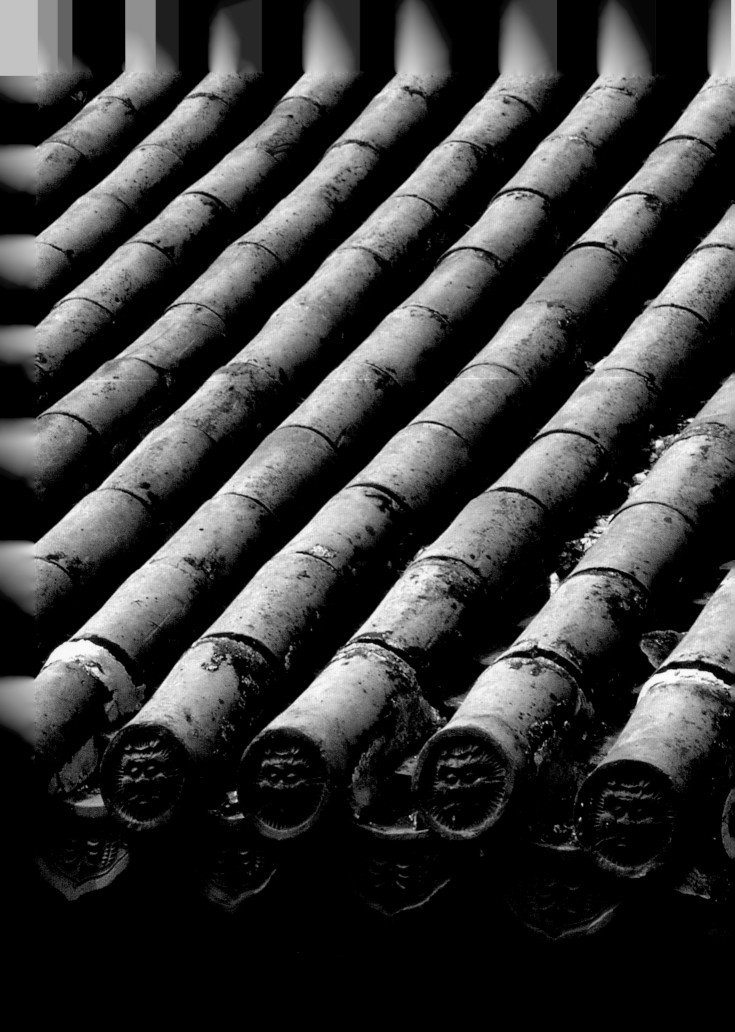

ELEMENTS OF AN IMAGE

There are no set rules governing how you turn the world in front of you into a digital image. However, some people are undoubtedly better at "seeing" pictures than others. Being able to visualize the potential photographic possibilities in even the most mundane of scenes is a skill that can be learned.

Fundamental to developing a photographer's eye is the ability to identify the key structural elements within the scene in front of you. Used widely in the teaching of art, this concept is equally useful when learning to make the best use of a digital camera. Whether the image is color or monochrome, subjects can be said to have up to five of these essential attributes: shape, tone, form, pattern, and texture.

Shape is simply the outline of the subject. Tone is the variation between light and dark that is essential to show us the edges of an image, to show the depth of a three-dimensional object, and to reveal the nature of a subject's surface. Form is the element that enables us to see that a ball is a sphere rather than a disk—and is very important in many forms of photography, because it provides the third dimension missing from a two-dimensional image. Texture shows the surface undulations of a subject. Pattern is the repetition of one or more of the other elements through the frame.

Sometimes just one of these elements will dominate the frame. It is also perfectly possible for a successful picture to contain all of the elements at once.

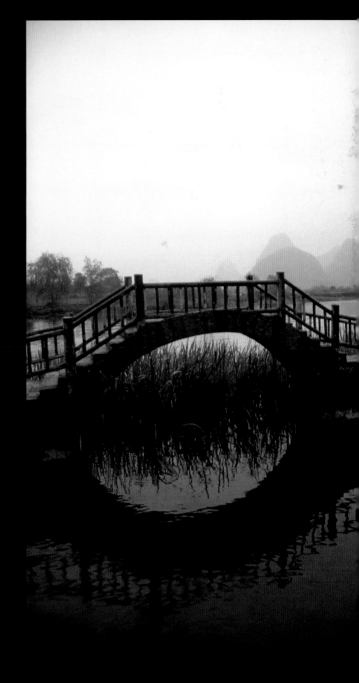

◄ TONE AND FORM
This close-up of a roof is partly about the pattern, but just as important is the variation of the tone that brings to life the cylindrical form of the bamboo.

► SHAPE
In this Chinese landscape, it is the shape of the bridge and the hills in the background that are key to the scene. These simple outlines suit the low-key backlighting well.

The significance of the five key elements lies in the fact that by altering viewpoint, or lighting, it is possible to accentuate one element in a scene above all the others. An image simplified in this way will often be more successful.

By choosing a camera viewpoint that emphasizes the pattern in a scene, for instance, you can sometimes produce a more artistic image than if you simply photograph the subject as a whole. Often there is more than one element you can exploit—which one you choose will have a dramatic influence on the resulting image.

▼ TEXTURE
In order to see the subject of this relief sculpture clearly, it is necessary to have the right lighting to add in adequate highlights and shadows. It is these that reveal the depth and the textural detail of the carving.

► PATTERN
The repetition of forms and shapes is probably the simplest of the five elements to both understand and exploit. Pattern often occurs in nature—as in this bed of scalloped nasturtium leaves with their subtle variation in color.

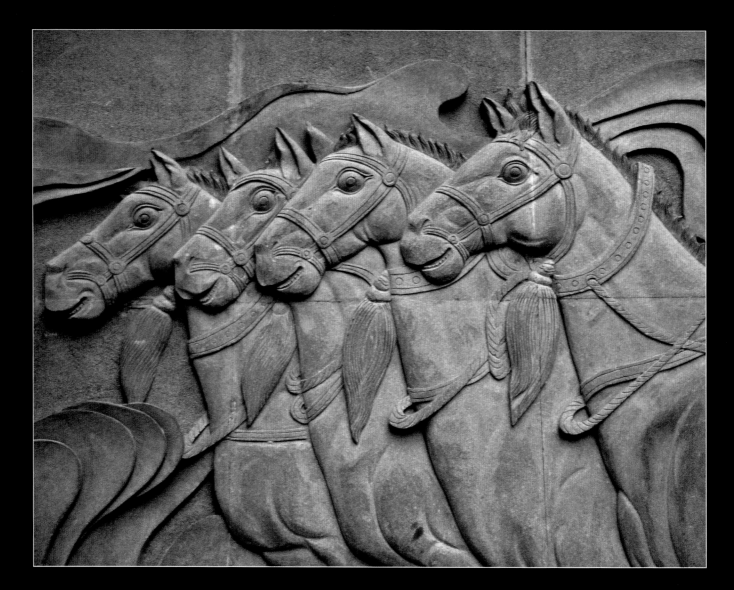

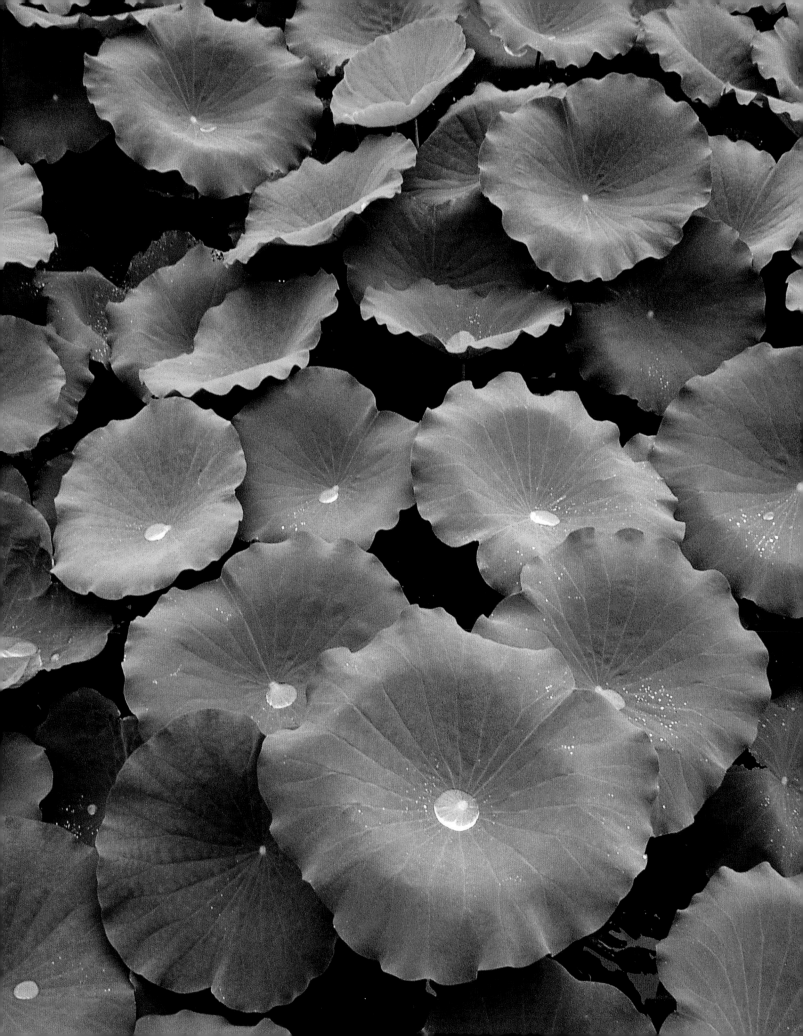

shape

IT IS POSSIBLE to identify many subjects from their outline alone. In order to use this successfully in a photograph, the camera angle must be chosen carefully. From some angles, a two-dimensional shape simply won't be as recognizable as from others. A dog, for example, is more identifiable from the side than from the rear.

Unlike other subject elements, the lighting angle is not particularly important for accentuating shape. Backlighting works well, simply because with the right exposure you can end up with a silhouette that shows shape in isolation (see pages 136–39). However, frontal lighting can work just as successfully. The important factor to include is a strong contrast between the subject and the background. This can be a contrast in brightness, as with a silhouette, but a contrast in color can work equally well in defining the outline.

When shooting silhouettes, the camera must be made to expose for the background, not the dark foreground. This can be done by using exposure compensation to underexpose the shot, or using spot metering to take a reading from the backdrop. Look at the results on screen carefully after each shot and reshoot if the background appears overexposed, or if the subject is not black enough. When you've got it right, the exposure histogram, if your camera provides one, should show the graph bunched up toward the left-hand side of the screen. If in doubt, take several shots at different exposures.

▶ SILHOUETTED STONES
The ancient circle of stones at Castlerigg in England's Lake District looks at its most mysterious when photographed at dawn. Shooting into the light, only the shape of the stones can be seen—this contrasts well with the light tones of the mist-shrouded mountains in the distance.

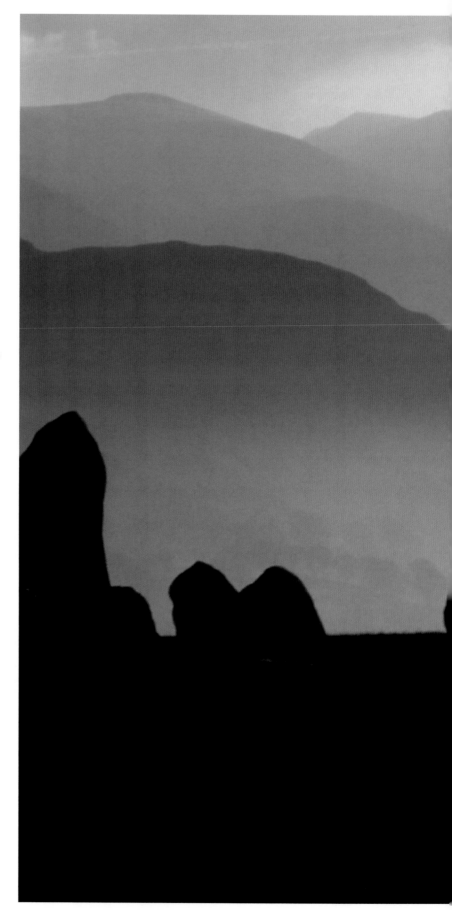

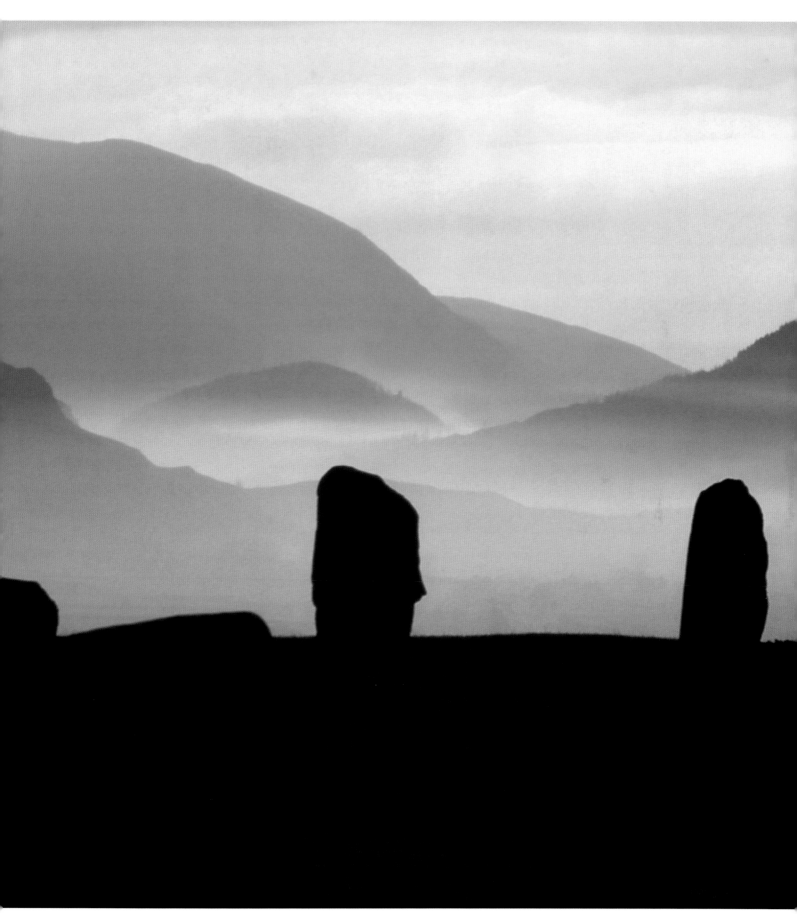

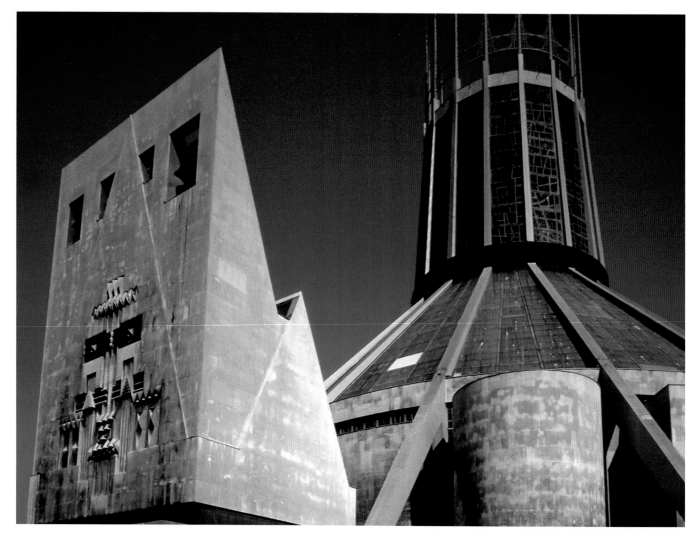

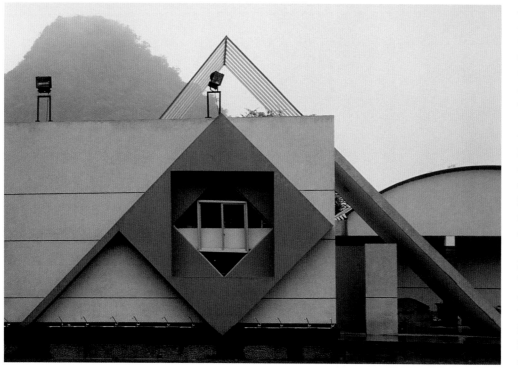

▲ LOW-ANGLE VIEW
Shape is best shown against a plain background. This shot of the modern Catholic cathedral in Liverpool, England, was achieved by crouching down so a clear blue sky could form the background.

◄ COMPARE AND CONTRAST
Even in dull light, the angular shapes of this modern building are appealing. But framing the shot so that the mountain in the distance echoes the triangular roof creates a stronger composition.

► SIMPLE BY DESIGN
This intriguing sculptural fountain is designed to look like a fishing boat. To appreciate the effectiveness of this simple shape, I photographed it silhouetted by the sun setting over the sea.

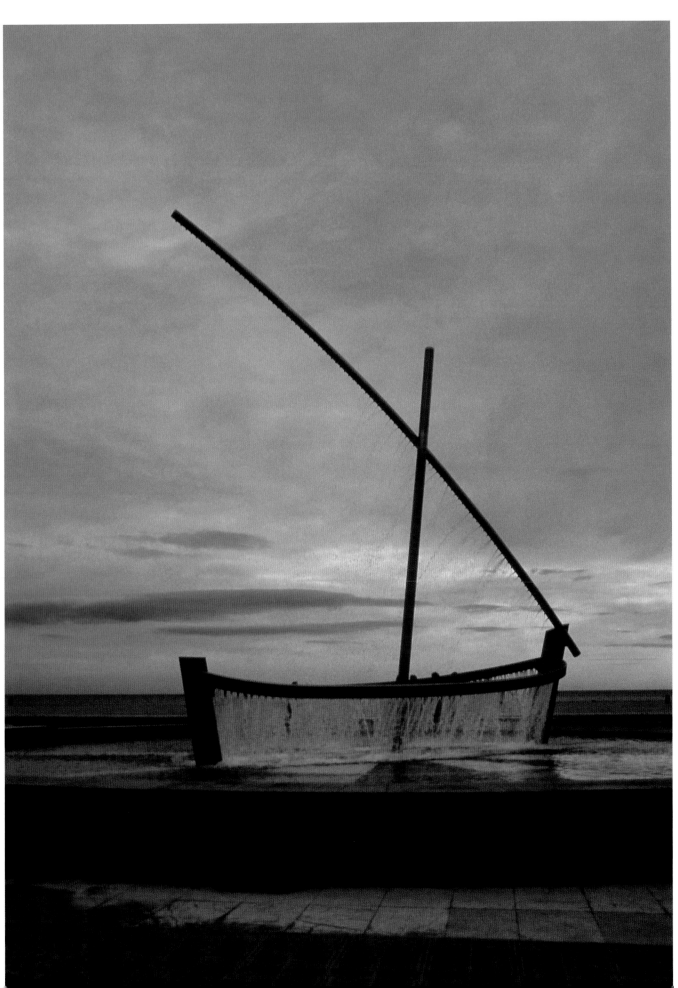

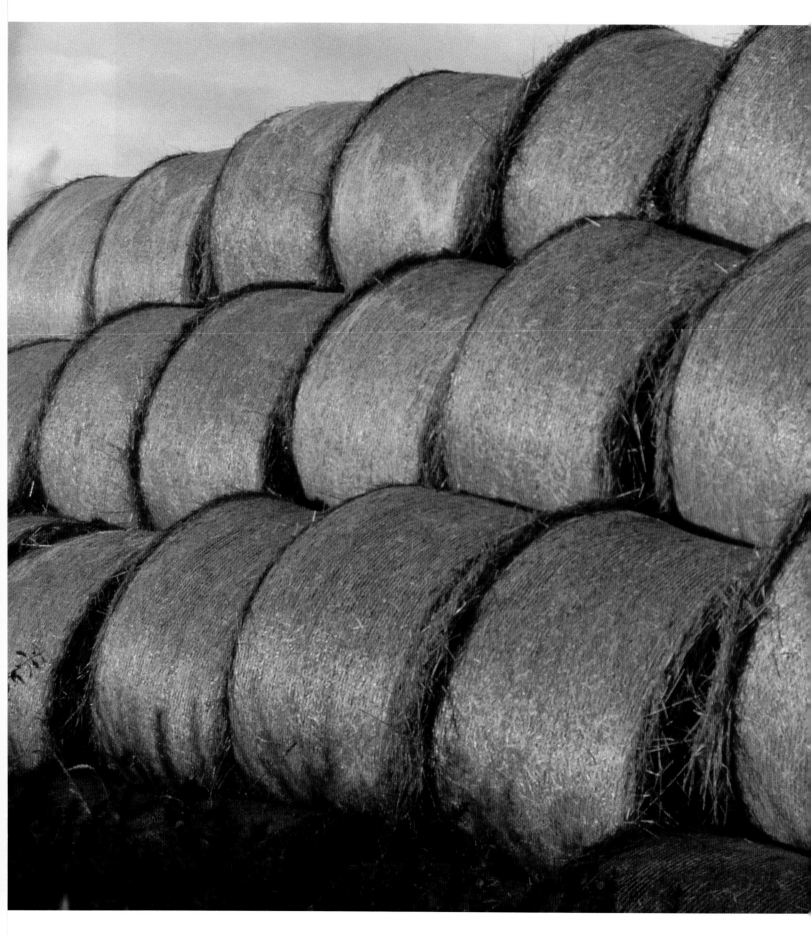

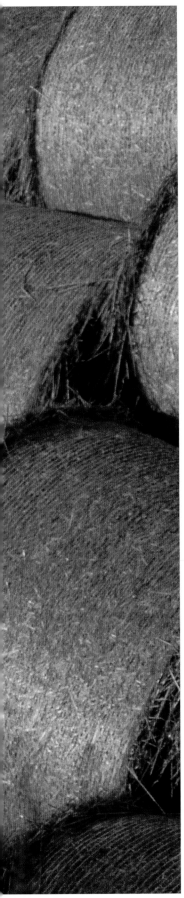

form and tone

IT IS THE MIDTONES that are all-important for providing a subject with three-dimensional form. The subtle gradation of shades in between the brightest whites and the darkest blacks gives body and substance to a flat photograph.

These tones are the photographic equivalent of the shading in an artist's drawing. They help distinguish the contours of a face, or a cube from a sphere, for example. To accentuate form, you want the changes in tone between areas of dark and light to be as gradual as possible. This is primarily achieved using lighting.

If a subject is lit from the side, rather than from another lighting angle, you get a higher proportion of areas that are half in shadow and half in the light. This then provides the crucial midtones that reveal the contours of a subject. Varying the angle of the lighting in relation to the subject, either by moving the light itself or by changing viewpoint, will change the mid-tones, and the amount of form that is revealed. The lighting must not be too direct, because this can create intense highlights that tend to drown out the subtlety of the shading. But it should not be too soft, either—otherwise the illumination is too even. The best light for accentuating form is halfway between the two. The partially diffused light you get by using a softbox over a studio light, or from sunlight that is softened by thin clouds, is ideal.

◄ GOLDEN GLOW
Outdoors, you rely on catching the light at the right angle to reveal form. Here, the low, late-evening sun to the left casts a golden light on the bales of straw, gently revealing their cylindrical form.

▼ SHADES OF GREEN
It is the gradual progression through different shades of green that suggests the undulating three-dimensional form of each leaf. The whiter highlights show the position of the sun, which was slightly to the right of the camera.

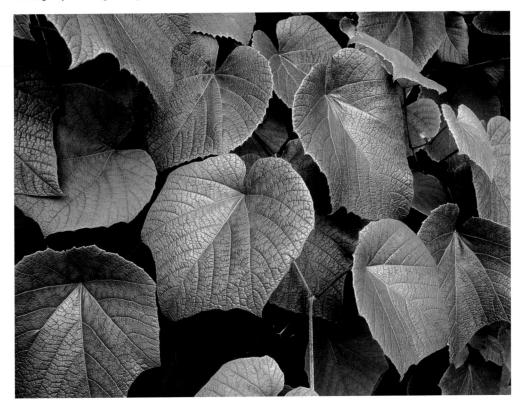

CHANGING LIGHT

These three pictures show how the direction and intensity of sunlight affects form. In the first, diffuse light from a cloudy sky gives no shading and a very flat image. With strong direct light from behind the camera, shown in the second shot, modeling is seen, but subtle. The best effect is in the third shot, with bright light from the side providing a gradation of tone across the cone-shaped structure.

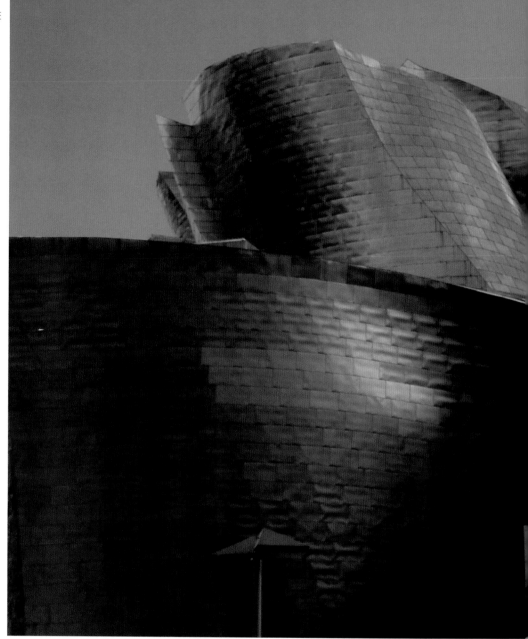

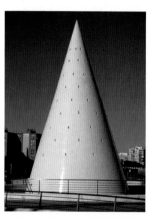

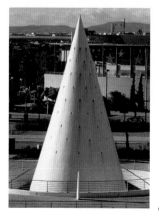

Outdoors, the darker side of a sidelit subject will almost always be lit indirectly—from sunlight reflected from surrounding buildings, the ground, or even from the sky. This natural fill-in helps to soften the shadows, and create a better range of midtones to suggest the three-dimensional form of the subject.

In the home studio, however, you need to provide this fill-in effect yourself—otherwise the shadows can end up being completely featureless and black. Although a second light can be used to partially balance that of the main sidelight, this is not really necessary. You can often simply use a reflector. This needs to be strategically placed to bounce light back from the main light source into the deepest shadows on the subject. Although specially made reflectors can be bought, a large sheet of white cardboard or paper, or a bedsheet, can be just as effective.

◄ SHINY SURFACES

The metallic walls of the Guggenheim Museum in Bilbao, Spain, designed by California-based architect Frank Gehry, reflect the light and the sky in interesting and ever-changing ways. With the late afternoon sun to the right of the camera, its futuristic form is revealed by the variation in tone across the rounded surfaces.

▼ CURVACEOUS BODIES

Sidelighting is the ideal type of illumination for revealing the subtleties of the human form—whether in the flesh, or in marble. This classical museum piece is lit from the right by a high window. Although some of the sculpture is in darkness, the daylight perfectly picks out the smooth curves of the beautifully carved body.

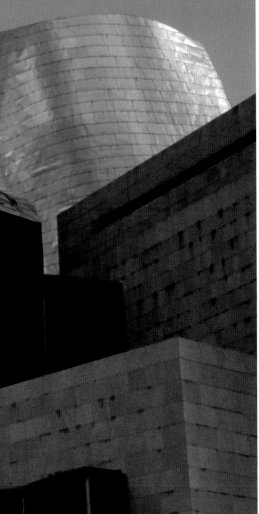

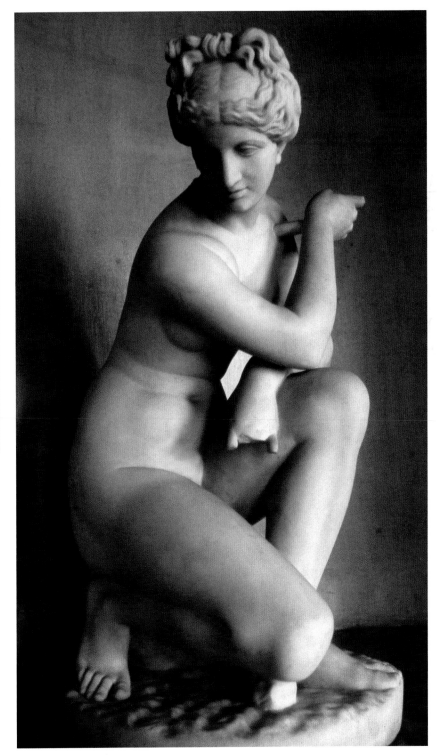

◄ BALANCING ACT

A single studio sidelight can often be too harsh, losing the subtlety of the subject's form. The simplest solution is to place a reflector on the opposite side of the subject from the light source, to bounce the light so that you get better gradation in the shadowy midtones. This still-life arrangement was set up to use the light from a window. By placing a large sheet of white cardboard to the right of the setup, light was bounced back from the window to soften the shadows. You need to look at your camera's LCD screen carefully to ensure that you have placed the reflector in its most effective position.

pattern

FOR A PHOTOGRAPHER, pattern is
a powerful tool—simply because
it creates order and beauty from
the jumbled chaos of everyday life.
Pattern is the repetition of a shape,
form, or texture—and can be found
practically everywhere you look.
From the repeated shapes of the
leaves of a tree, to the stone blocks
of a wall, patterns surround us.

The attraction of pattern is that we rarely even
notice, let alone study, the repetitions that are
under our noses. By picking out repeating
elements with the lens, you can show them in
isolation—allowing you to see and appreciate
the pattern with new eyes.

It often pays to use a long telephoto lens
setting and a distant viewpoint so that as many
similar subjects as possible can appear tightly
within a frame. This reduces the visual distance
between the different elements of the pattern,
making the image easier to read.

A close-up setting, or a macro lens, can
also be used to reveal pattern on a miniature
scale that would otherwise go unnoticed. Even
a heap of nails, for instance, can appear
interesting when the pattern fills the frame.
Powerful patterns can also be created by hunting
out identical items that are not usually seen in
groups—such as dozens of cabs in line at an
airport, or piles of mannequins in a warehouse.

◄ MAN-MADE REPETITION
Patterns are found in every building—from the bricks in
a wall to the tiles of a roof. The mixture of curved and
straight beams used in this modern walkway makes an
interesting pattern against the sky.

► PATTERNS WITHIN PATTERNS
This nest of dishes creates a fascinating pattern of frames
within frames when viewed from above, but would have
looked too abstract on its own. The free-form rings of the
cut onion create an interesting visual break.

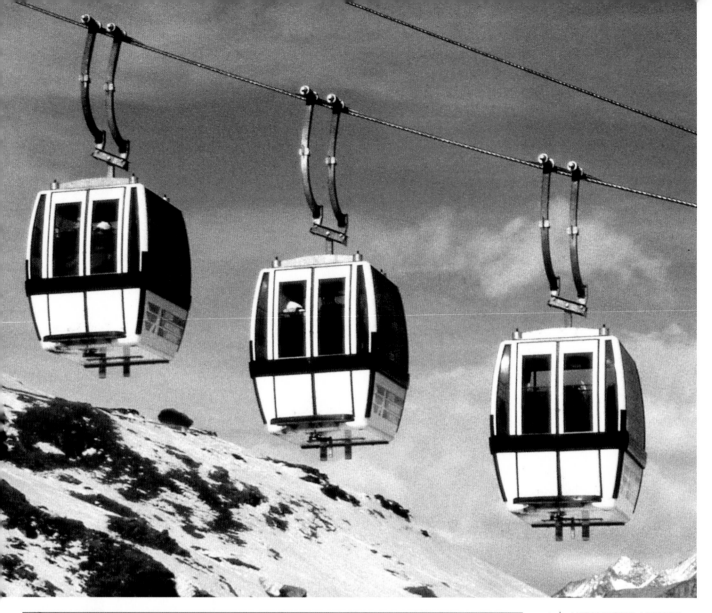

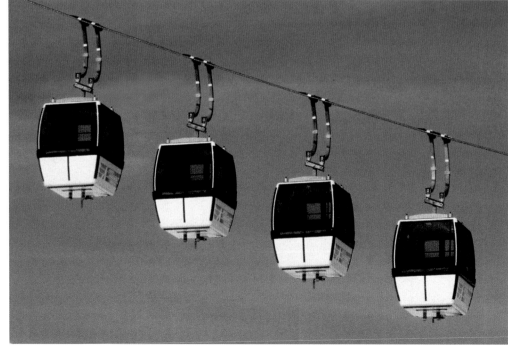

◄ ▲ ALTERNATIVE ANGLES
Four cable cars framed together in the same picture create an unusual repetition—as well as providing a novel view of a ski resort. One of the reasons the shot works is that the composition creates a strong diagonal line that leads the eye across the frame. When you find a subject or view that you are particularly pleased with, don't rest on your laurels—shoot it once, then look for a better angle. The version with the mountains behind (above) is good—but the alternative version (left), shot from the other side, is arguably better still because of its simpler, more abstract, composition.

Hunting out pattern with a digital camera can turn into something of an obsession—but try to avoid exact visual repetition. Often, shots work best when framed so that the pattern is not perfect. A close-up shot of a pile of white paperclips looks more interesting if there is one single red paperclip in the heap; this provides the focal point for the picture that would otherwise be missing.

Breaking up the pattern to some degree is particularly important because pattern has a flattening effect on any picture. Without a way of creating some form of visual variation across the frame, pictures of pattern can end up looking very two-dimensional.

Composition and lighting can be used to disrupt a pattern slightly—creating a more dynamic and interesting, three-dimensional image. Some items can be placed so that they are closer to the lens, making them look much larger within the frame than those that are more distant. Sidelighting can also be effectively used so that some objects are bathed in light, while others are plunged into shadow.

PASTING WALLPAPER

Patterns do not have to be found—they can be created on the computer, using the same technique used to make wallpaper. Here, a shot of a daffodil has been duplicated many times to fill the frame. You can alter the size and color of each tile, and cut out shapes, to create a more artistic mosaic.

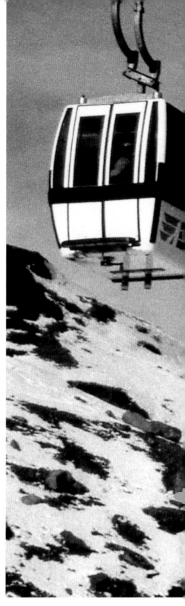

◀ LOOKING UP
Finding combinations of patterns and then framing the shot tightly can let you create abstract studies from seemingly mundane scenes. It is an approach that seems to work particularly well with architectural subjects. In this shot, a staircase is viewed from below. The unusual low-angle close-up creates an intriguing image from what, at first glance, could appear to be an uninspiring subject.

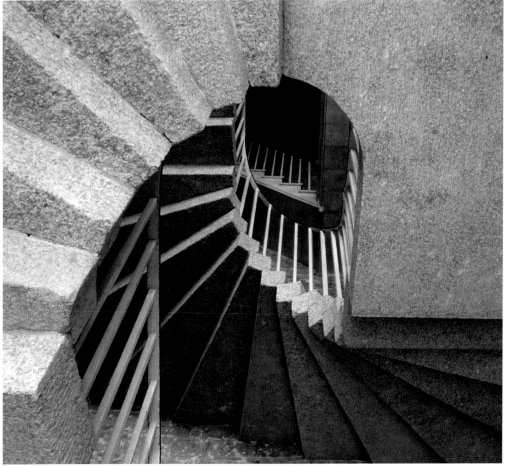

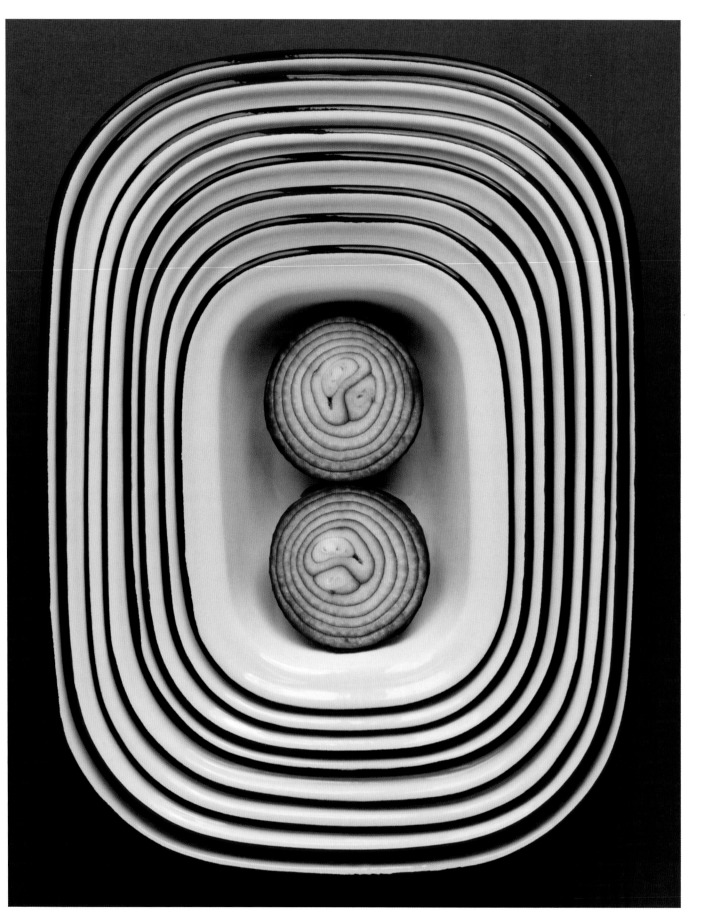

texture

A SENSE OF TOUCH can be given in a photograph by capturing texture. By accentuating the surface undulations, or lack of them, you can provide useful information that will help the viewer identify the substance of the subject.

◄ ▼ FINDING AN INTERESTING SURFACE
Texture can be found all around us—look for interesting rocks and old pieces of stone. The surfaces of fruit and vegetables are often very textural—as is a wrinkled face. Even a woodpile can produce interesting pictures that combine pattern with texture.

Texture is not just about identification—it can be isolated to create strong, semi-abstract images. By moving in, or zooming, to remove clues about shape and form, you can concentrate on the texture alone. Get in close enough, using your camera's macro mode or with special accessories, and you will often find that surfaces are less smooth than they first appear.

To maximize the visibility of texture, light needs to cast shadows into the furrows and dips in the surface, and illuminate the ridges. As with form, sidelighting is often useful. However, if a surface is reasonably flat, the light rays just need to rake across the surface at an acute angle. The lighting can therefore be directly above, to the side, or below the subject.

Unlike most subjects, texture can often be shot successfully in the midday sun. Interesting texture is often found on vertical surfaces—such as the peeling paint on walls or the gnarled wood of an old door. This means that the raking light from the overhead sun can pick out all the textural detail without any problem. Inscriptions carved in stone also show up clearly when the sun is directly overhead.

In the studio, it pays to avoid making any artificial lighting too harsh. Otherwise, you will end up with large areas of burned-out highlight, which are impossible to recover satisfactorily using digital manipulation. Either diffuse the light slightly or place a reflector to reduce the contrast across the surface that you are photographing, so you can expose for both shadows and highlights successfully.

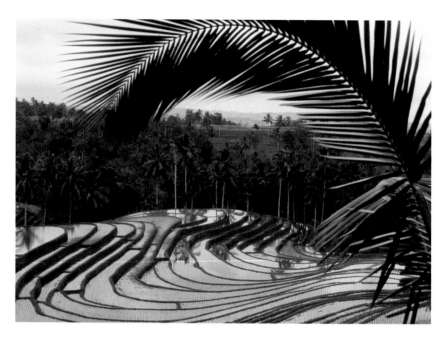

▼ ROUGH AND SMOOTH
Photographing two very different textures together often results in a successful composition—as in this detail that contrasts the smooth steel links of the snow chain with the rough rubber of the tire.

▲ GRAND SCALE
Texture is not always a close-up subject—it can appear on a grand scale if a landscape is lit in the right way. In this shot, the stepped contours of the rice terraces are clear to see.

► CAREFUL BALANCE
To reveal the texture of the plastic cup and the soap bubbles required the right lighting. The main light was placed to the left of the subject, with a softer fill-in light placed to the right.

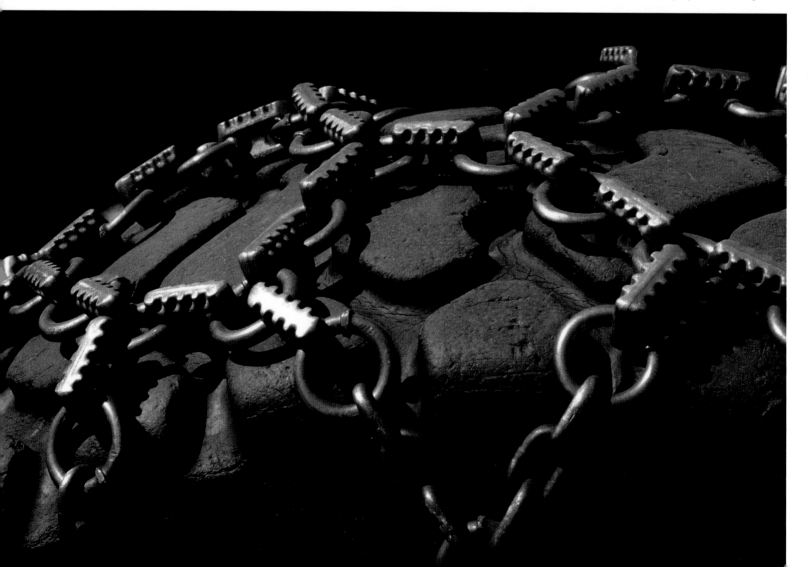

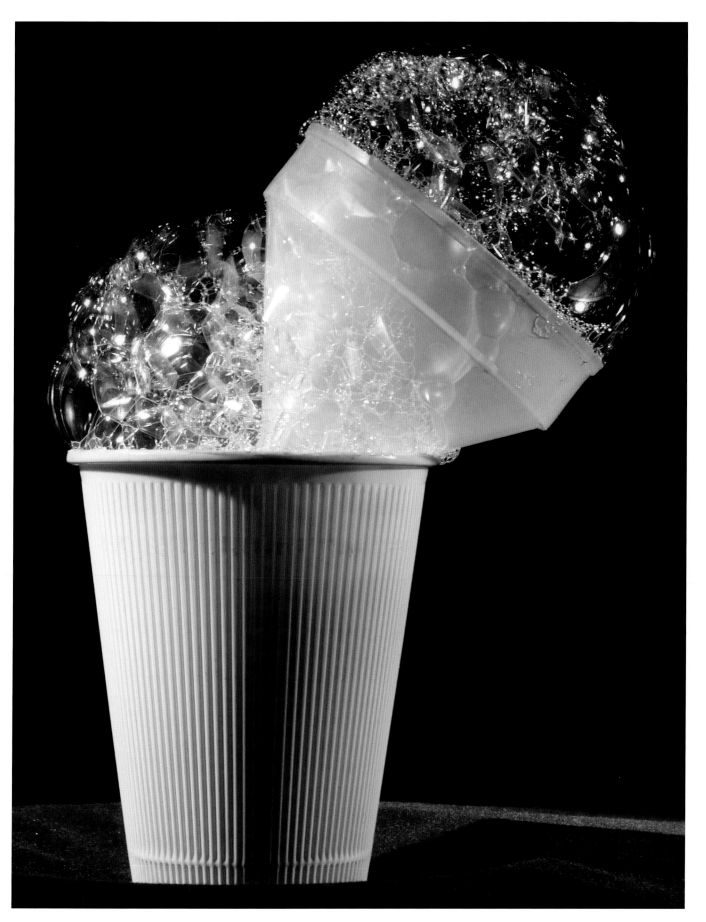

Color can be thought of as just another one of the essential elements. However, it has a much greater significance in digital imaging than form, pattern, texture, shape, and tone. A digital camera's sensor always sees the scene in full color—because each of its pixels registers either red, green, or blue light. Although you can choose for this information to be discarded before being recorded, it is almost always better to shoot in color, even if you want a black-and-white picture. You then convert to monochrome at the manipulation stage (see page 60). Unlike with film, a digital color "negative" can be used to create both quality color and black-and-white prints—giving you the flexibility to decide how to treat the image long after the picture has been taken.

Color is also an important element because it can draw such a strong emotional and psychological response. Different hues are associated with different moods—so you can create a feeling of excitement and energy with some colors, but an air of tranquillity with others. It's not just the individual shades of color that count—it is the way that they are grouped within the viewfinder. Some combine in a riotous way, and others sit together harmoniously.

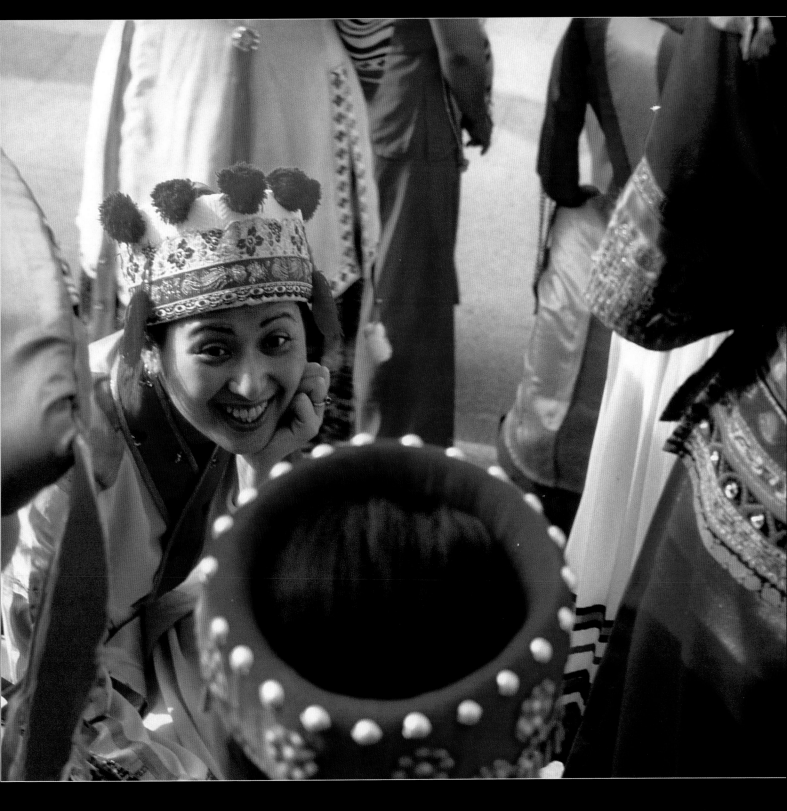

◄ DRAWING THE EYE
As with other areas of picture composition, often
the "less is more" approach works well with
color. The red shutter is not particularly bright,

▲ DRESSED TO IMPRESS
There are so many bright colors in this shot, it is
hard to know where to look first. Once your eyes
become accustomed to the brilliance, you discover

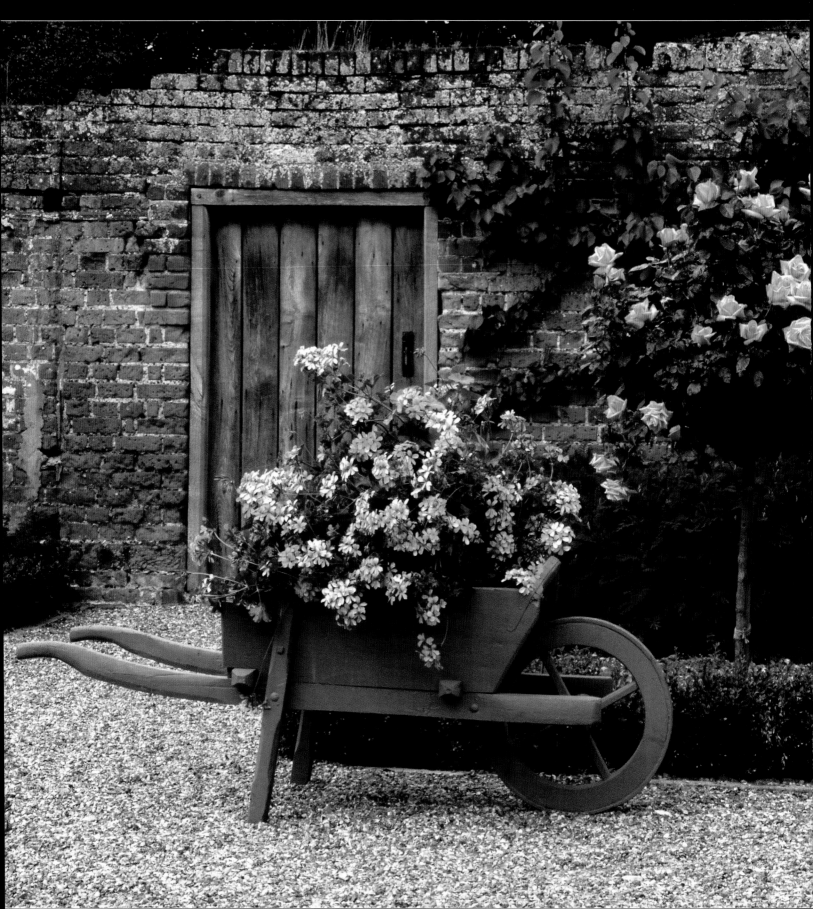

As with other elements, lighting has a significant impact on the way that color appears within an image. Some forms of lighting will give a boost to the coloration but others will tone everything down so that even clashing combinations of hue become subdued.

There is still some value in the old advice that you should stand with the sun behind you as you take your pictures, because this form of lighting will nearly always give you the strongest hues. Bad weather and overcast conditions will do the reverse—turning even vibrant colors into pastel shades. Backlighting, at its most extreme, can drain every last drop of color from a subject—although not necessarily from the scene as a whole.

Unlike in the days of film, the colors that are recorded digitally are not set in stone. Digital manipulation provides powerful tools for changing the color balance of a picture, and to increase or decrease the saturation.

These corrections do not need to be global. With a little effort, it is possible to change the color, saturation, and shade of just one particular area of the picture. This provides you with the tools to ensure that discordant and distracting colors are tweaked until they blend in.

More frequently, you might use digital manipulation tools to increase the presence of a certain color. You might want to boost the blue of a sky to what you had hoped it would be, rather than as you found it on the day you went out with your camera, for example.

◄ SAY IT WITH FLOWERS
In some photographs, the color is the most important of all the visual elements. We can see the texture of the wall, and the shape of the wheelbarrow—but this picture is really all about the bright hues of the flowers.

▲ PERFECTLY MATCHED
Yellow is a bright color that catches the eye, even if it only occupies a small part of the frame. In this unusual view, the color takes over the whole picture—with the walls looking as if they have been painted to match the old-fashioned steamroller.

impact and power of color

SOME COLORS LEAP OUT of a photograph more than others. The most powerful of all the hues is undoubtedly red. Just a small splash of crimson is enough to draw the eye—and using this property in your compositions can work to your advantage. A single red poppy in the foreground, for instance, can enliven a whole landscape.

▼ RED FOR DANGER
Road signs often use the color red because it always grabs attention. Cropped in close, so the context cannot be seen, this photograph uses the power of the hue to create a strong, abstract composition.

Other colors that are capable of commanding the attention in this way include yellows and pinks. Often, subjects work well in photographs simply because of these vivid hues; use an identical object in a more reserved color, and the image loses all of its impact.

You can deliberately hunt out colors, or sometimes you can engineer them into the composition. In portraiture, you might ask the sitter to wear pink rather than green. With a still life, you can use a red prop rather than a brown one. This trick can add a strong focal point to your picture—but you have to make sure that it is not so strong that it detracts from more important subjects within the scene.

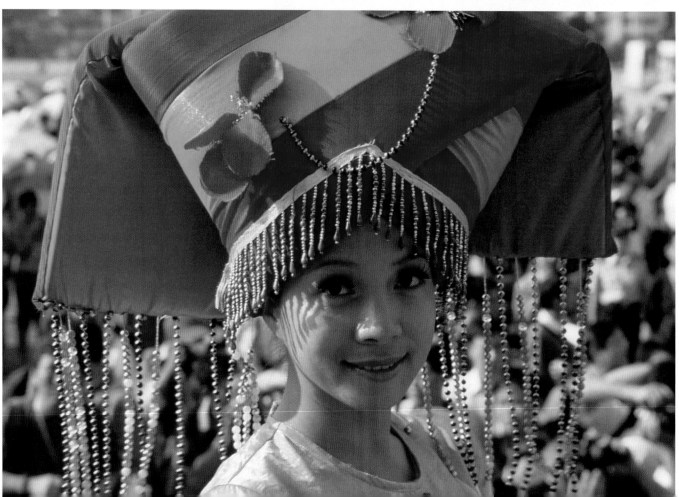

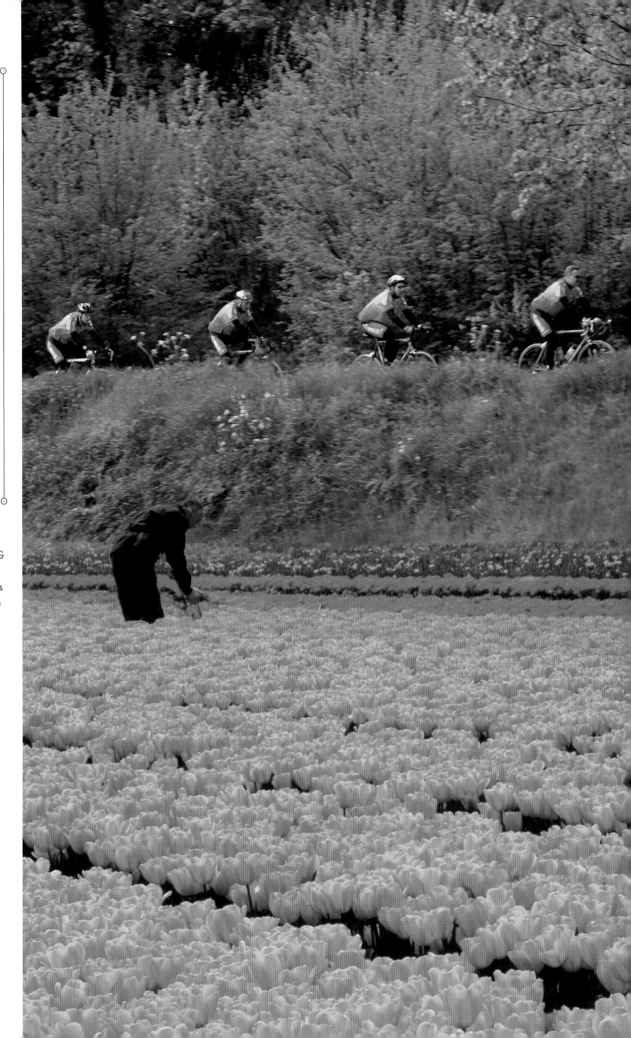

COLOR CALIBRATION

Every camera, computer screen, and printer sees and displays color slightly differently, and some cope with a greater range of color than others. Unless your equipment is calibrated correctly, it is likely that the colors of your images will look different when viewed on another computer, or when printed out. The best solution is to create a profile that tells the next device how the last device sees color. This profile is passed along with the image, so that the image can be seen accurately the next time it is shown—whatever the device used. The most important step is to ensure that your own monitor is calibrated regularly. Low-cost visual calibration software can be used—but for accuracy buy a system that uses a colorimeter, which will measure color from the screen itself.

◄ A QUESTION OF LIGHTING
Colors look stronger and more saturated when in direct light. In this shot, much of the elaborate costume is in shade—and this subdues the power of the design—leaving just patches of rich hue where the material is lit directly by the sun.

► FOLLOW THE LEADER
Some days, photographs just fall into place—in ways that you couldn't possibly plan for. The tulip fields of the Netherlands are a photographic paradise—with long rows of bright primary colors that light up the landscape and create superb abstracts when cropped in close. While I was shooting this scene, a group of cyclists appeared out of nowhere—dressed in outfits that, by chance, match the dazzling flowers. Note how these colors appear stronger contrasted against the complementary greens of the grass and trees.

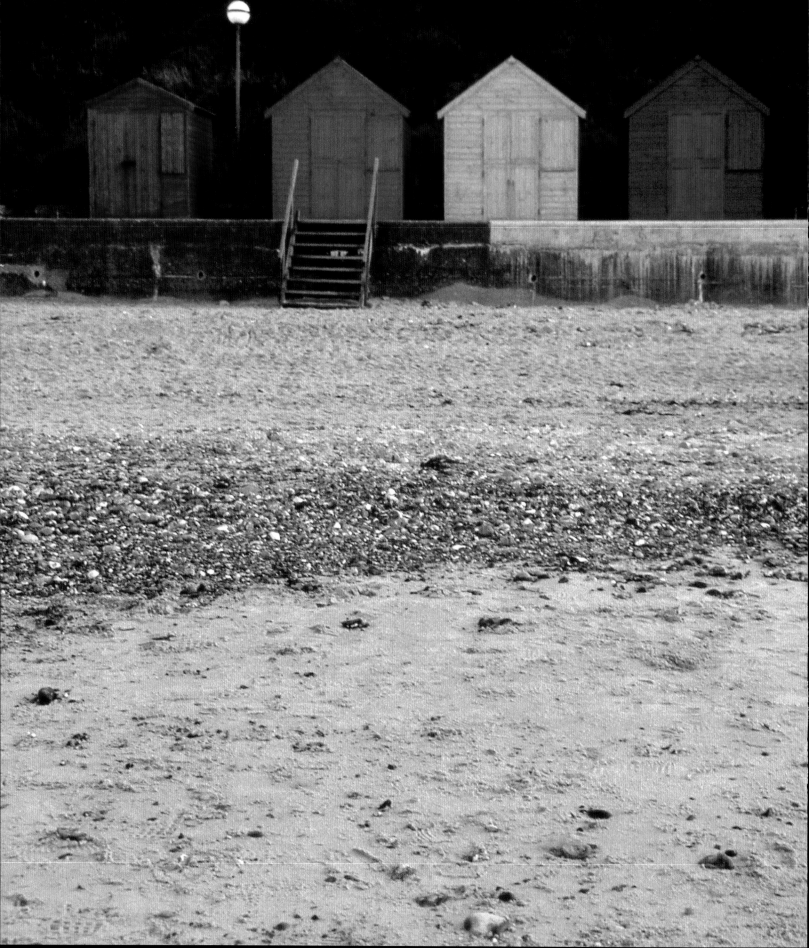

Just as some colors, such as reds and yellows, demand attention, others tend to recede into the distance. Blues and greens, for instance, often appear to blend into the background. Combining colors from these dominant and recessive groups can be a powerful way of adding more drama and depth to your pictures.

Choosing pairs of colors to create impact has to be done with care—there is always the danger that they will clash. The best contrast is usually achieved by combining complementary colors. Red and green is a potent pairing—as is blue and orange, or mauve and yellow.

Photographers can rarely be as picky about their palettes as painters—it is simply a matter of noticing when two colors appear to complement each other well. The blues of the sky or the sea are very useful, because they can provide a recessive, non-competing, and extensive backdrop against which to frame brightly colored subjects.

◄ ON THE SEASHORE
Put side by side, yellow is the lightest-toned of all the primary and secondary colors. This is why the yellow beach hut in the row stands out the most in this seafront shot taken in low light.

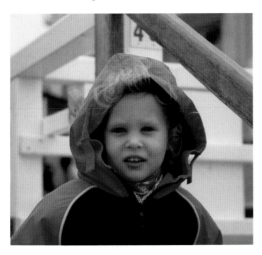

▲ ATTENTION SEEKER
Red has the power to bring any scene alive. Despite being shot on an overcast day, the bright red of the child's coat still grabs your attention when you look at this head-and-shoulders portrait.

► PAINT EFFECT
Some subjects make great photographs simply because of their color. The yellow walls make this building almost irresistible to a photographer. Painted white or brown, they would have little appeal.

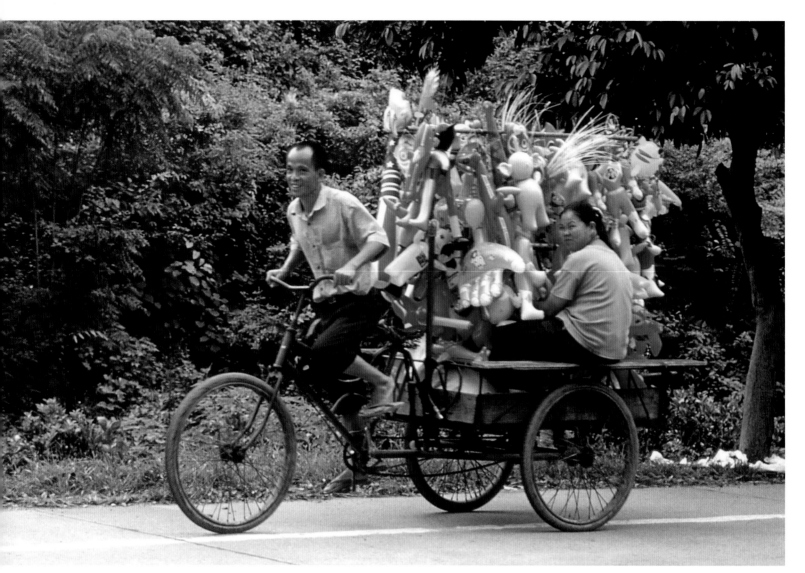

SATURATION CONTROL

Many digital cameras allow the user to set a preference for the degree of color saturation recorded in the image. However, it is better to leave this boosting facility turned off, and then adjust the saturation on the computer. This allows you to change the color more precisely, and to suit the lighting and subject of each individual composition. In this shot of a sunflower, Photoshop has been used to increase the brightness and saturation of half of the yellow petals of the sunflower; the other half shows the dull original colors captured on an overcast day.

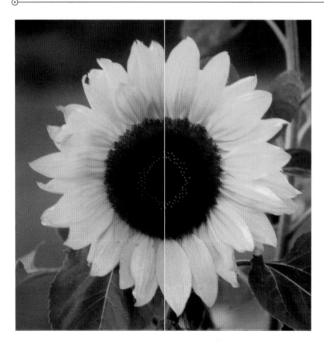

▲ PEDAL POWER

A cycle rickshaw is a common sight in Asia, so coming up with a different way of depicting this mode of transport is a challenge. This shot proves that it is always worth having your camera with you, ready for the unexpected. A cargo of brightly colored inflatable toys makes an unusual sight, even in China—and a great subject for a picture.

▶ RED LETTER DAY

This bold red Dutch mailbox would be a great subject in any setting. Here, the uncluttered background and foreground provide perfect surroundings for this still life. The two eyelike windows made the scene an obvious choice for a symmetrical composition.

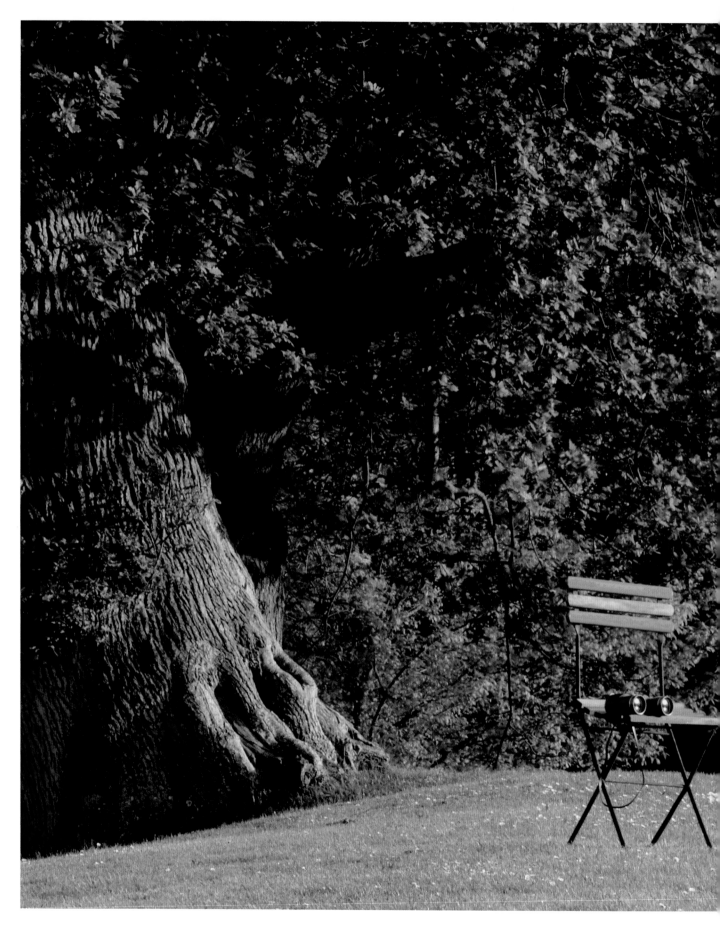

color harmony

COLOR CAN BE such a powerful ingredient within a picture that other elements are effectively drowned out by the bright hues. But although this works well with some subjects, there are plenty of others where you don't want to take such a brash approach. Sometimes you want to use color more conservatively—to provide a subtle image where other elements can come to the fore.

You don't always have control over the colors of your subjects, but you do get to choose what pictures to take—and of those, which you keep and which you delete. Even if you cannot directly control the environment, the number of colors in a scene can often be controlled; you can do this simply by altering your viewpoint to find an alternative background.

The secret to achieving harmonious colors is to keep it simple. The most radical approach is to limit yourself to shades of just a single color—creating an almost monotone image. Remember that white and black do not count—so these can be thrown freely into the composition without any risk of upsetting the subtle effect that you are trying to achieve.

◀ PEACEFUL PASTURE
A green lawn chair blends peacefully into the foliage and grass surrounding it. The pair of binoculars creates a sense of intrigue—and provides a strong focal point for the picture.

▼ DRESS CODE
To show the unspoiled beauty of this gorge, you don't want to add unnaturally bold colors. In his gray shirt, the oarsman blends in; it would be a very different shot if he had worn red.

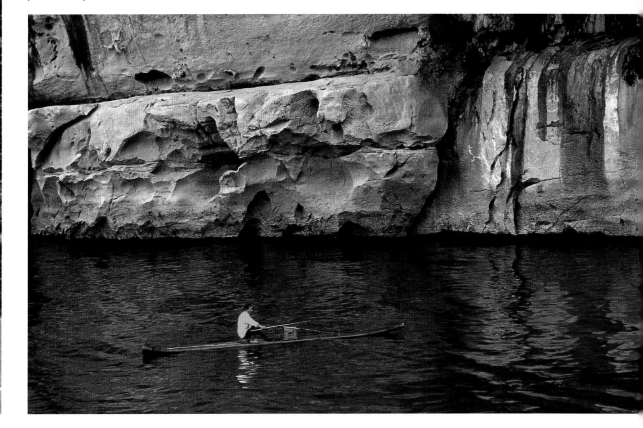

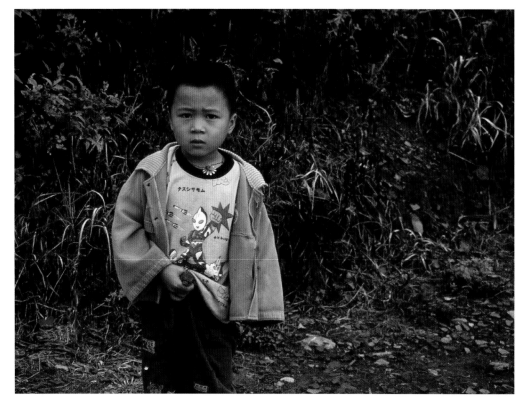

▲ RAINBOW RULE
Orange and yellow follow each other in the rainbow, so they should blend together well. Here, this color combination means that the bright clothes do not distract from the portrait.

▼ SHADES OF GREEN
This shot consists of shades of green: the clear green water, the fresh green produce on the boat, and the dark green bushes on the bank. The restful combination links all the picture elements together.

► DILUTED BY DISTANCE
Atmospheric haze weakens the intensity of distant colors, but affects nearby colors less. In this telephoto shot of the Great Wall of China, the effect is to give a blue gradated wash to the scene.

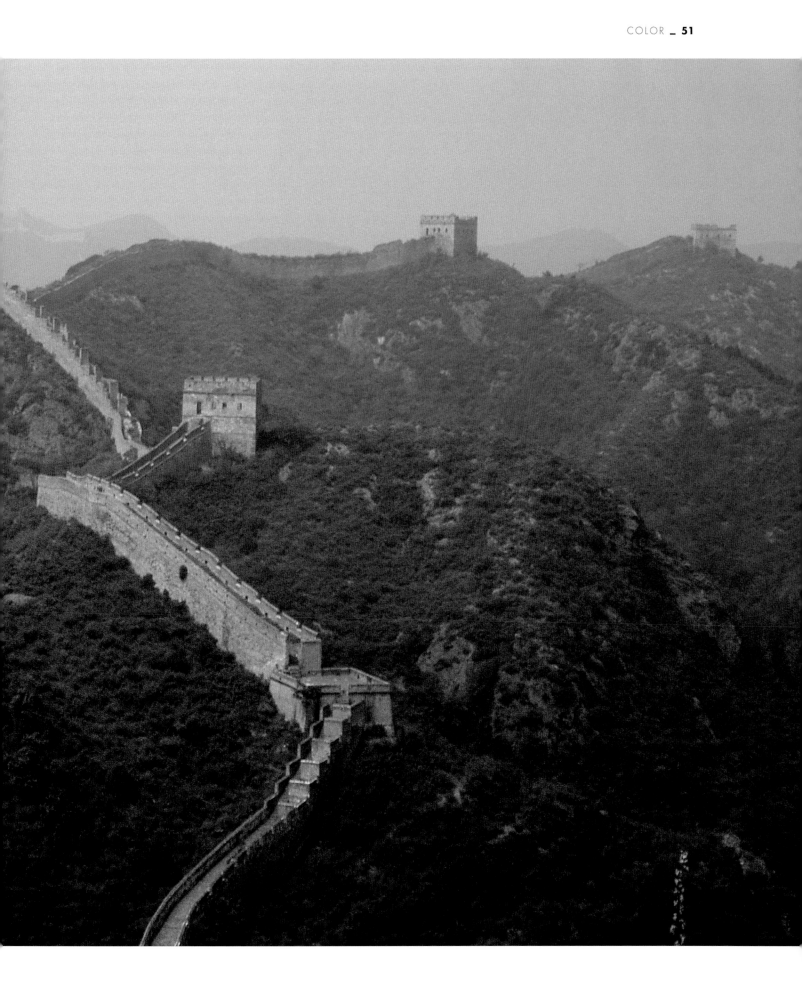

A more adventurous approach to harmonious color combination is to mix hues that are made up using similar amounts of the same primary color. Think of the sequence of the colors of the rainbow—red, orange, yellow, green, blue, indigo, violet. You will not go wrong if you combine neighboring colors from this sequence. So shades of yellow and green will work fine—as will blues and purples. It goes without saying that pastel tints will create more gentle compositions than bold, pure versions of the same color. But, of course, color combination is ultimately a matter of personal taste—just as when decorating a room in your own home.

You will discover that you can be more adventurous with natural colors and still get pleasing combinations. The flowers in a vase can be from different ends of the spectrum and still work together harmoniously—but an arrangement of plastic objects with similar hues will not be as restful on the eye.

The intensity of a color that is badly placed in a shot can be reduced in a number of ways—should this work in favor of the composition as a whole. Soft, indirect lighting—such as that provided on an overcast day, or found in areas of shade, will weaken the saturation and strength of colors.

Areas in the background that are the "wrong" shade can also be weakened by using camera settings that throw the area out of focus—because this will reduce saturation (see pages 82–85). Slight overexposure will also have the effect of reducing saturation, just as slight underexposure can be used to provide an increase in color intensity. You can also apply these effects later, with a digital image manipulation program.

◄ SEA OF BLUE
This shot has been radically cropped to create an almost abstract picture. The key element of the building is the shape—its color is secondary. The blue sky with its fluffy clouds is pleasing to the eye, and fills more of the frame than usual.

► SHADES OF PALE
All-white subjects suit a restricted color palette. You can then set up the lighting to accentuate the form and pattern. With a white surface as a background for the garlic, it was simply a matter of getting the intensity of sidelighting right.

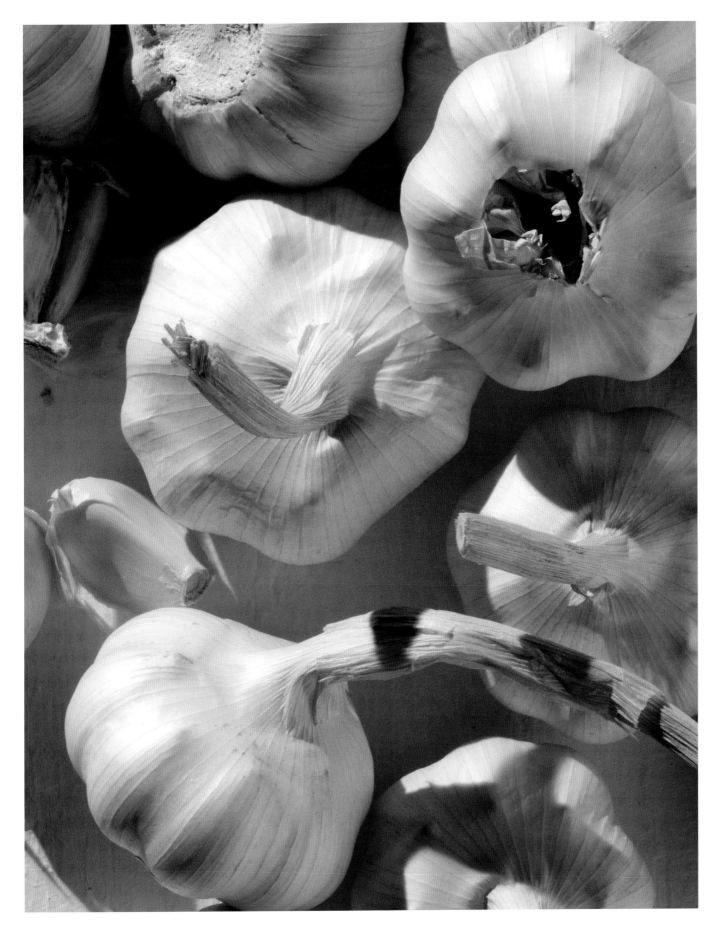

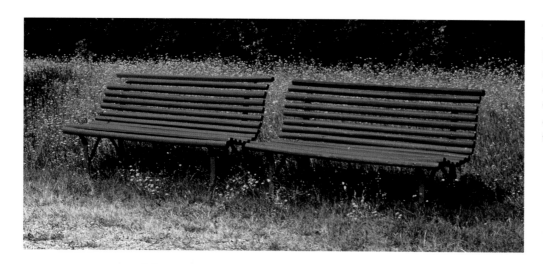

◄ SIDE BY SIDE
These two green benches have been designed to blend into their surroundings—without creating a blot on the parkland landscape. Cropping in close lets the image concentrate on the shape and form of the furniture.

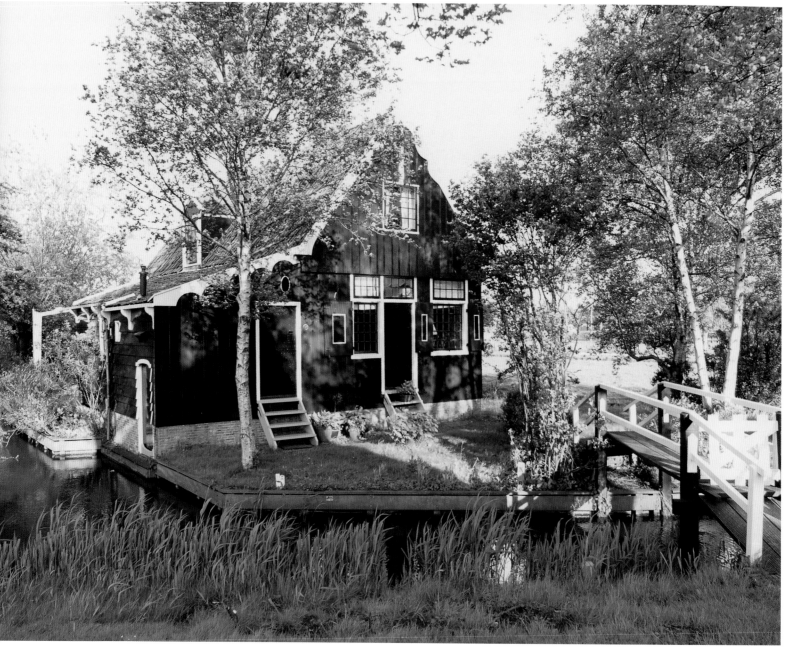

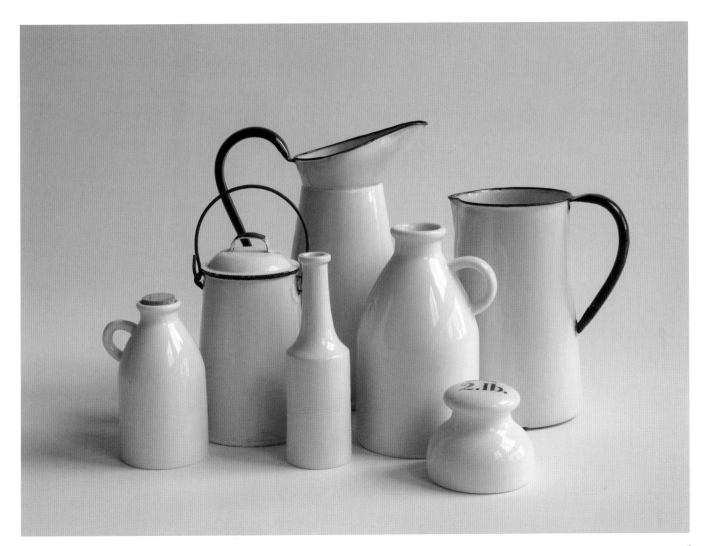

▲ STUDIO MANAGEMENT

In the studio you have almost total control of the color range in your pictures. You can pick the background and choose the props, so that the colors match the subject as perfectly as you wish them to. This arrangement of creamy white pottery and enamelware has been photographed against a curve of paper that creates both foreground and background, known as a cove (see page 199). The lighting is from a window to the right of the setup.

◄ BACK TO NATURE

For this shot of an unusual dark green house, the viewpoint has been chosen to show how the owner's choice of paint works well in the building's lush surroundings.

COLOR CONTROL

Bright colors can sometimes be distracting. In this shot, I felt that the bearded gentleman's red scarf drew too much attention away from his face (right). For digital images, there is an easy solution—simply manipulate the color on the computer. In this case I chose a blue that would match his shirt (far right). A global adjustment was not possible—because this would also have had an effect on the skin tones. Instead, the adjustment was made selectively. This can be done in a variety of ways, such as selecting the area to be worked on before you start, or creating a mask for the adjustment. An alternative route in Photoshop is to change the colors of the whole image, then undo this change, then selectively paint back the effect using the History Brush.

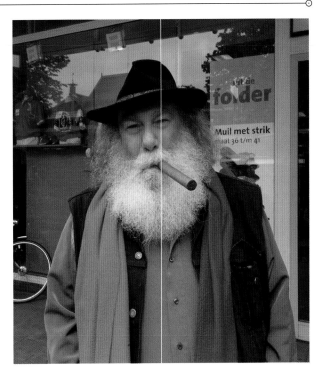

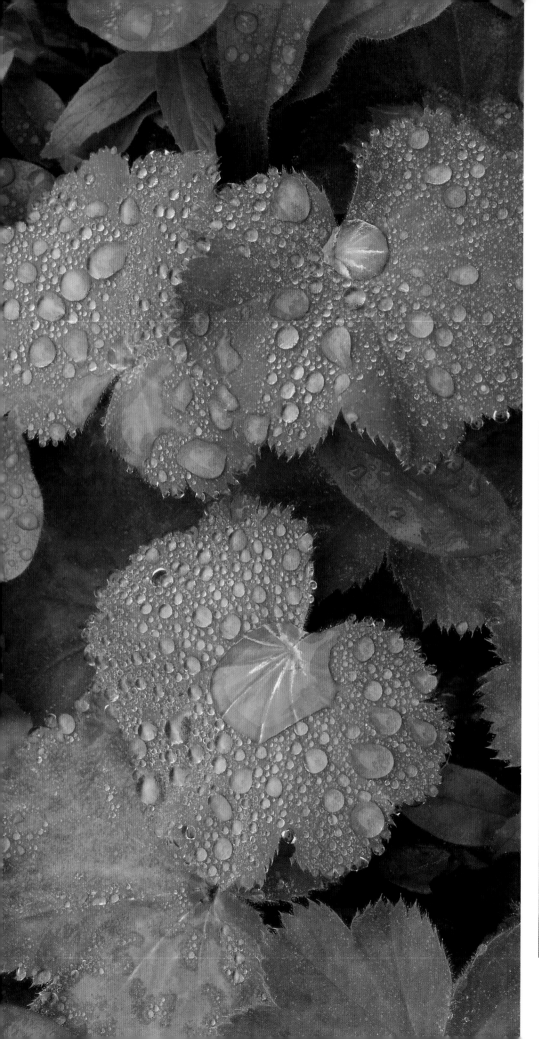

◄ MONOCHROME APPROACH
This shot would work well in black and white. However, since it is monochrome anyway, the color does not detract from the close-up study, which emphasizes the shape of the leaves and the texture of the water droplets.

► PROVIDING CONTRAST
If you fill a frame completely with a vivid color, it starts to lose some of its dominance and power. In this shot, it is the dark lines between the flower beds that attract the attention—and the solitary dark figure of the man checking the blooms.

▼ EMPHASIZING PATTERN
Low light and backlighting both tend to suppress color intensity and detail. These lighting conditions have robbed this Irish seascape of its color, and it has become a pattern of blues and blacks.

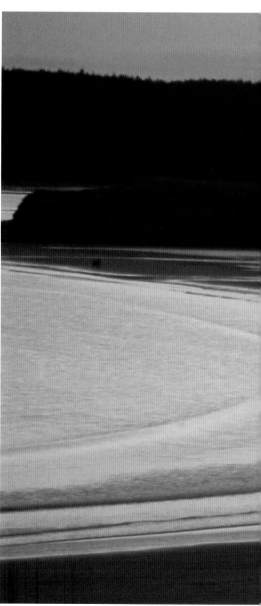

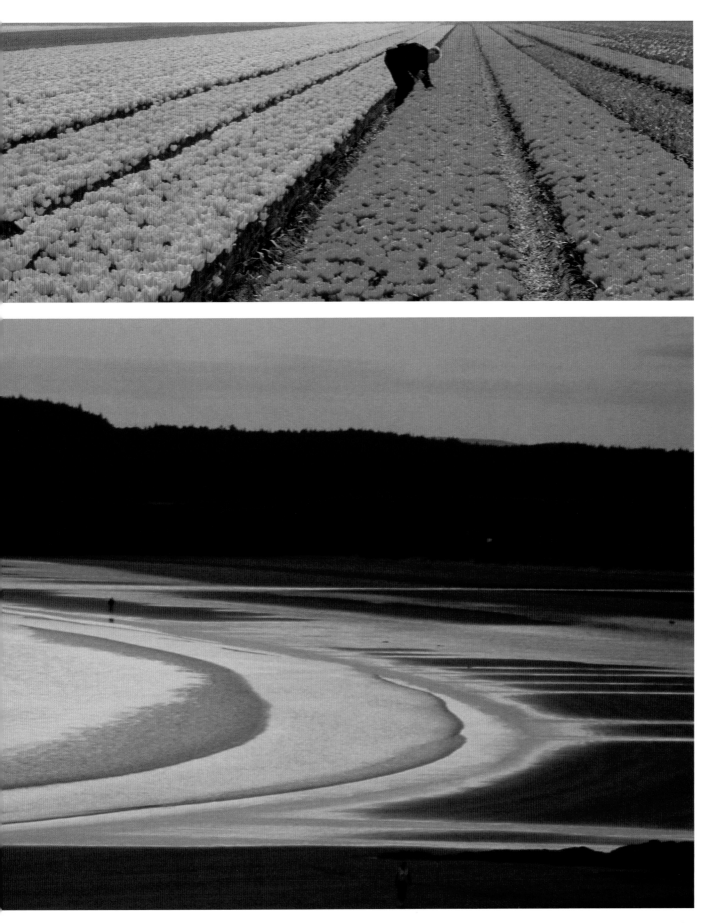

color temperature

ALTHOUGH THE HUMAN eye rarely notices it, all light sources have their own color—varying from the deep red light of a candle, through to the blue light that is typical just before daybreak. This is known as a light's color temperature.

The human brain automatically compensates for these differences, so that the pages of a book look white whether read in daylight or with a flashlight. Digital cameras can mimic this process, automatically measuring the color temperature of the scene and adjusting the "white balance" of the image electronically to give natural-looking colors in all lighting situations. This is a significant advantage over film, where filters often had to be used at the shooting or printing stage to ensure that the picture did not have a strong color cast.

Although the automatic white-balance system does a good job on most occasions, it is not foolproof. Most cameras have a manual override so that you can alter the overall color of the image to get a more accurate representation, or for artistic effect. White balance is set manually by choosing the lighting type (cloudy, sunny, and so on), or by specifying the color temperature precisely using the Kelvin (K) scale. On some models, the white balance can be set by using the camera to take a color temperature reading from a sheet of white paper.

► WARMER SKIN TONES
Some pictures, such as portraits and architectural shots, benefit from using manual white balance to create a warmer-toned picture. Set to auto, the baby looks blue (right); using a Cloudy setting gives a more pleasing picture (far right).

▼ SUNSET CORRECTION
Automatic white-balance systems can overcorrect the colors of a sunset (below). Switching to manual allows you to choose a color temperature setting that records the image as you want it (below right) .

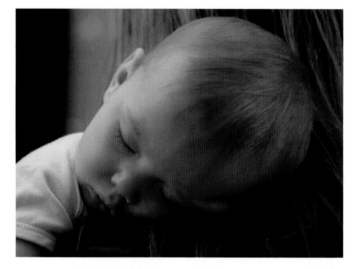

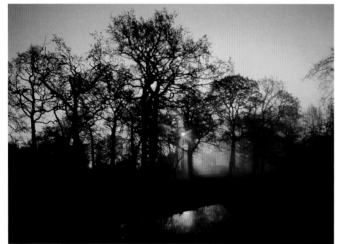

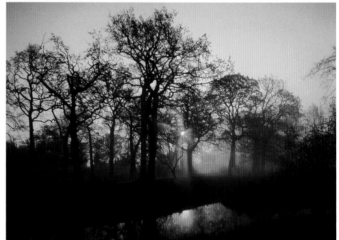

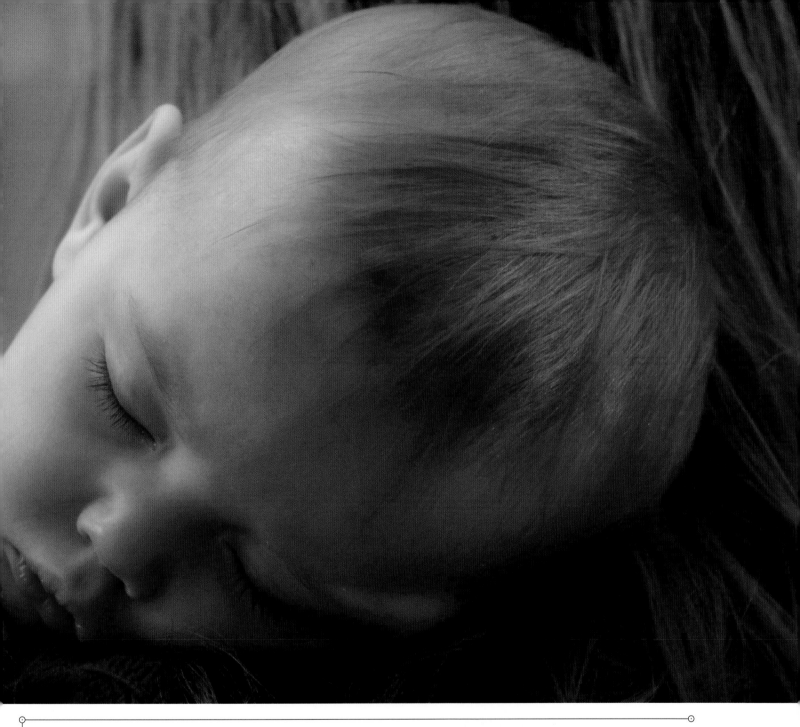

MIXED LIGHTING

Some scenes are lit by several light sources—each with a different temperature. You can only correct for one light source using the camera, so in mixed lighting, choose a white-balance setting that best suits the main subject. In the first shot (right), there is an obvious orange color cast. Adjusting the white balance gives a more natural coloration to most of the frame, but the distant lights still look orange (far right).

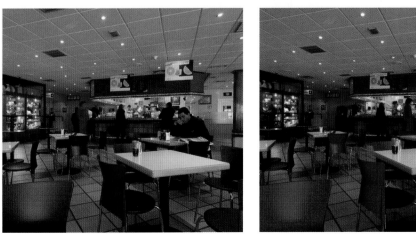

shooting in black and white

WITH A DIGITAL CAMERA, you can switch from full color to black and white with ease. There's no need to shoot a whole roll of film—you can simply change the camera mode on a shot-by-shot basis. Some models may even offer other monochrome modes, such as sepia.

◄ ▼ STRAIGHT SHOOTING
Black and white is particularly effective for portraits. This sequence was taken with a digital camera set to its black-and-white shooting mode.

Black-and-white photography has a timeless quality that is particularly suited to some subjects. A lack of color simplifies a scene, accentuating other elements, such as form. It is especially popular with both portrait and landscape photographers.

Surprisingly, though, it is usually best to shoot the image in color and then convert to mono on your computer later. Of course, this gives you the choice to use the image in color, as well as in black and white. But more importantly, the color information can be used to give you precise control over what shades of gray specific colors are converted to. The blues of a sky can be tweaked, for instance, to make dramatic, dark tones; and dark foliage greens can be made a lighter shade of gray than a straight conversion would have made them.

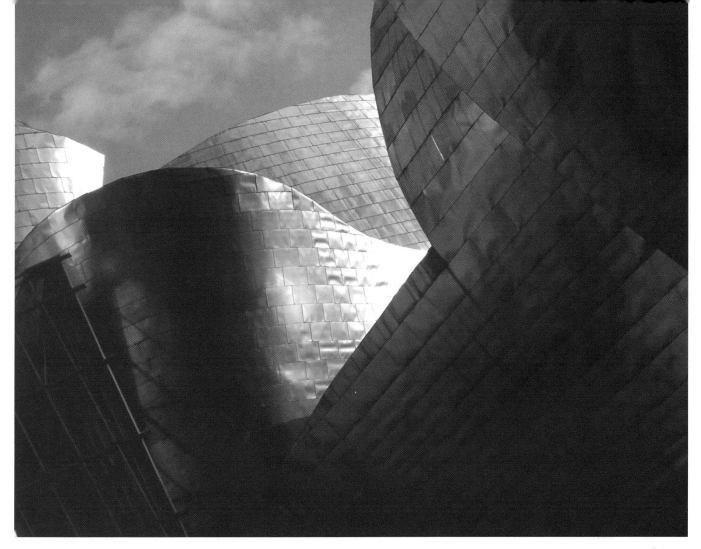

◄ ▼ CHANNEL MIXING
A straight grayscale conversion on a computer creates a black-and-white shot from a color original (below). But using the Channel Mixer or Hue/Saturation controls produces a punchier portrait (left).

▲ ABSTRACTION
One appeal of black and white is that it can create a more abstract image. This architectural shot was taken in color and then converted on the computer.

▼ SHADES OF GRAY
The absence of color means black and white is useful when you want to accentuate form. The blue glass bottles in this still life have been subtly converted into blacks and grays.

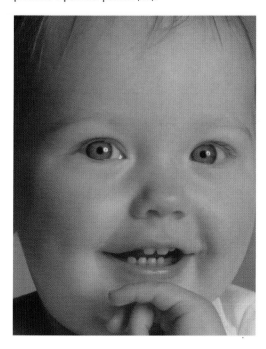

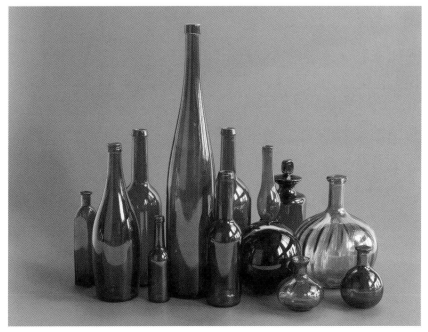

◄ ▲ BLACK SKIES

Converting this silhouette using a Hue/Saturation adjustment layer creates a dark, dramatic sky. This, and similar Channel Mixer adjustments, recreate the effects that would be given by using colored filters with a film camera.

▲ ► SEPIA TONING

After converting a color image to mono, using Hue/Saturation or Channel Mixer adjustments, you can then give the image a tint, similar to using a metallic toner in the darkroom. In this portrait a Hue/Saturation adjustment was used to create a sepia effect.

DUOTONES

Images can also be created using two colors of ink. Converted from a grayscale image, "duotones" can provide subtle coloration in selected midtones. Tritones add a third ink color, and can create more psychedelic effects.

DEPTH

Despite all the advances in technology, the pictures that we shoot today are as flat as the ones that were taken by the Victorian pioneers of photography. We still take pictures of a three-dimensional world—and, with few exceptions, turn them into two-dimensional representations.

Whether you look at the picture on a computer monitor, on your camera's LCD display, or printed out on sheet of high-gloss, premium photographic paper, the image is flat; it has no physical depth.

For this reason, creating an illusion of depth is all-important in photography. We frequently want to add the missing third dimension—to make our pictures more representative of the subject matter itself.

There are numerous ways in which you can do this. The human visual system uses two eyes to provide a stereoscopic view of the world, helping us to judge distance. However, many of the clues about depth that we use subconsciously when we look at the real world come from the content of the image itself. By learning to include as many of these clues as possible, photographers can create a better three-dimensional experience in their pictures. Many of these telltale signs will be there in the composition anyway—but making the most of them will make your images come alive.

Some of the tricks have been covered already, such as using lighting and tone to reveal three-dimensional form, or including dominant and recessive colors. But there are many other techniques for creating a sense of distance.

Perspective is one of the most important properties that you can manipulate in order to create a stronger feeling of depth. Perspective is, actually, a series of different tricks that are used by the human brain to judge distance—to work out which objects are closer, and which are farther away.

It is linear perspective that obsesses the art student, because it is necessary to draw parallel lines so that they converge convincingly on the paper. As a photographer, you have no such problems—the lens and imaging chip do everything for you. However, the feeling of linear perspective can be accentuated through viewpoint and the choice of lens setting; it can also be purposely reduced, to make objects look much closer together than they really are.

Other forms of perspective that can be used to a photographer's advantage are: diminishing size (things look smaller the farther they are away); overlapping forms (from certain viewpoints, closer objects obscure more distant objects); and aerial perspective (particles in the atmosphere make distant objects look less sharp). Additionally, depth of field and image composition can be used to control the feeling of distance in a picture.

◄ FOCUS EFFECT
Our brains understand that some posts are farther away because they are slightly out of focus. Known as depth of field (see pages 82–85), this is a useful tool for providing a three-dimensional effect.

► LEADING LINES
From the right camera angle, the horizontal lines of a building can be made to look as though they converge. This effect can be exaggerated by changing camera positions and by using a wider lens setting.

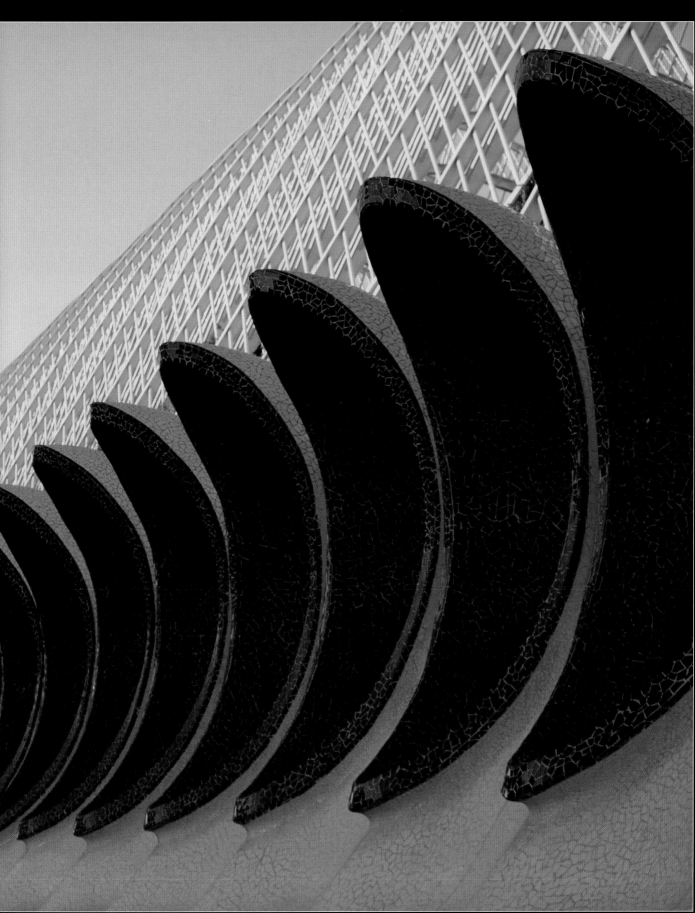

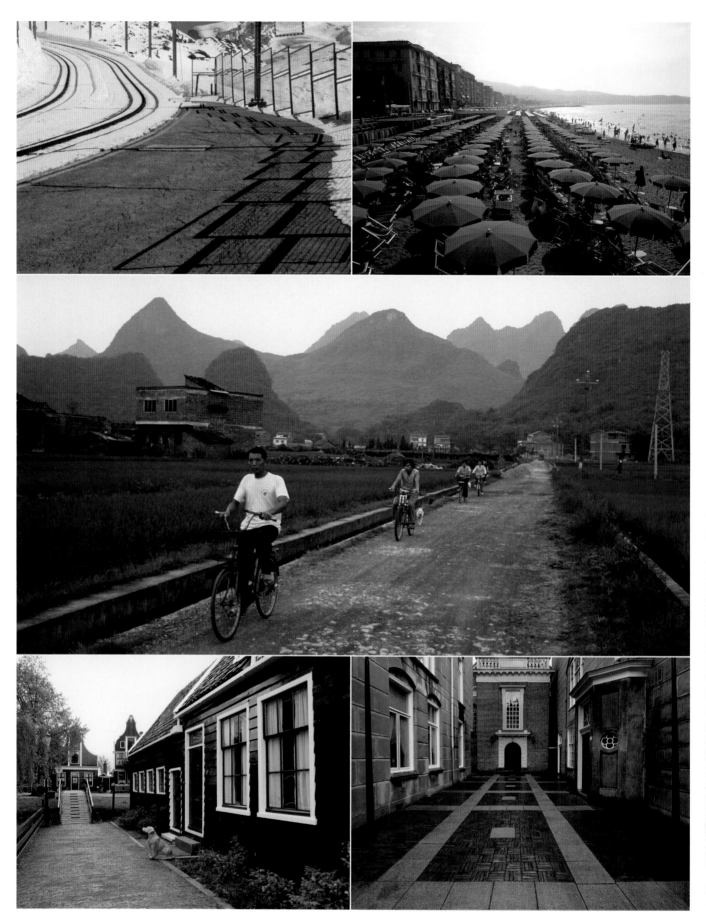

using perspective

STRONG LINEAR PERSPECTIVE in photography is usually achieved by using wide-angle lenses—the wider the angle of view, the better the effect. However, perspective is not actually changed by zooming out, using a different lens, or adding wide-angle converters. Linear perspective can only be changed by viewpoint.

▼ ALONG THE LINES
Including linear perspective in a composition creates depth. By standing in the middle of the pathway, the sides of the Great Wall of China appear to gradually converge as they weave their way toward the horizon.

The perspective simply looks like it has altered because you have increased the angle of lens coverage. Because areas of the foreground that are much closer come into shot, the parallel lines appear to converge more sharply.

The perfect subjects for this approach are ones that have strong parallel lines—such as a road, or train tracks. Getting down low will ensure that the foreground is as close as possible—helping to exaggerate the effect of the wide lens.

Diminishing size is essentially a by-product of linear perspective. However, subjects of similar size will appear smaller the farther away they are, even if there are no converging lines. This illusion works best when the subjects look as identical to each other as possible. Like linear perspective, it can also be exaggerated using wide-angle lenses, and by being as close as possible to the nearest object.

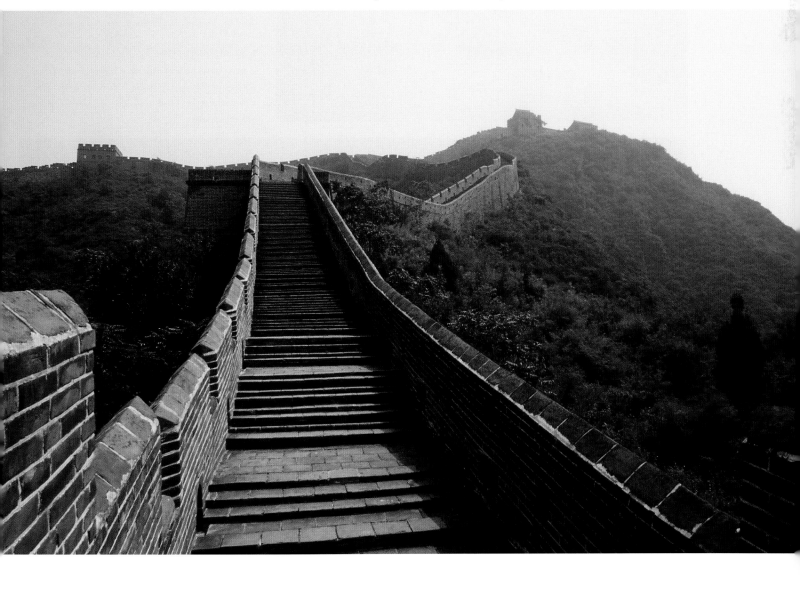

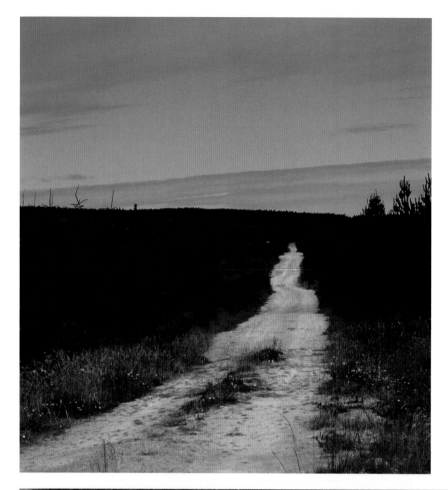

Composing an image so that distant objects are partially obscured by ones that are closer can be used, together with other perspective tricks, in order to increase the feeling of depth. At its more extreme, you can set up a composition so that foreground elements—such as branches of a tree—cut through the main subject in the distance. The distraction this may cause can be controlled by ensuring that the foreground is out of focus (see pages 82–85).

◄ ALONG THE TRACK
A classic shot that uses linear perspective to good effect: this country track not only leads the eye gently through the landscape and into the far distance, but tapers as it meanders on its way.

► INTERIOR SPACES
Super-wide-angle lenses are often used for interior shots, because walls restrict camera position. This means the lines of the room appear to converge steeply, making small spaces seem larger than they actually are.

▼ VANISHING POINT
To make these beds of pink tulips converge into the distance as steeply as possible, I knelt down with the widest lens setting I had available, and filled the frame with the blooms.

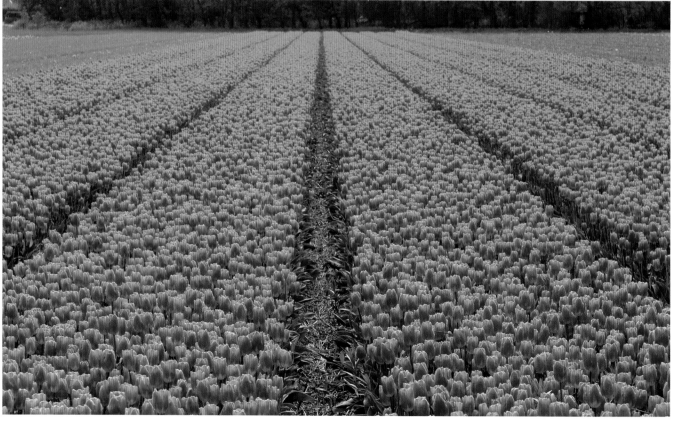

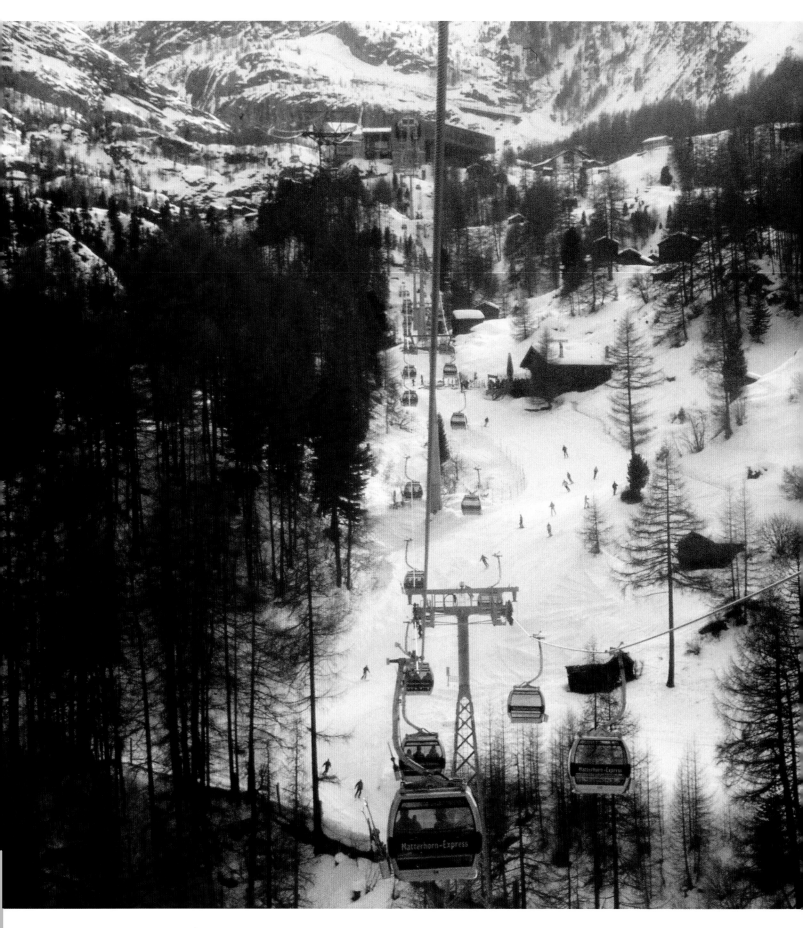

◄ HANGING ON THE LINE
Pictures in which distance is accentuated often use several forms of perspective. This shot of an Alpine resort combines linear perspective, aerial perspective, and overlapping forms—but it is the diminishing size of the cable cars that gives the strongest suggestion of depth.

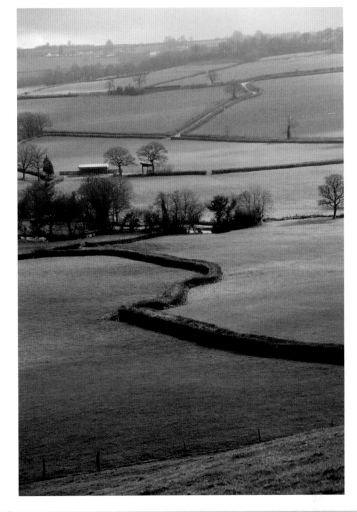

► SUBTLE DECLINE
The human brain can use quite subtle clues to help get a better idea about depth. In this shot, even though the fencerows are not in a continuous straight line from foreground to background, they still appear to lose height as they get farther into the distance.

▼ THE SAME, BUT DIFFERENT
A classic example of diminishing size: we can be pretty certain the windmills are the same size in reality—the fact that they look successively smaller provides a strong sense of depth.

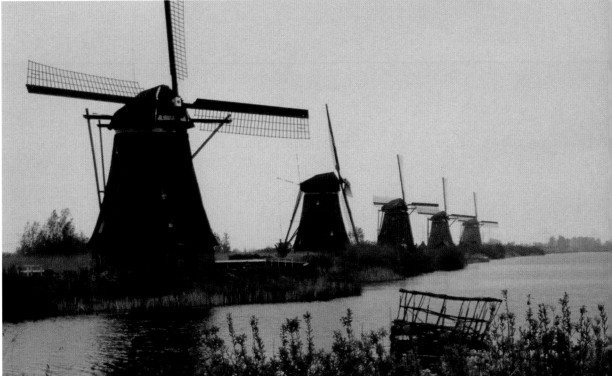

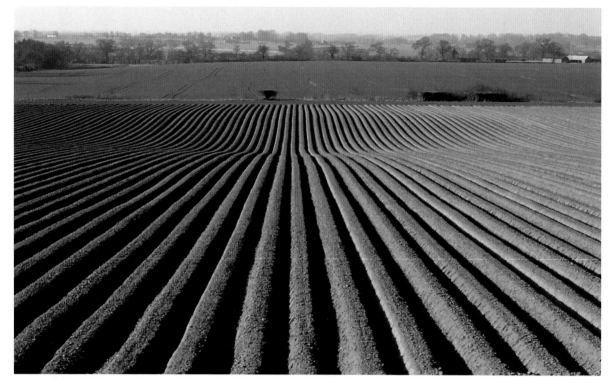

▲ GRAPHIC PATTERN
Arranging the camera angle so that the lines run directly away from the camera provides the strongest feeling of depth—particularly if the lines are bold and well-defined, as in this shot of a freshly plowed field.

▼ SIZE AND DISTANCE
People typically only vary in height by a few inches, so the difference in size between the skiers close the camera, and those further up the piste, can be used by your brain to give a fairly accurate idea of distance in this shot.

► DIAGONAL SWEEP
The effect of linear perspective is not so obvious if the lines run diagonally across the frame, and the image won't be as graphic. Nevertheless, this fence creates a strong feeling of depth as the posts diminish in size across the Scottish landscape.

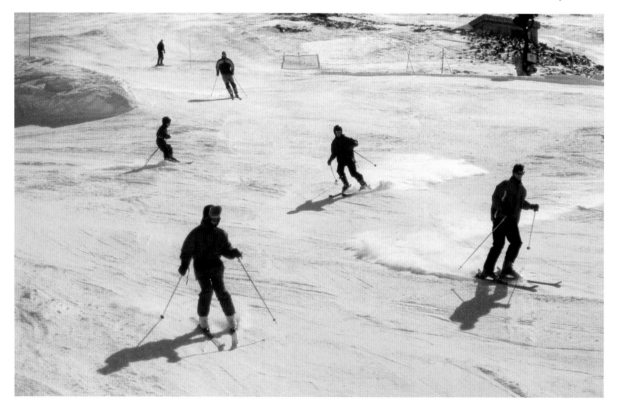

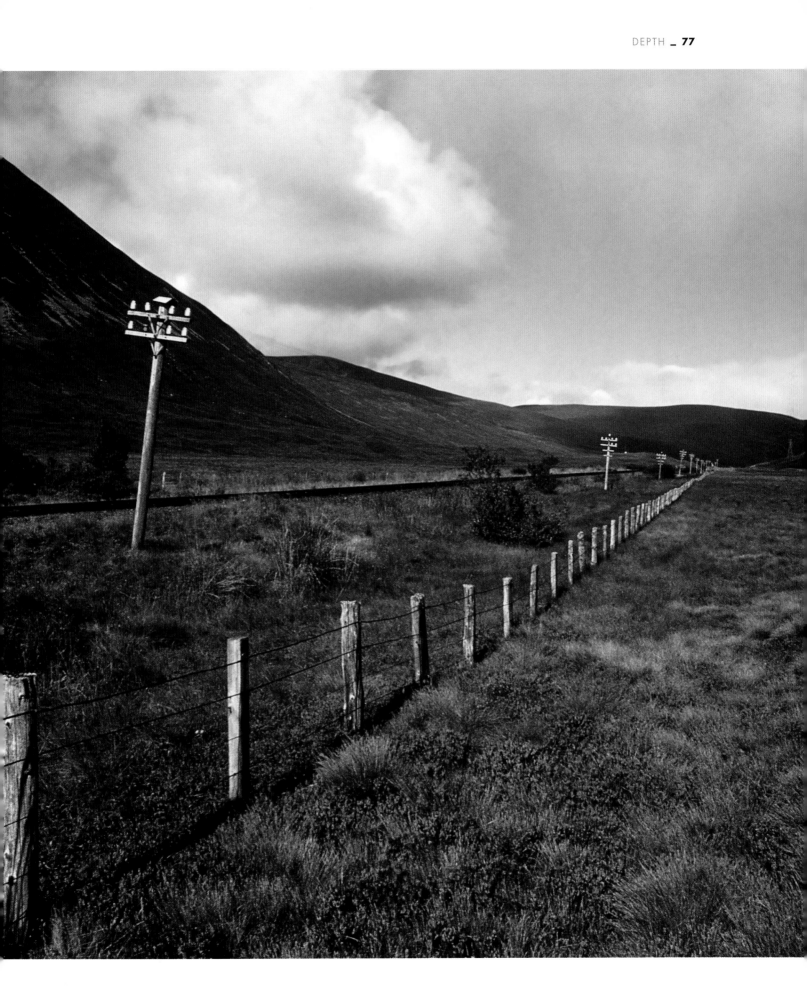

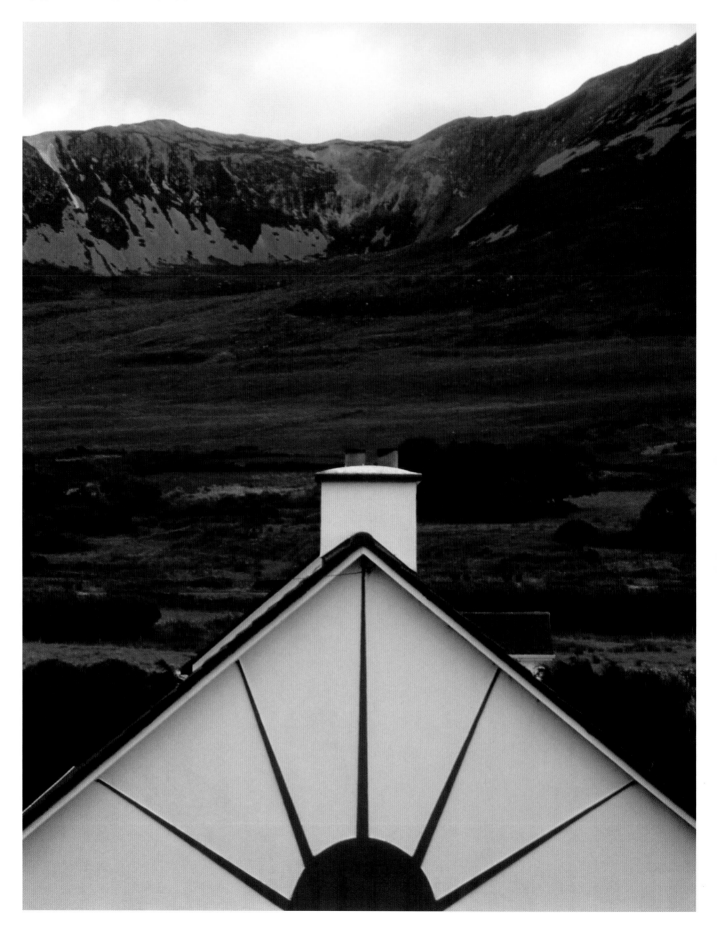

◄ OVERLAPPING FORMS
Here, the closeness to the viewer of the triangular gable of the house creates a very dramatic sense of depth as it cuts through the horizontal lines of the landscape beyond.

▲ DISTANT HILLS
In mountainous areas, nearby hills obscure the lower slopes of distant peaks. This effect works to increase the sense of distance and is reinforced here with aerial perspective (see page 80).

▼ LAYERED LANDSCAPE
This scene is made up of a series of overlapping layers. The wall partially obscures the hedge; the hedge hides some of the water; and the trees and shrubs at the water's edge hide the far shore.

aerial perspective

THE FARTHER THINGS ARE away from the camera, the less distinct they become. This is because the air affects the light as it travels from subject to sensor. Dust particles and water droplets diffract the light—making the image weaker. This effect is known as aerial perspective and can be used to make an image seem more three-dimensional.

How marked the effect is on the image is largely dependent on distance. Many subjects are within a stone's throw of the camera and aerial perspective only starts to become noticeable over long distances. It is therefore more useful when shooting landscapes rather than portraits—although the effect can be seen in any picture where the background is far enough away from the camera. Atmospheric conditions are a contributory factor: heat haze, mist, and pollution will weaken the distant part of the image more noticeably. The effect can be accentuated by the use of long telephoto lenses, since these allow you to juxtapose a clearer foreground with a diffuse background.

▼ BLUE HILLS

Dust particles in the atmosphere do not just weaken the image. They diffract some wavelengths of light more—and this causes the distant hills to look bluer than the foreground landscape.

► DISTANT PEAKS

Aerial perspective is particularly useful for photographing mountainous landscapes. It helps give a feeling of distance by making each successive peak look increasingly pale and diffused.

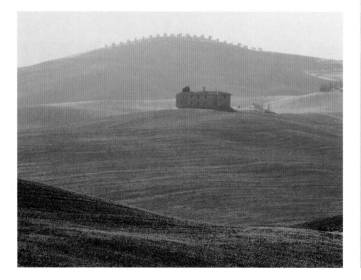

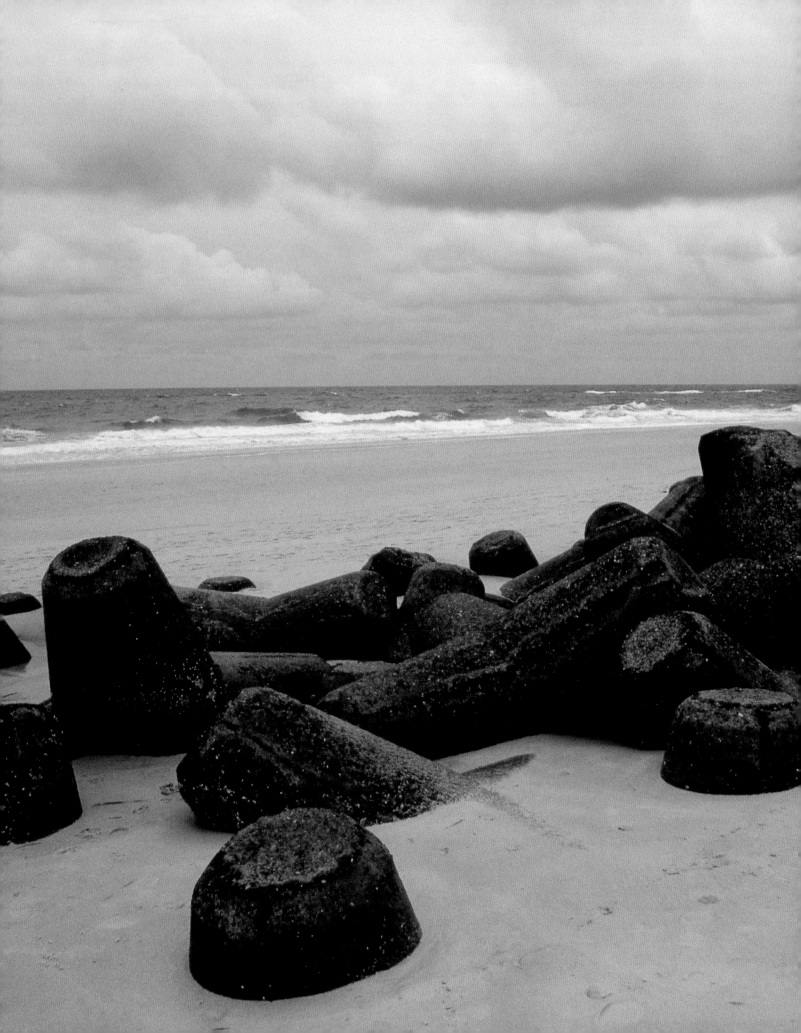

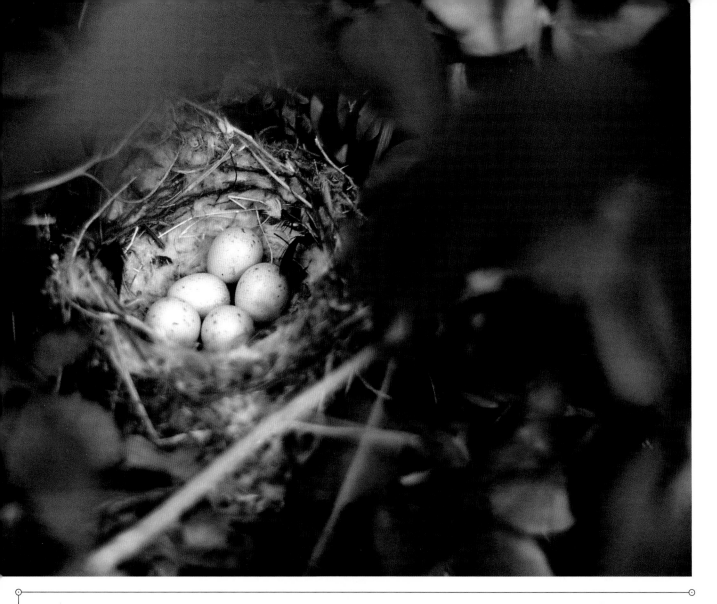

DIGITAL BLUR

Although it is almost impossible to increase depth of field on a computer, you can restrict the in-focus areas of a picture that you have already taken. Programs such as Photoshop typically provide a number of blur effects that can be applied selectively and at different intensities to areas you wish to de-focus. Parts of the picture that you wish to remain unaffected are simply masked. Alternatively, a blur effect can be painted on with a brush tool. The most commonly used blur filter is called "Gaussian blur," but there are other several other types. To hide the crowd behind this girl (right), a motion blur effect was applied to the background (far right).

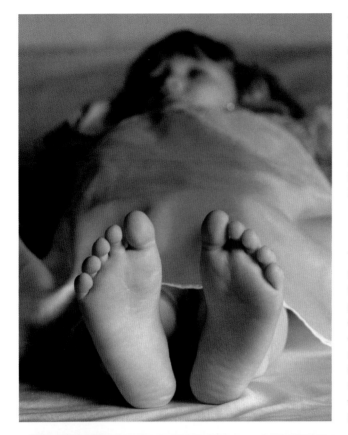

◄ FEET FIRST

Adjustments to the depth of field can be used to alter the emphasis in a picture. In this shot of a sleeping child, it might have been more obvious to focus on the face, or to use depth of field to try to keep the whole body in focus. However, by focusing on the feet and using the lens at its widest "open" aperture, the depth of field has been restricted to the feet, and a more unusual portrait has been created.

▼ HIDING CLUTTER

Depth of field is frequently restricted to hide distracting backgrounds. This portrait emphasizes the aging features of this Chinese gentleman—but in order to do this, the busy street behind needed to be softened. By using a short telephoto lens close to the subject, and using the largest aperture available with the zoom, the shops and people in the background become a blur.

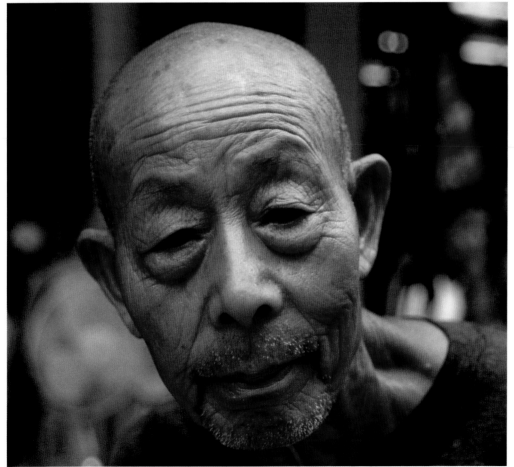

▲ WINDOW ON NATURE

Limited depth of field can sometimes be used to emphasize the background, rather than the foreground. For this shot of bird's eggs, I wanted to give the impression of peering through the leaves to the nest beyond. However, I did not want the foliage to appear sharp—keeping the focus of the picture on the nest. By ensuring that the leaves were close to the lens, and shooting with a wide aperture, the foreground greenery appears nicely blurred.

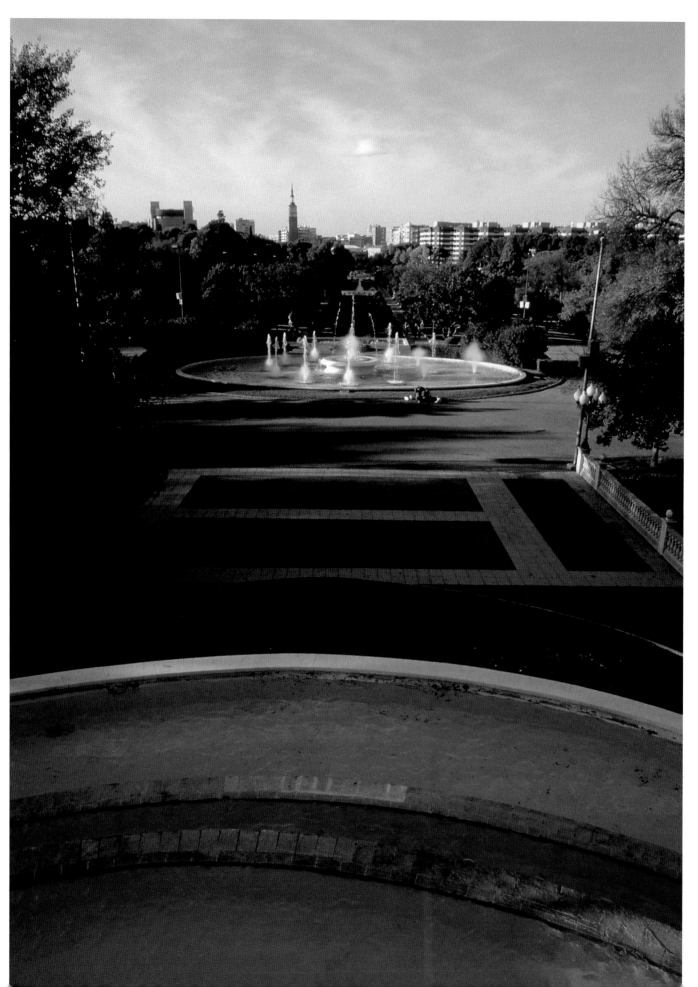

depth of field

ONE OF THE MAIN ways in which you can alter a picture using the camera controls alone is by changing the depth of field. Focus on a single point in the scene, and there will always be areas closer and farther away that are also sharp. This zone, where things are in focus, is known as the depth of field. Its extent can vary significantly.

The simplest way to control the depth of field is by varying the aperture—the opening in the lens that is also used to regulate exposure. The size of the aperture is measured as an f-number. A small aperture and large f-number gives a greater depth field. A large aperture and small f-number reduces the depth of field, and can be used to throw areas out of focus.

The depth of field is also dependent on other factors—notably the focal length of the lens, and the distance between the camera and the point that the lens is focused on. With a long zoom setting and the subject close to the camera, there is less depth of field to play with.

► INTO THE DISTANCE
In architectural and landscape photography, you typically want as much of the scene to be sharp as possible. A wide-angle lens and small aperture are the simple solution, as used here.

▼ EXTREME MEASURES
Super-wide-angle lenses offer great depth of field but, as in this image, they may cause distortion. It is hard to exercise any control using aperture or distance—use these lenses when you want everything to be sharp.

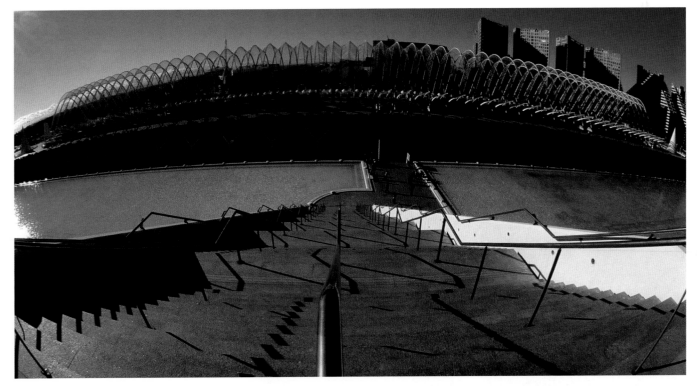

USING THE APERTURE

Aperture is a key creative decision in most photographs; the setting you choose alters how much appears sharp in the image. There is not a right and wrong value—it depends how much detail you want to show, or hide. In this sequence, the girl is in focus in both shots. But with a large aperture, the background is out of focus. A much smaller aperture (far right) ensures that everything looks sharp.

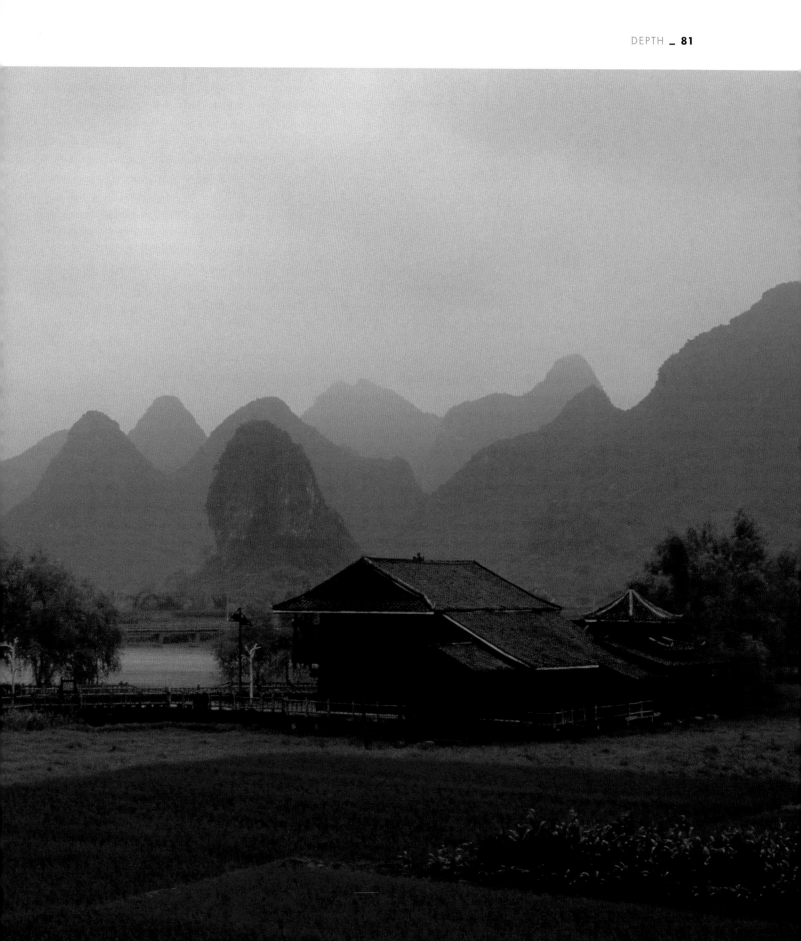

scale

JUST AS WITH DEPTH and distance, the physical size of things can be difficult to tell from a photograph alone. For this reason, it can be helpful to provide some sort of scale object that gives the viewer an idea of just how big, or how small, the subject really is.

Of course, this is not necessary with all, or even most, subjects. Many of the things that we photograph are sufficiently familiar to every viewer to ensure that they don't need any guide to their size. For example, if you see a picture of a still life, you make automatic, and fairly accurate, assumptions about the size of the bottle of wine and the apples that have been arranged.

When photographing less familiar objects, it can pay to provide some way for the viewer to gauge the proportions of what they are seeing. In scientific photography, such as might be used on an archaeological dig, the solution is simply to lay a ruler beside the subject that is being documented, and include this within the frame. In artistic and everyday photography, a more subtle approach is called for.

In order not to ruin the composition, a subject of a known size is used to act as a visual comparison. People are frequently used, for example, to provide a sense of scale to a rock formation or a building. This is particularly useful if the subject is unusually large—you can reveal the true height of a tower more easily if you can see antlike people on top of it.

However, it is important to realize that this trick only gives a general idea of scale—and can be used to completely mislead. You can only judge the size of one subject compared to another if they are the same distance from the camera—otherwise the farther one will look smaller because of perspective. If you put the person significantly closer to the camera than the main subject, then it becomes much harder for them to be used as a scale. However, you may not be able to pick out a passer-by who is close enough to the building you are shooting, or it may not be feasible to get a model close enough to a mountain—by necessity, the scale will be less than accurate. Nevertheless, this technique is still often useful to give an approximation of size.

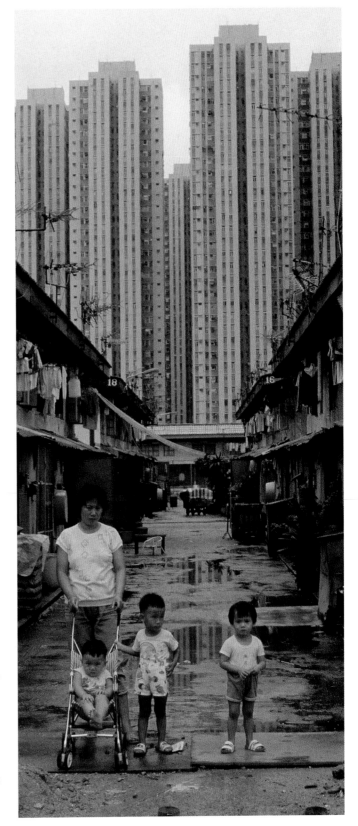

◄ **UNFAMILIAR FORMS**
Without any scale object, it is impossible to accurately judge the size of these lumps of concrete lying on the beach. This results in a more abstract composition.

► **TOWERING ABOVE**
A mother and children stand in the shadow of giant apartment blocks in China. The people provide a sense of scale to the buildings—even though they are some distance in front.

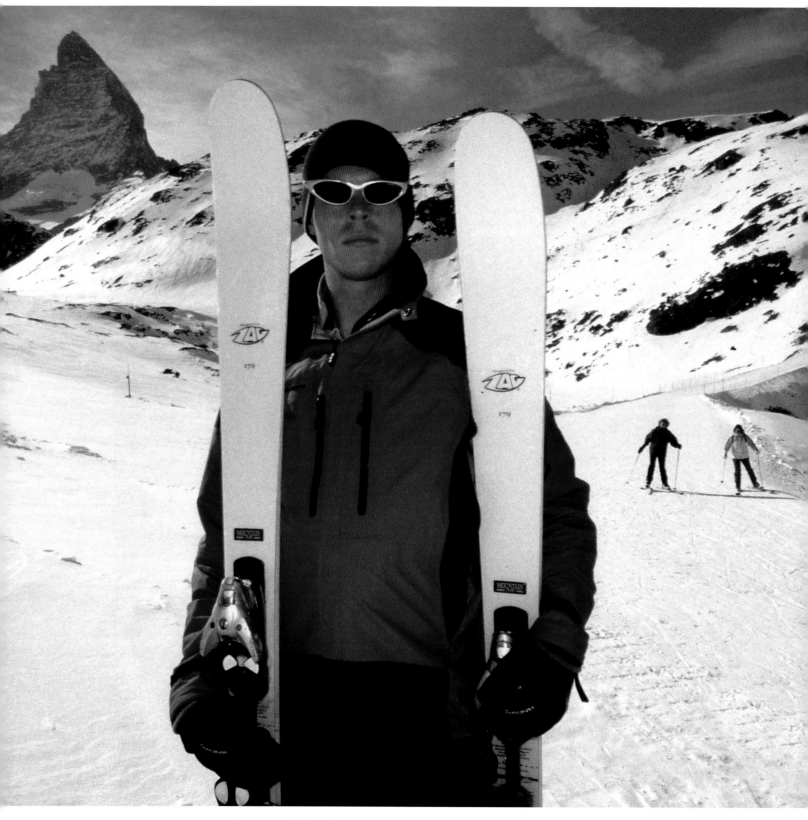

▲ ► PROVIDING SCALE

These two views of the Matterhorn both include people in the frame. The sense of scale is more effective in the one on the right because the people look small in comparison to the Matterhorn's summit. In the portrait above, the skier is so close to the camera that we get less of an idea of the mountain's size.

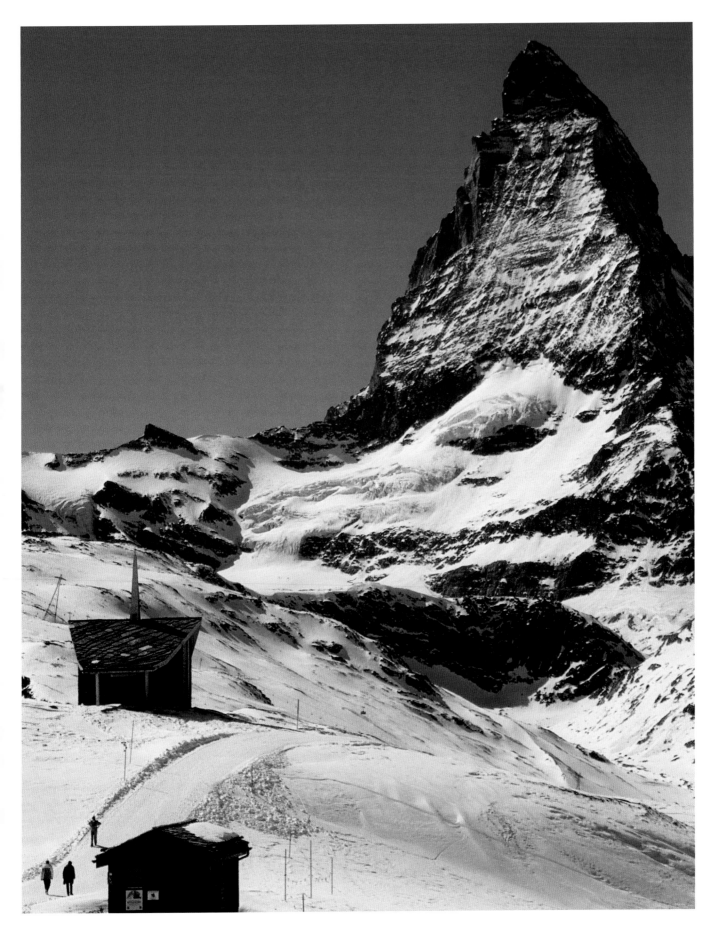

high and low viewpoints

WHEN USING A DIGITAL CAMERA, most people simply hold it at eye level, look at the scene through the viewfinder or LCD, and shoot. However, varying the camera height to get high-angle and low-angle viewpoints not only adds visual variety to your pictures, it can also help create depth in your shots.

In particular, a low-angle shooting position can prove a useful way to create a more dynamic, three-dimensional image. With tall buildings, the viewpoint is usually imposed upon you, and the tilted camera creates parallel lines that converge upward, creating a feeling of depth through linear perspective. But with shorter subjects, such as people, the same approach can be used to give them a stronger physical presence—simply kneel or lie down on the ground, or use a camera with a flip-out LCD and hold it down low, to get the necessary angle. A high viewpoint, on the other hand, gives a bird's-eye view of the world—both literally and metaphorically, you get a feeling of looking down on the subject.

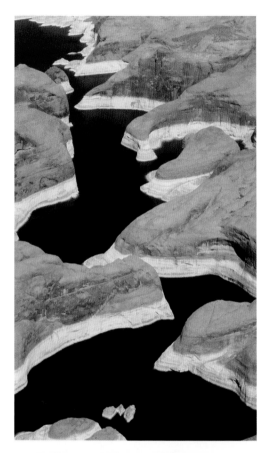

▼ LOOKING FOR HEIGHT
Whatever you are photographing, it is always worth trying to find a vantage point that will let you shoot the subject from above. Look for balconies, benches, and bridges you can stand on to gain height. This often allows you to find less cluttered backgrounds, as shown in this shot of The Venetian, a resort in Las Vegas.

► UP IN THE AIR
An aircraft provides the ultimate in high-level viewpoints—giving an almost two-dimensional view of the world below. This semi-abstract aerial shot is of the snaking Colorado River, taken from a small plane during a sightseeing trip over Arizona's mighty Grand Canyon.

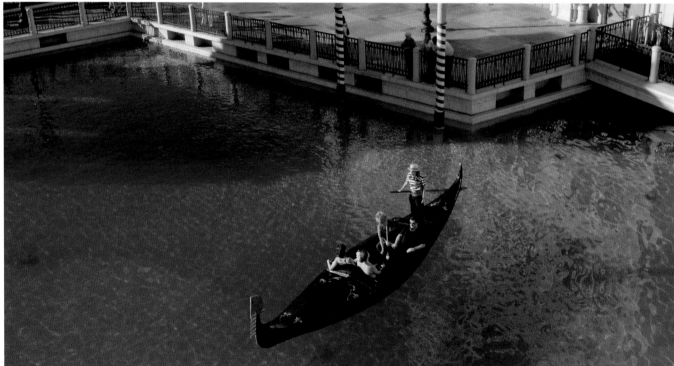

► MAN AND MOUNTAIN

A wide-angle zoom setting and a low vantage point combine to create this powerful picture of a climber taking on an ice wall. The resulting perspective gives a great feeling of height and distance.

THREE VIEWS

Moving a camera just a little makes a huge difference to the appearance of this statue. A low angle (top) makes the figure look imposing, while in a high-angle shot, taken from a stepladder (bottom), it looks as if she is cowering. The middle shot is taken from eye level.

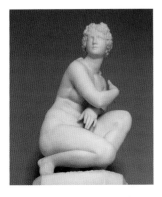

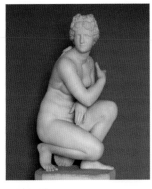

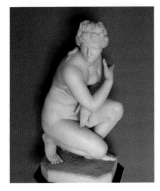

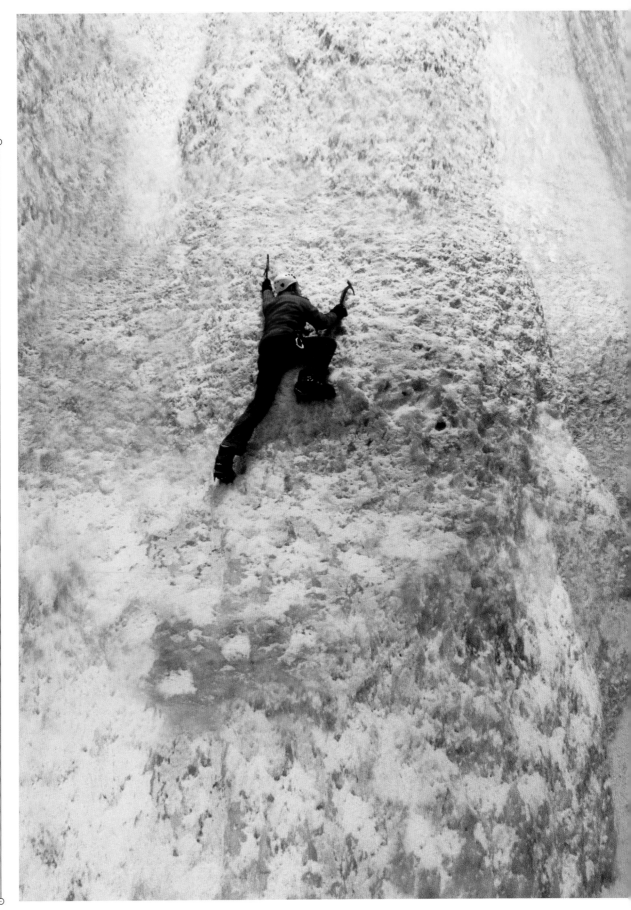

THE FRAME

No matter what sort of digital camera you use, one of the sure-fire ways with which to improve your pictures is through composition. How you choose to frame your subject—which elements of the scene you decide to leave in or leave out—is the first step to taking good pictures.

There are no set rules to how this is done—but some approaches definitely work better than others. These can be applied whether you use the simplest camera phone or the most sophisticated, top-of-the-range SLR.

Some areas of photography, such as portraiture, or still life, allow you to move the subject around until you get the right balance and composition. You can also use the zoom, or different lenses, in order to restrict or expand your angle of view. But the most important tools for composition are your feet. You need to move around in order to find the best camera angles. By circling the subject, and investigating different viewpoints, you can discover ways to make even the most photographed places in the world, and the most familiar objects, look striking and different.

The trouble is that the camera views a scene in rather a different way than the human brain. The eye can scan a scene, and ignore distracting elements. But a straight photograph of a scene can end up making a jumbled mess of an image. As a photographer, you need to find ways to create some sort of order—to help the viewer to see what you see. This is done not only by what is included within the composition—but also by the way in which it is laid out within the four edges of the frame.

Often, all it takes is a simple change in viewpoint to alter the subject positioning within the frame. This can completely change the power of a picture—transforming the dull into the dramatic.

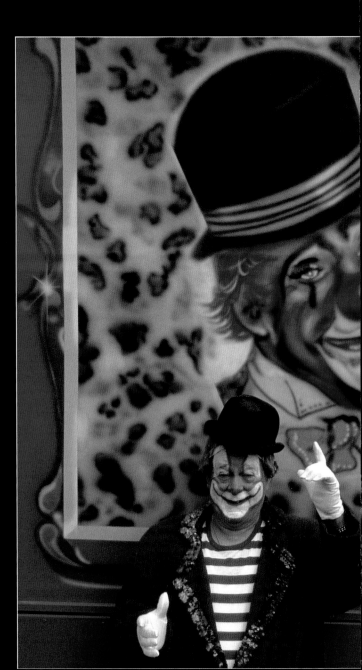

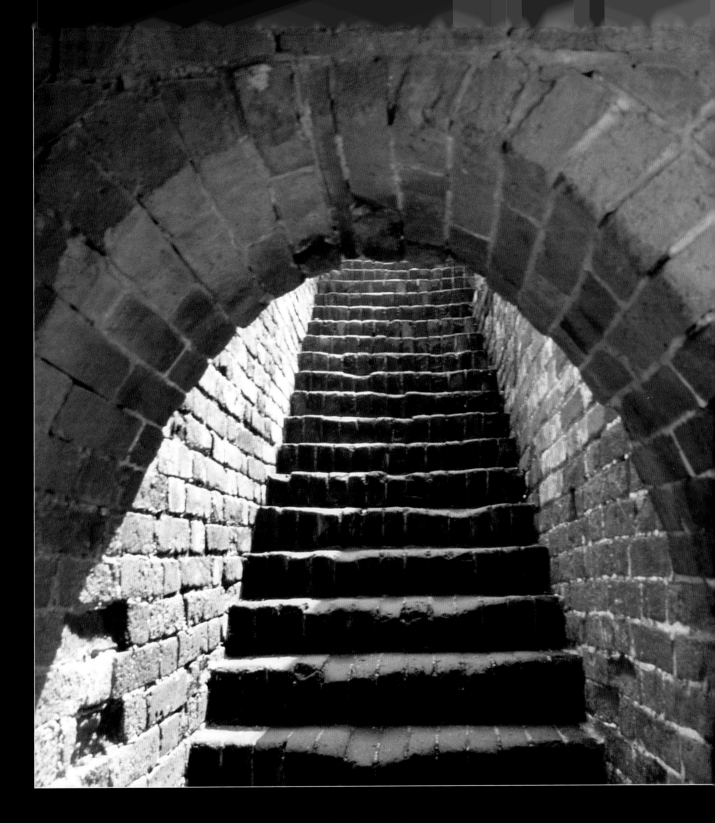

◄ DOPPELGANGERS

An ideal background can do one of two things. It can
either be chosen so as not to distract from the main
subject, or so that it adds something to the composition.
Here, a circus advertising picture works as a fitting

▲ THIS WAY UP

An ancient stone staircase creates an interesting contrast between
the straight lines of the steps and the curve of the archway, and
is transformed by the pattern of streaming sunlight. To create
a simple abstract shot, a viewpoint was chosen to make the

Try to see a scene with new eyes. You must learn to look at the whole image area—not just the main focal point. The central subject is literally only part of the picture. Use the viewfinder to scan the background to see whether it works well in the shot—and look into all four corners to spot visual distractions. And, if possible, make good use of your camera's LCD screen to look at the image captured in more detail—zooming in to look for oversights, and for ways in which to make the next shot a better one.

▲ STRIKE A POSE
Posed portraits give you more control over composition because you can ask the model to move. Here, the woman's stance creates a powerful, dramatic line across the frame.

► LEAD BY THE LINES
In this shot, strong diagonals have been captured by the creative use of viewpoint. The lines of the staircase lead the eye up, down, and around the composition.

simplifying the scene

THE FIRST RULE of photographic composition is to keep the shot as simple as possible. This rule can often be successfully broken, but it always makes a good starting point. Begin a new composition by trying to find a way of capturing the subject with as few unnecessary details and unwanted distractions as possible.

Make full use of the zoom to crop in tight to the subject, but remember that, instead of increasing the focal length, it is sometimes better to simply get yourself closer in the first place. Alternatively, with digital images, it is very easy to crop any unwanted parts of the image on the computer—but the disadvantage of leaving the cropping until later is that this will mean cutting pixels from the picture. The fewer pixels that make up the digital image, the lower the resolution, and this will ultimately affect how far the image can be enlarged when producing high-quality prints. To ensure that you have some margin for cropping in postproduction, use the highest quality resolution setting your camera allows whenever possible—even if this restricts the number you can fit on your memory card.

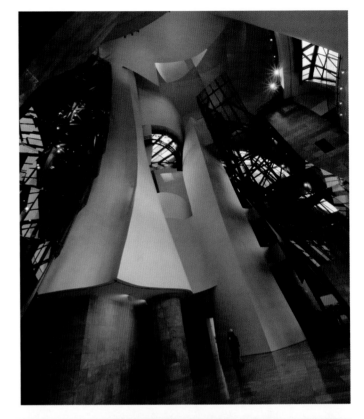

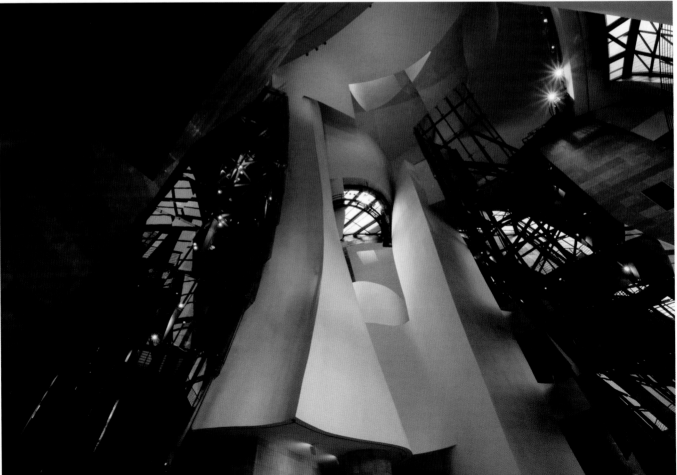

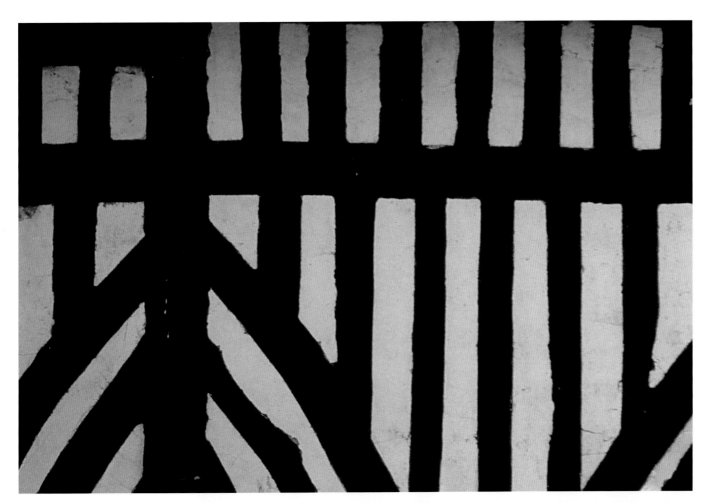

▲ ► LESS IS MORE

Cropping in close allows you to concentrate on key elements of the subject and cut out unnecessary detail. In the first shot of this Tudor building (right), the plants and roof are not needed. The simpler composition (above) creates an image that focuses on the pattern of the timber.

◄ SIDEWAYS VIEW

Many photographers take nearly all of their pictures using the horizontal "landscape" format. However, the upright "portrait" format works more successfully for some subjects because the change in aspect ratio lets you make better use of the available picture area. Sometimes both orientations work equally well, as with these interiors of the Guggenheim Museum, Bilbao.

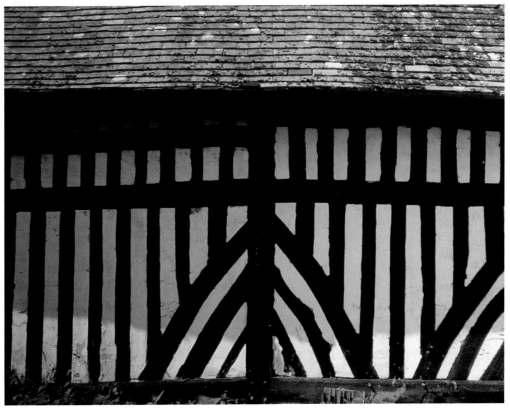

SHAPE SHIFTING

Most digital cameras produce rectangular images with a fixed aspect ratio of either 3:2 or 4:3. An advantage of cropping on the computer is that there are no constraints on shape or proportion. In the original shot of a rider, the composition is too loose. Cropping in tighter to create an almost square image produces a stronger picture.

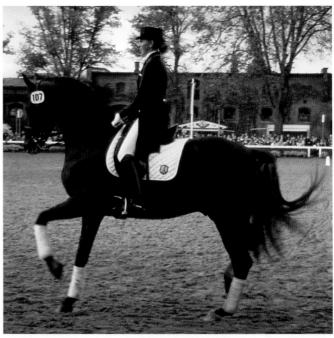

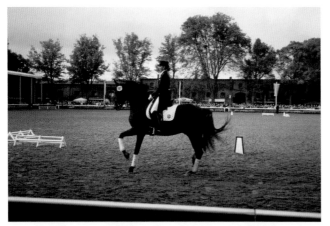

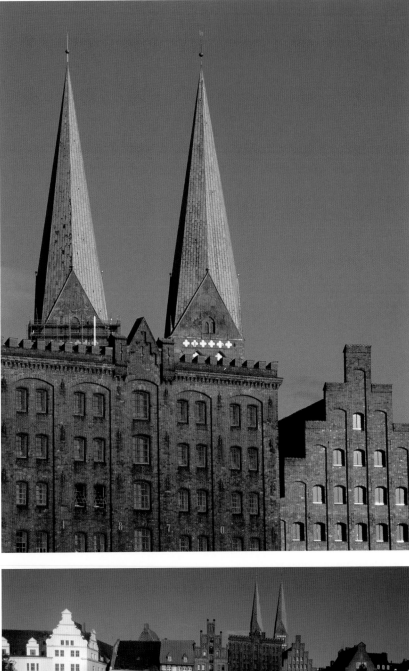

▼ ▲ SEEING THINGS DIFFERENTLY

Part of the skill of becoming a good photographer is learning to see the pictures within the view in front of you. The image of waves and a distant shoreline (above) is fairly ordinary. Zooming in to capture the breaking waves alone (below) creates a more abstract, enigmatic study.

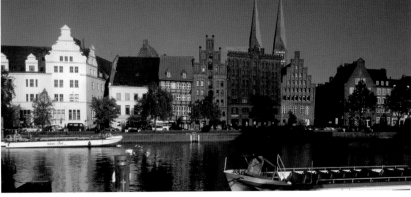

▲ LEARNING TO SEE AGAIN

The human eye can ignore the clutter surrounding a subject. The camera, however, captures everything, so you need to use composition to simplify the scene. The wide-angle view of the medieval port of Lübeck, Germany (above), is what you see as you stand by the river. The towers of the Marienkirche, however, may well be what you focus on (top).

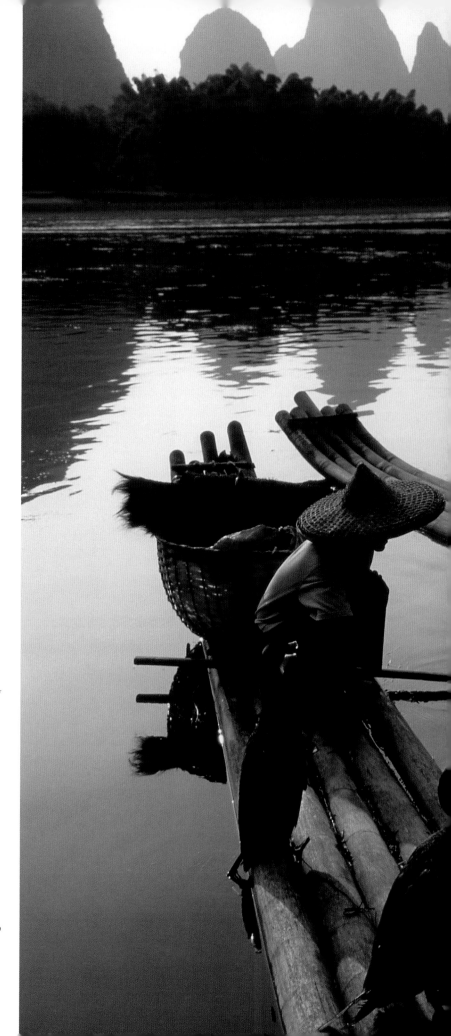

leading the eye

COMPOSING A PICTURE is like telling a story—you need to connect elements together in a logical way. This is especially important if you are trying to capture a complex scene. One of the easiest ways of doing this is to provide a visual path that the viewer can follow.

This path can be as simple as a physical line within the image that links the foreground to the background. In landscape photography, if you are lucky, the scene may already contain a meandering river or a country lane that draws the eye through the picture. Since people scan images, rather than just staring at them, this provides a route for them to follow as they read your picture story.

This solution is fine for when you have a suitable stream, road, or railroad track to place strategically in the composition. But these are not available in every landscape, let alone other photographic subjects.

The answer is to use one or more diagonal lines. Diagonals can be found all around you—and can be engineered in areas where they are not obvious simply by altering the camera viewpoint—you just need to think creatively. For example, the straight lines of the front of a building can be turned into strong diagonals by getting in close and off-center—this will result in linear perspective creating converging verticals or horizontals.

▶ POINTING TO THE PEAKS

These Chinese fishermen use tame birds to fish for them. The cormorants dive into the water, and return with their catch. The converging angles of the boats point to the top half of the picture—and the strange pinnacle mountains that are found all around the city of Guilin.

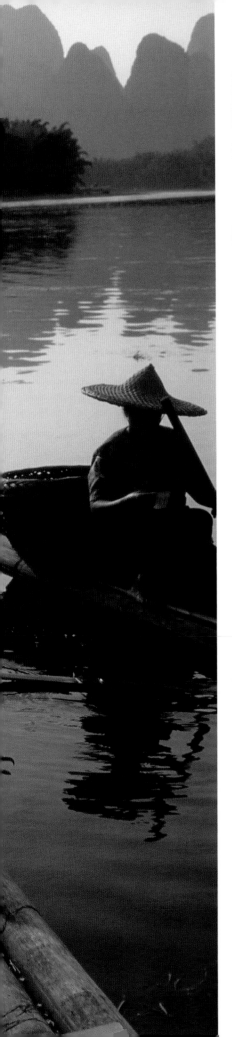

◄ EMERALD ISLE
This picture is primarily about the Irish landscape—but including the figure in the foreground creates a more interesting composition. The man helps to suggest a visual path across the picture, linking the two major landscape areas—the lush vegetation and the distant mountain peak.

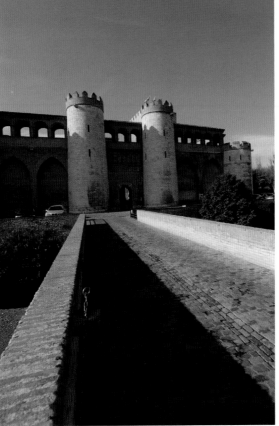

◄ LOOK THIS WAY
You can use linear perspective to create strong, dynamic, diagonal lines that can lead the eye through the picture. Here, a wide-angle lens has been used low down so that the low walls on either side of the bridge point toward the Spanish palace beyond.

The beauty of diagonals is not just that they are so easily found, and provide such a simple visual route across the picture. They also suggest a continuation beyond the confines of the image and give a feeling of movement. Strong diagonals make strong pictures, and part of the reason they have this effect is that they never run parallel with the sides of the frame.

However we shoot, show, and crop our digital images, they are almost always rectangular in shape. These four perfectly straight edges are not just boundaries to the picture—they are effectively part of the composition. If lines in the picture follow the same directions as the edges, the picture will tend to look predictable and staid. A diagonal refuses to go with the flow and so makes the composition more dynamic. With single lines, the maximum effect is achieved when the line is at 45° to the edges, and breaks into the picture at one of the four corners.

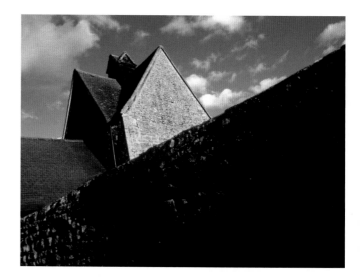

▼ FEELING OF MOVEMENT

Framing sports pictures so key elements are placed diagonally conveys the action much better than if they are placed parallel to the sides. Below, the shadow along the half-pipe, the skier's skis, and the snowboarder's arms create useful diagonal lines.

▲ LEANING IN

Try tilting the camera sometimes so that diagonal lines become pronounced. Make the tilt obvious, so it doesn't look like a mistake.

► MAXIMIZING THE ANGLES

With two diagonals, the 45° rule doesn't work. The central column and the bridge had to be at different angles to each other and the frame.

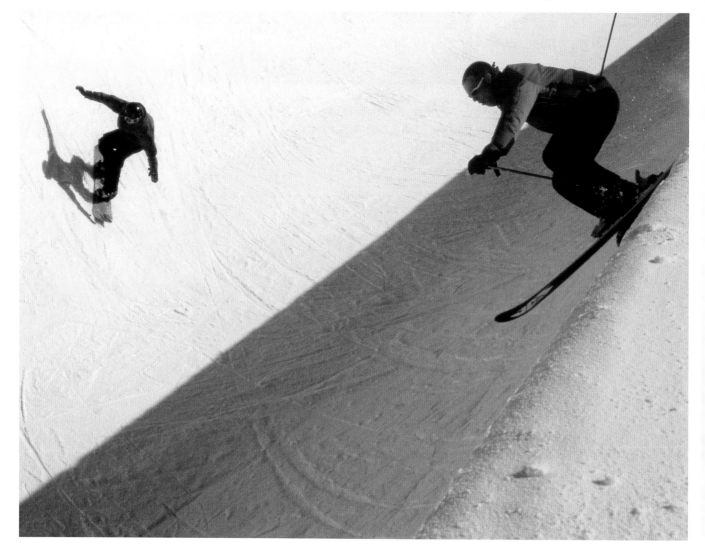

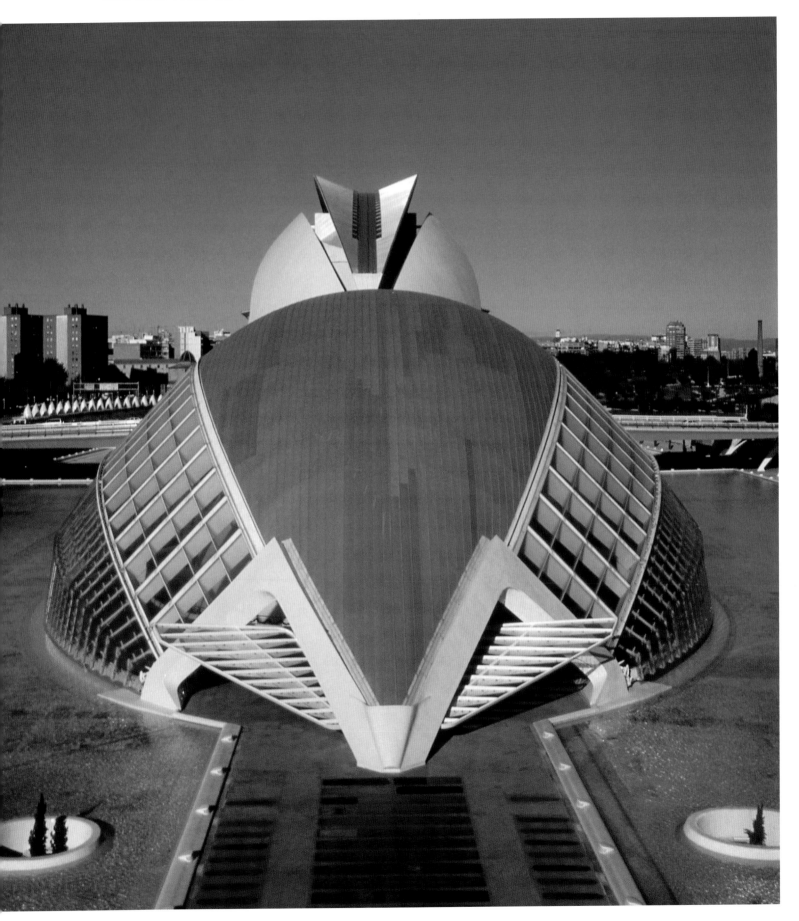

exploring angle of view

THERE IS NEVER JUST a single great composition for a particular subject. Whatever you are photographing, there are always alternative viewpoints and perspectives you can try. Learn not to be afraid to keep shooting. Back in the days of film, there was a cost consideration for being trigger-happy. In the digital era, each shot can be taken for free—you can choose which frames you want to keep later.

When you visit a new place, take as many pictures as possible, regularly review what you have just taken, and learn from what you see to maximize your chances of a good shot. Resist the temptation to stand in the same place—you need to hunt for different viewpoints and camera angles. By varying your distance from the subject and by changing lens settings, you can alter perspective and crop into different details. You must also learn to circumnavigate a subject when possible. This not only lets you see the subject from different sides, but also changes the lighting angle to reveal different elements in the scene—such as shape instead of tone. The photographs of La Ciutat in Valencia, Spain, on these and the following pages were taken using this approach.

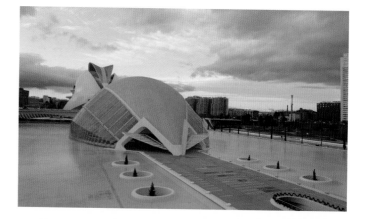

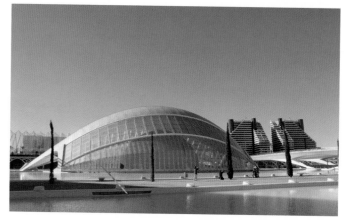

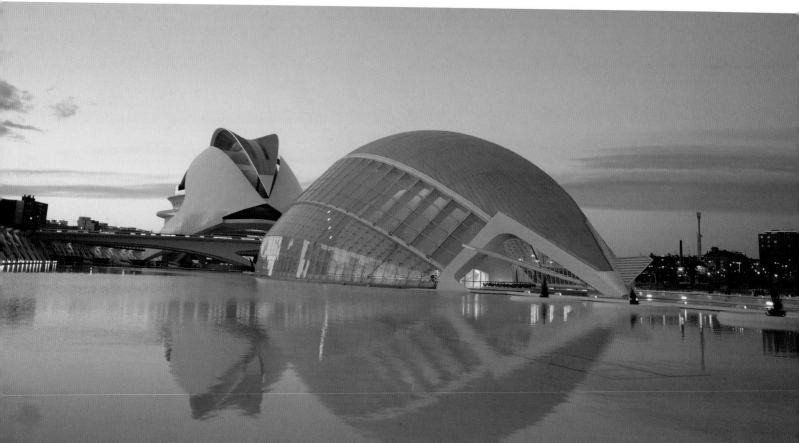

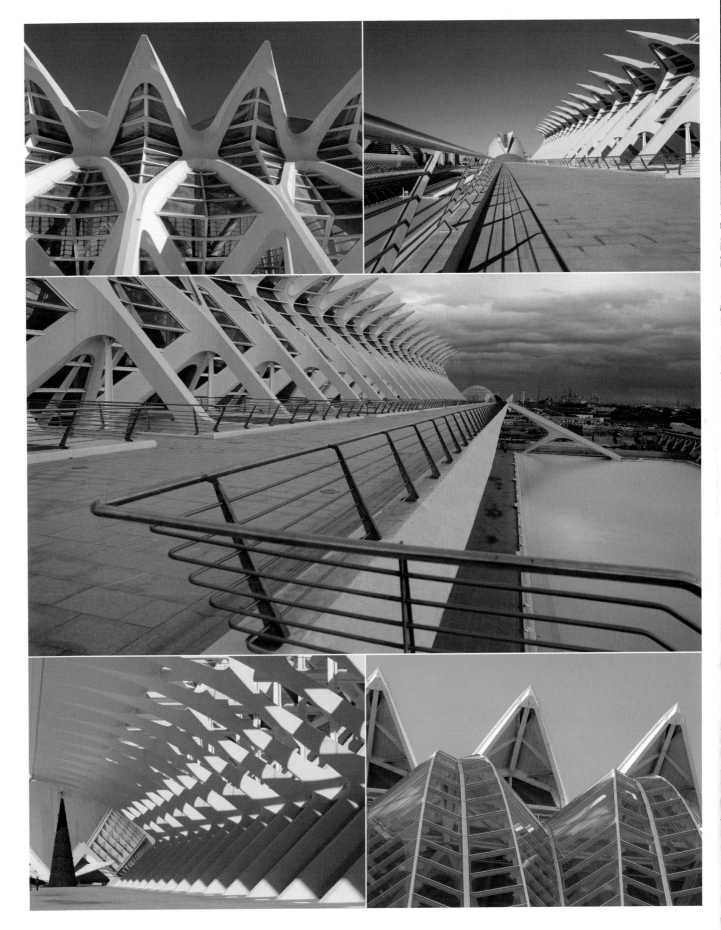

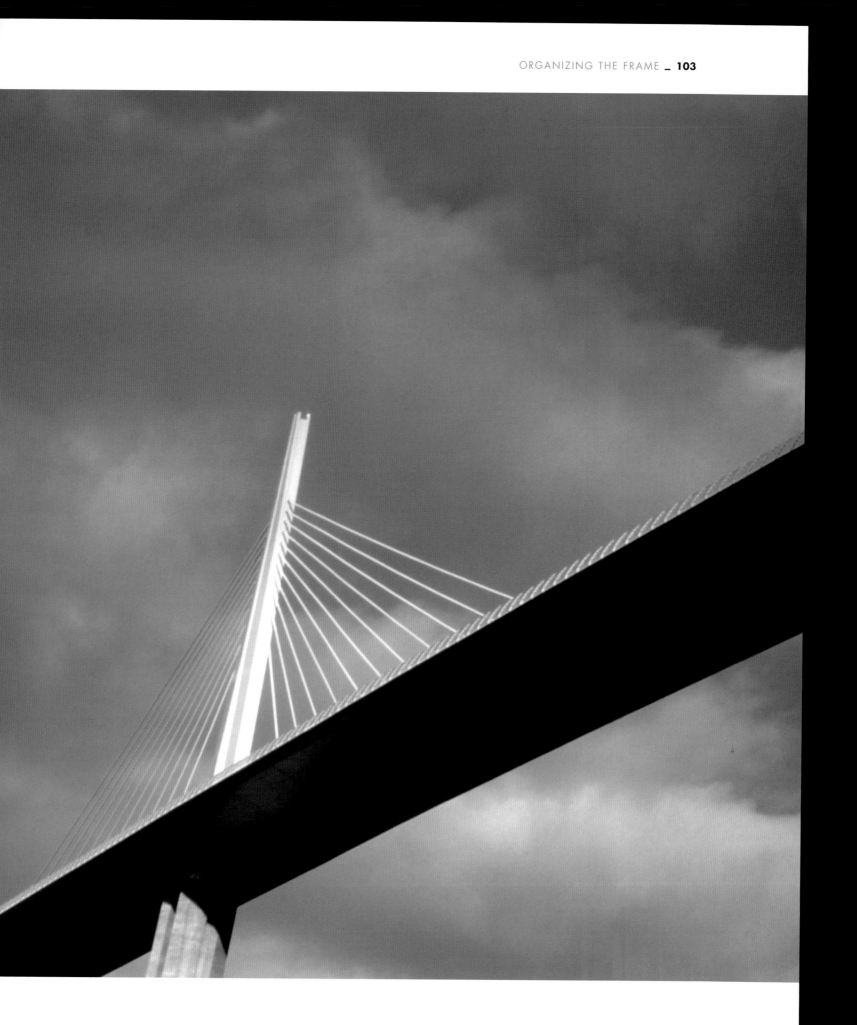

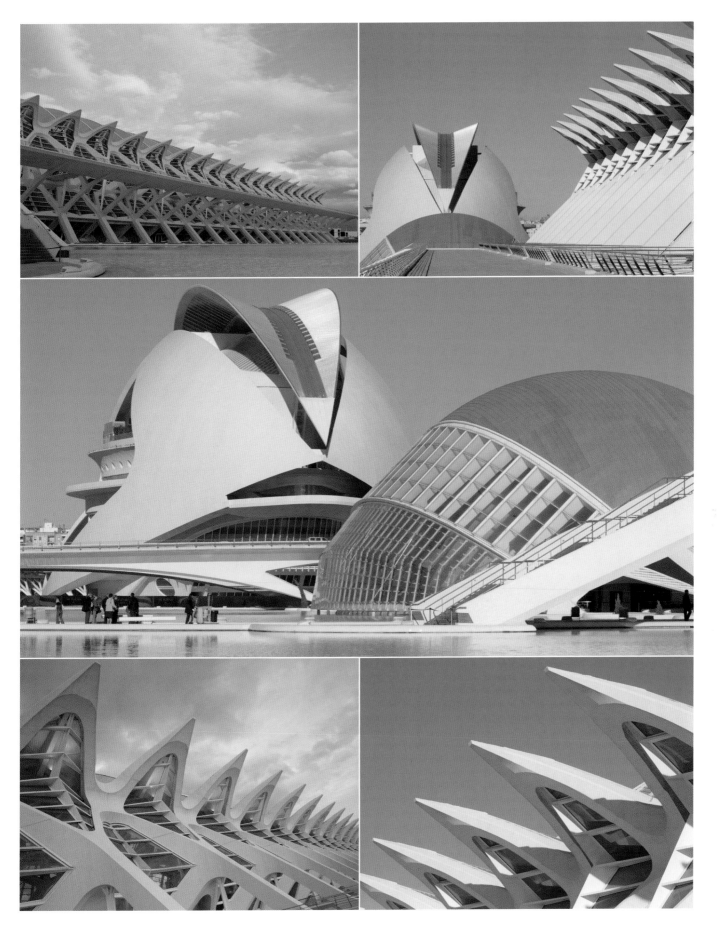

balance and proportion

HAVING FOUND YOUR SUBJECT and camera angle, you have to decide where to place the main subject within the frame. It is always tempting to put it dead center, but shots often look better if they are less symmetrical.

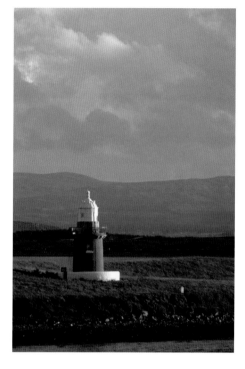

Place a subject right in the middle of the frame only if you want a restful image. In most pictures it pays to place key elements away from the center because this creates a more dynamic, exciting composition. Unless you are deliberately aiming for a radical look, the subject should not be too close to an edge, either. The traditional approach is to put key elements a third of the way in from one of the vertical edges, and a third of the way in from one of the horizontal edges; this provides four key points on which to put the main subject.

◄ LEANING TO THE EDGE

These flowers were purposely arranged so that the key focal point is in the top left-hand corner of the frame—creating an unusual, off-balance, nonsymmetrical image.

▼ HANGING IN SPACE

It is tempting to frame subjects tightly, but to give the visual imbalance that creates great shots, it is often worth zooming back. This parachutist is placed off-center.

▲ RULE OF THIRDS

The best place to put the main subject within the frame is a third of the way in from one side, and a third in from the top or bottom, as in this shot of a lighthouse.

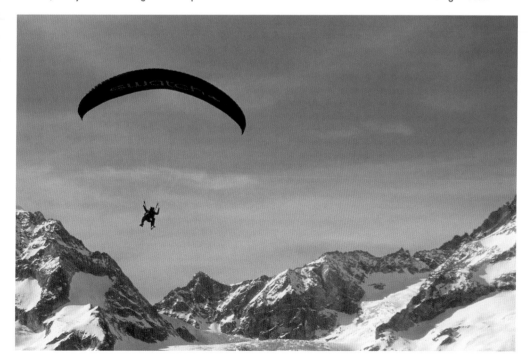

framing

EVEN IF YOU ZOOM in tightly, you will often find that large areas of the picture are wasted. Architectural shots might include too much sky, while landscape pictures have unremarkable foregrounds, and so on. A simple solution is to find something that will fill this unused space.

By changing the viewpoint, something as simple as an overhanging branch can be used to cover over a dull area—effectively creating a border around the image. This technique can be extended to provide a complete frame within the viewfinder. Arches, doorways, and window frames can be pressed into service, simply by moving back so that they are in-view. The trick is not just useful for hiding unwanted elements in a picture. It can also be a useful way of adding visual interest to a picture—particularly if the framing element has a strong shape. By adding an interesting foreground, you also create a greater feeling of depth in the picture, as you peer through the frame to see the image beyond.

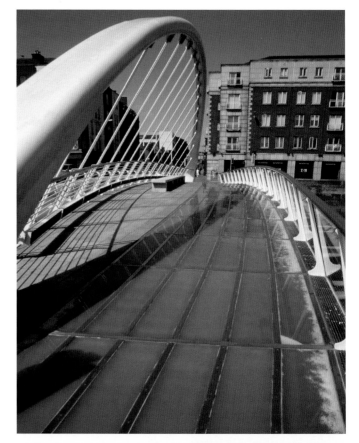

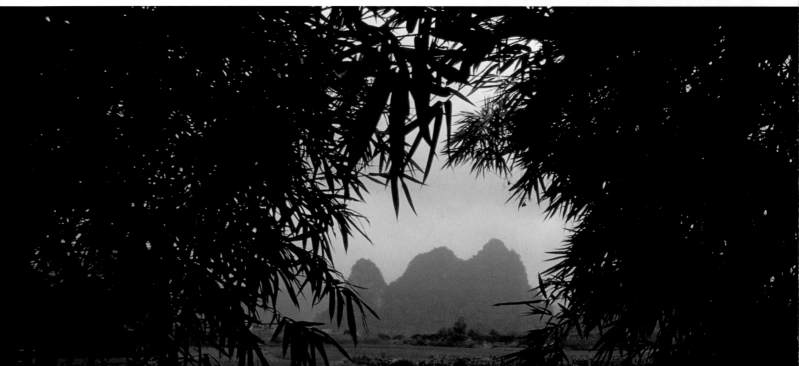

◄ NEW AND OLD
Sometimes a frame can be as interesting as the subject it confines. When shooting the James Joyce footbridge in Dublin, Ireland, it occurred to me that the sweeping curved lines of the modern structure could be used to isolate the older, traditional, architecture in the distance.

◄ FRAME OF FOLIAGE
A gap in a fencerow can be a useful frame for landscapes. It works well in dull weather to help counteract the effect of flat lighting. In this shot, a frame of unmistakably shaped bamboo leaves helps set the scene for the Chinese mountainscape beyond.

► FILL THE SKY
A low-level, wide-angle view of this church in Zaragoza, Spain, allowed me to frame the bell tower with the picturesque neighboring houses. However, from my first vantage point I was left with too much sky. The answer was to take a few steps back and use the leaves of the nearby horse chestnut tree to fill the empty space.

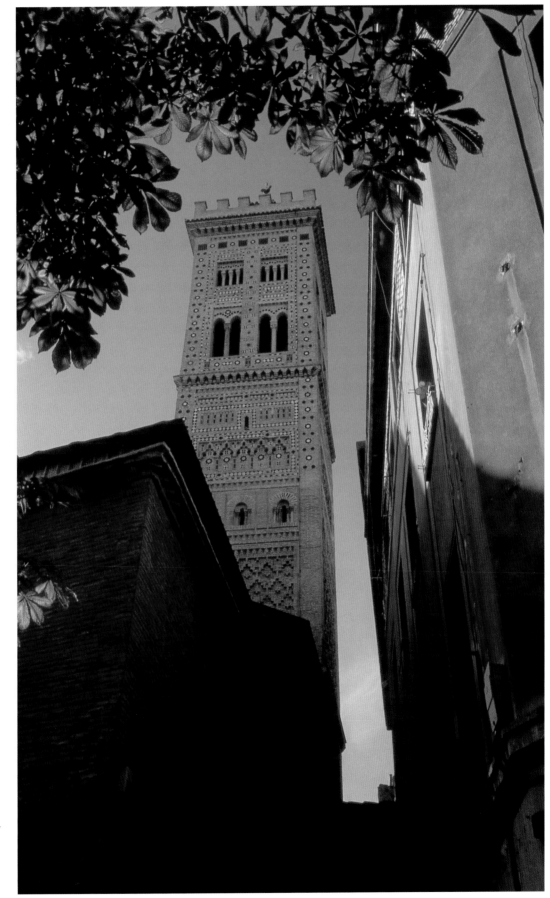

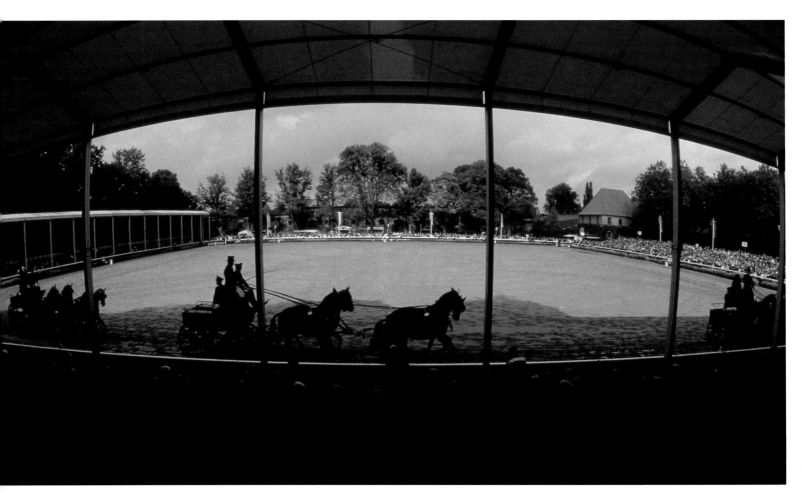

▲ GRANDSTAND VIEW
A super-wide-angle lens, used from the back of the grandstand, creates a sense of viewing this horse parade, at the German Riding School in Warendorf, through a window.

▼ FRAMED FACE
Mirrors make great frames because they can be positioned to reflect an image of almost anything. Here the car mirror catches a woman applying her lipstick.

► NATURAL FRAME
This unusual archway was built using two whale bones. It creates an interesting frame that provides a strong foreground for the picture and helps lead the eye down the pathway and through to the building beyond.

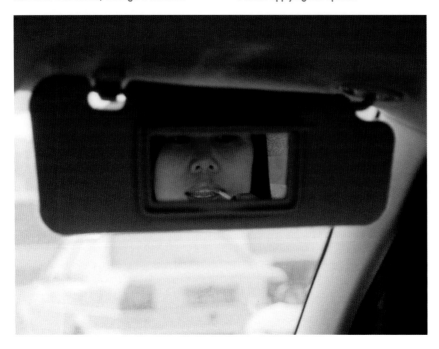

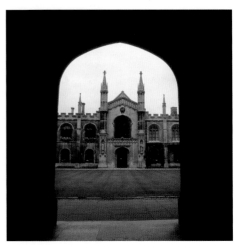

▲ ARCHITECTURAL FRAME
A classically shaped archway creates a symmetrical frame around the building in the distance—adding interest, and reducing the amount of grass and sky visible in the shot.

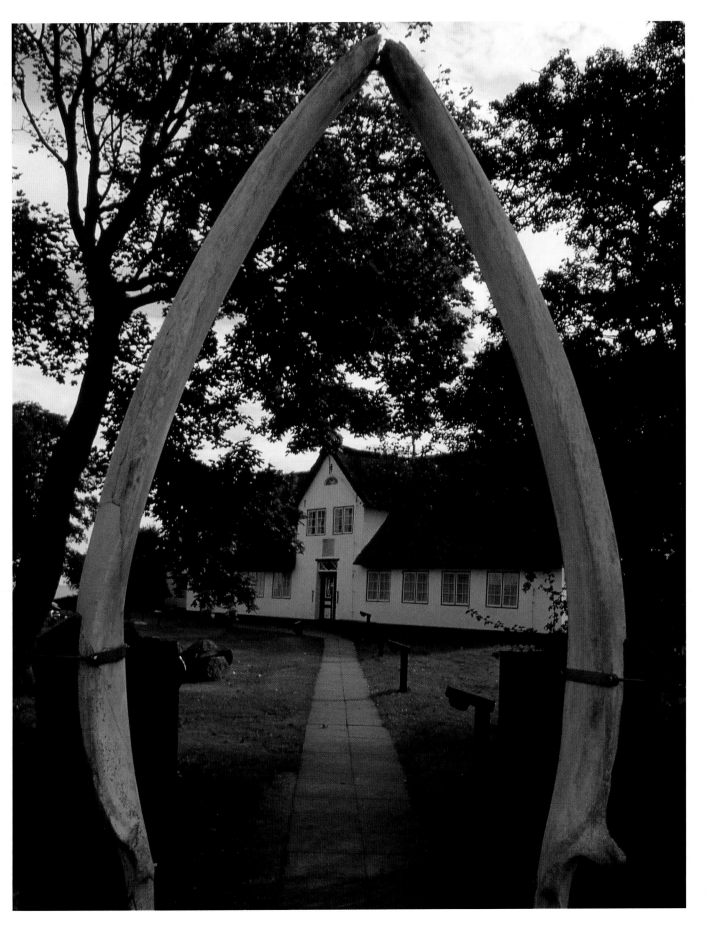

choosing backgrounds

BECAUSE YOU ARE CONCENTRATING on the subject itself, it is easy to pay little or no attention to the background when shooting a picture. But the degree to which the distant elements work within the frame is crucial. A poor background distracts you from the main part of the picture; a good one strengthens the composition.

You will find you have a surprising amount of control over the background you choose for a fixed subject. Review your shots as you take them, and if you feel the background doesn't quite work, try changing the angle of view, or the camera height, and you will often find a better backdrop to shoot against. When this is not possible, you can soften a less suitable background by blurring it, using the widest aperture available (see pages 82–85).

With portraits, where you can move the subject, or in the studio, where you can completely change the background, you have even more control. An ideal background is one that either blends in with the main picture, or provides useful detail that adds to the story that you are trying to tell. The simplest type of background is neutrally colored or works harmoniously with the color of the subject. A wide range of special fabric and paper backgrounds can be bought for home studio use, but tarpaulins or white sheets, for example, can be just as effective.

▲ CREATING CONTRAST
In these two pictures the liquid pouring from the bottle has been frozen by the short duration of the flash. Even though the pale wood background blends better with the bottle, the effect shows up much more clearly when the dark blue fabric backdrop is used.

▲ SIMPLE SETTING

Tarpaulins are favorite backdrops with many photographers because they are inexpensive, hard-wearing, and work well with many different subjects. The color and brightness of all backdrops can be controlled through exposure and lighting.

◄ WORKING TOGETHER

In this portrait, the backdrop is an important, integral part of the picture. To take full advantage of the large abstract oil painting, the model's clothes were carefully chosen to echo the background.

ONE SMALL STEP

Outdoors, even small changes in camera position can make a significant difference to how well the background fits in with the rest of the image. Check the background after each shot using your camera's LCD screen, or learn to look carefully at the whole viewfinder area before firing the shutter. In this shot of a woman carrying her vegetables to market, a low viewpoint (far right) means that the line of mountains directly behind her head is distracting. A much clearer view of the landscape and the woman is achieved by raising the camera so the horizon line no longer cuts through her body (right).

lighting 2

DIRECTION OF LIGHT

The type of lighting that illuminates your subject will have a major impact on the success and feel of a photograph. In digital imaging, it is not the amount of light that really counts. Even in the dingiest conditions it is possible to get enough light rays to reach the camera's sensor—you simply need to use a longer shutter speed. It is the quality of the lighting that transforms an ordinary shot into a great picture.

Several factors contribute to lighting quality, but the easiest to change is the direction of the light source relative to the subject. This determines where the shadows fall, and which parts of the actual subject are lit.

► FRONTAL LIGHTING
With the sun coming from behind the photographer, the building is evenly lit. This sort of lighting is good for accentuating color—as seen here in the red of the brickwork and the blue of the sky.

▼ BACKLIGHTING
Most of this scene is illuminated indirectly by backlighting. But the narrow beam of direct light brings one part of the scene alive— revealing the archway and the texture of the barn floor.

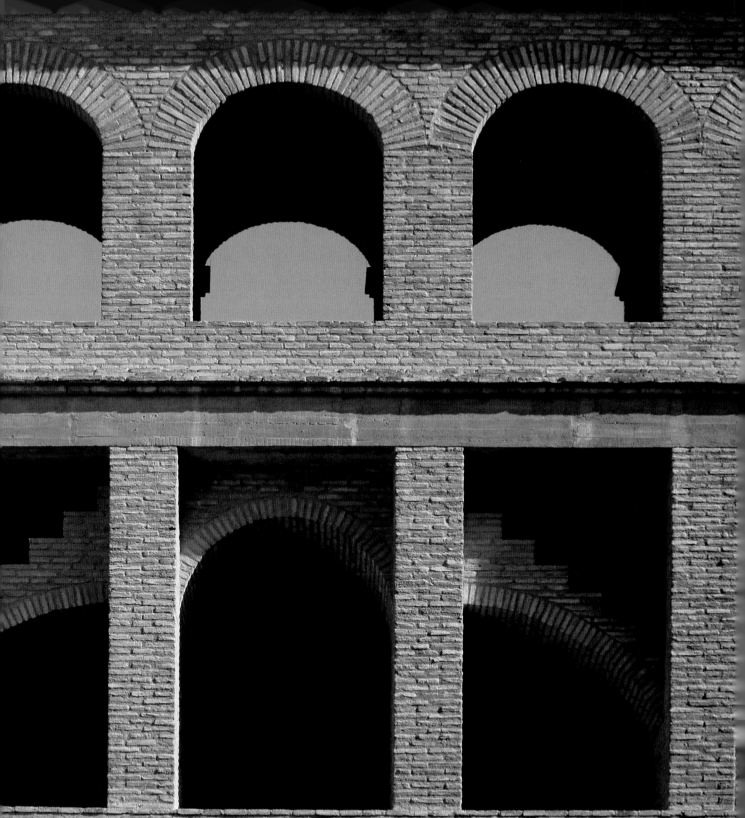

The light on a subject can come from any angle. Many pictures are taken using daylight, so the angle it comes from can vary through 360° around the subject, but also through a 180° arc depending the height of the sun in the sky. In the studio, the subject can also be lit from below.

For simplicity, photographers usually talk about just three broad types of lighting direction. The light can be in front of the subject—this is often called frontal lighting. Alternatively, it can be behind the subject—known as backlighting. Or the light source can be to the side of the subject, and this is called sidelighting. Each type of lighting has its own characteristic effect on the image.

This simplistic view is complicated by intermediate angles—a scene may exhibit features of both sidelighting and frontal lighting. You also have to take into account the characteristics of the lighting itself. Direct lighting on a clear day, or from a built-in flash, gives a different feel than lighting from the same angle but on an overcast day, or if the flash is being scattered through a clip-on diffuser.

It is also important to realize, particularly in outdoor photography, that although shadow areas are not lit directly, they are not in complete darkness. Even in the shade, subjects are lit indirectly by the sun's reflected rays.

◄ MIXED DIRECTIONS
This girl is lit by natural sunlight from the back and side. Most of her face and figure are in semi-shadow, lit only by soft, reflected light. But some parts of her body, and her translucent hair and clothes, are bathed in strong direct sunlight.

► SIDELIGHTING
Direct sidelighting typically creates both strong shadows and strong highlights. In this shot of a grasshopper, you can see some parts of its exoskeleton in great detail, whereas some parts are in total darkness.

direct and indirect light

ALTHOUGH LIGHT TRAVELS in straight lines, its path from source to subject is not always straight. Light can be diffused by clouds or reflected by surfaces, causing it to scatter, softening its effect.

The degree to which the light is softened in this way can be significant in your final image. Diffuse, indirect light, by its very nature gives an even illumination with less distinct shadows. The bold characteristics associated with sidelighting, for example, are subtler when the light is diffused by cloud cover than they would be on a clear day. This kind of soft lighting suits some subjects, but others look better with a more direct, less diffused illumination. The degree of diffusion is variable, of course, offering an almost infinite number of permutations.

▼ BREAK IN THE CLOUDS
Rolling clouds mean that the quality of light varies from minute to minute. In the first shot (below), the sunlight is diffused by clouds, subtly revealing the sculptured form of the building. In the second (below right), the light is direct, creating more noticeable highlights.

DIRECT SUNLIGHT AND SQUINTING FACES

The type of lighting that you use doesn't usually change the subject—only the way that it appears in the photograph. This is not the case, however, with portraits. Bright, direct sunlight will tend to make people squint. Unwanted shadows also appear under the nose and in the eye sockets (bottom). Because of this, it is usually best to use diffused lighting for portraits when possible. If necessary, move the person so they are standing in an area of shadow (top), since this will produce a more natural expression. If the shadow is deep, you can alter the image in postproduction (see page 185).

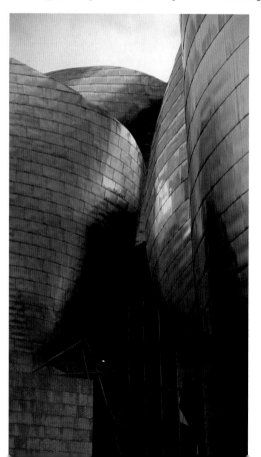

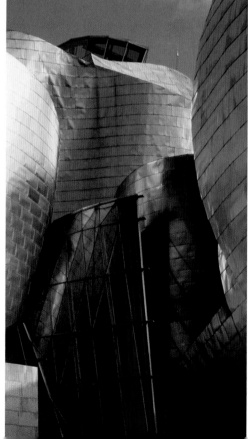

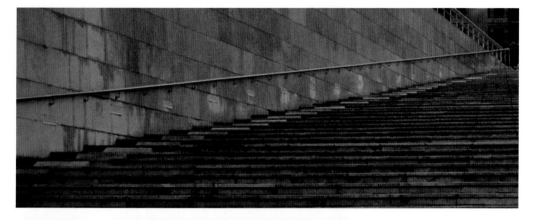

◄ BANISHING THE GRAY
Overcast conditions provide a
soft light that creates an almost
shadowless image—as in the shot
of these stairs (bottom). Waiting
for the cloud to break breathes
life into the scene (top), with the
stronger highlights creating a
more three-dimensional image.

▼ RAIN CLOUDS
The heavier the clouds, the softer
the lighting. Such diffusion is
unflattering for many subjects, but
the rainy weather helps this crowd
scene. The kaleidoscope of colors is
turned to pastel hues, and faces are
not obscured by shadows.

frontal lighting

THE SAFEST WAY in which to take successful pictures is with the sun behind you. This is because the majority of the shadows are thrown out of view, behind the subject, and surfaces are relatively evenly lit. Frontal lighting maximizes visible detail in the scene and, when direct, provides the strongest color saturation.

The main disadvantage of frontal lighting is that the lack of shadow means that it cannot provide strong clues to texture and form. If lit from straight on, in fact, buildings can look like two-dimensional cutouts. For this reason, it is better to use frontal lighting if the sun is over your shoulder rather than directly behind you; this slight change in the lighting angle provides sufficient shading to add some feeling of depth and form. Unlike with sidelighting and backlighting, frontal lighting creates a scene with a contrast range that a digital camera can easily manage. This means that automatic exposure systems cope well, without need for manual overrides.

▼ SIDE TO THE SUN
With the late afternoon sun behind me, the light provided great richness in color in this portrait of a prize bull. However, although his shape is distinct, his form is not well defined.

► SIMPLIFYING THE SCENE
In complex scenes, strong shadows create a jumbled mess that can obscure too much detail. The three-dimensional pattern of this building works best with frontal light.

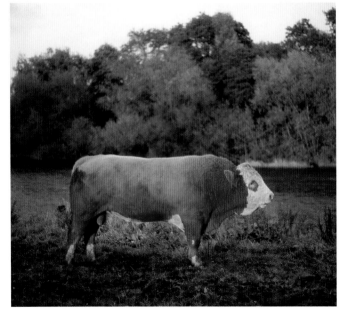

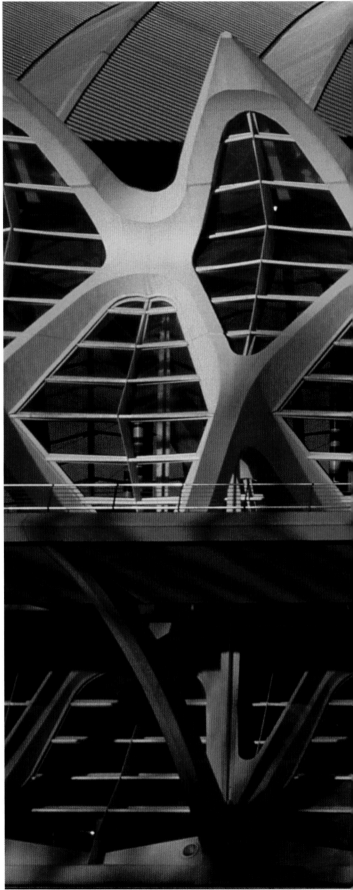

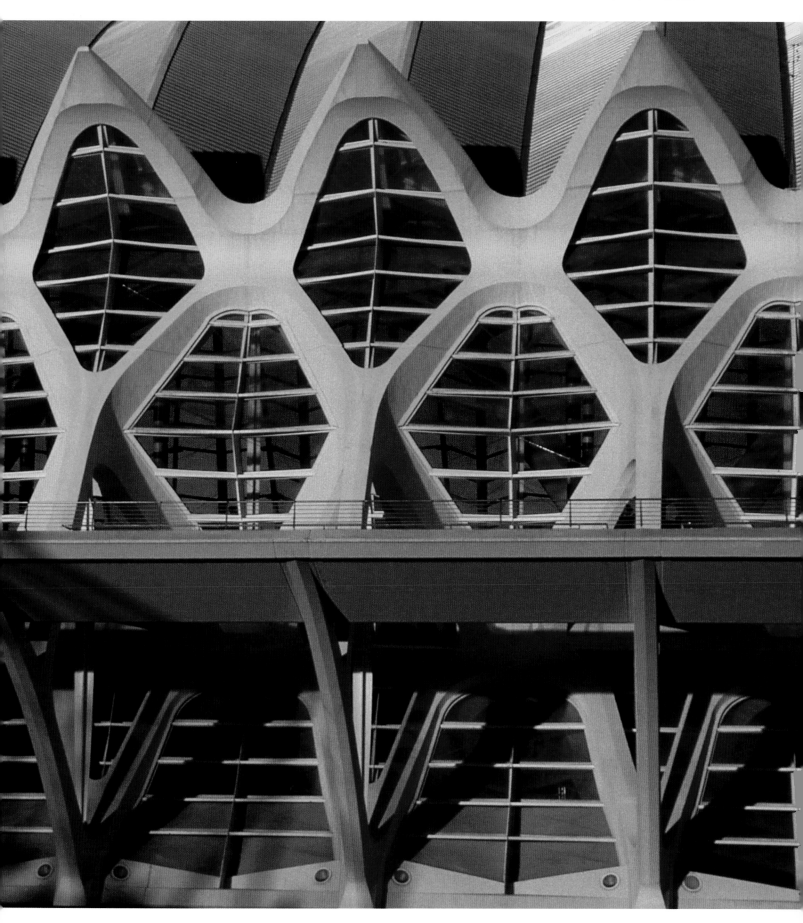

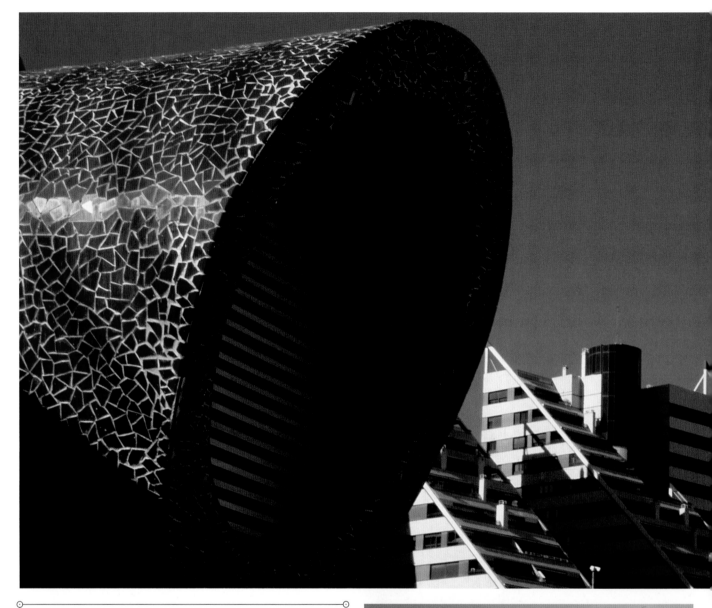

CONTROLLING HIGHLIGHTS

Highly reflective subjects are difficult to light successfully, since areas directly facing the light source become over-bright highlights. The glazed bowl (left) was lit from a window to the right of the setup; the resulting window-shaped highlight distracts from the pattern. One solution is to retouch the image on the computer (right).

sidelighting

SHOOTING WITH THE LIGHT to the side of the camera frequently creates drama in a scene. The angled light creates a complex pattern of light and shade. Some areas are well lit—and show good color saturation. Others are in shadow—hiding both detail and color. These boundaries between light and dark are very good at revealing the three-dimensional form of a subject.

Depending on the surface, this direction of light can also be excellent for revealing surface texture. The real difficulty, however, is that shadows often end up obscuring important details—and the more complex the forms, the more difficult it becomes to use sidelighting successfully. Even with simpler, more identifiable subjects, sidelighting is best when it is tempered—for example, when it is softened by clouds so that the contrast between light and dark is less extreme.

In the studio, sidelighting is not just diffused, but used in combination with reflectors to precisely manage the contrast across the subject.

▲ ACCENTUATING CONTOURS
Sidelighting from an off-camera flash shows the sculptured detail of this Brancusi bronze and a reflector to the left controls the shadows.

▼ TUBES AND CUBES
Simple forms work well with sidelighting. Here it has been used to emphasize the solidity of the round turrets and the square tower of this palace.

▲ PATCHES OF COLOR
Sidelighting reveals color selectively across the scene. In this architectural shot taken in Valencia, Spain, the sun reveals the intense blue of the tiles in one area of the image but throws other areas into deep, colorless shadow. The result is a dramatic, modernist composition.

◄ HALF IN SILHOUETTE
It is the lighting that makes this picture. The skeleton of the tree against a foreboding sky is brought to life by a shaft of late afternoon sun—highlighting the trunk and the branches with warm, golden light.

backlighting

SHOOTING INTO THE LIGHT is often thought of as simply a way of creating silhouettes (see page 140). Attempting anything else can seem futile when almost all the subject detail is lost in deep shadow. The lack of direct light on the subject means that form and color are lost—and you have to rely on shape alone for identification. Despite this, backlighting does have other uses.

A backlit subject is not usually in darkness—it is lit by indirect light reflected from its surroundings. If you expose for the foreground, cropping as much bright background from the shot as possible, backlighting can be particularly good for portraits—giving a soft light without distracting shadows. Backlighting is also essential for showing the translucence and color of subjects such as stained glass and flower petals. If the light source is just out of the frame, or behind the subject, backlighting can become rim lighting—although the majority of the subject is in shade, its outline is caught by the light, creating a halo effect.

▼ RIM LIGHTING

With the sun low, and just out of shot, the backlighting has thrown only part of the girl's face into silhouette. The light catches a small area along the edge of her profile, creating a bright rim around her face. Precise positioning and exposure are needed to pull off this sort of shot.

► BREAKING OUT

Clouds are not simply diffusers that shade the sun's light; their translucent forms can also make photographic subjects in their own right. Here, I took the shot in the moment just before the sun finally broke from behind this dark cloud, creating a bright outline.

CHANGING LIGHT

The beauty and challenge of natural light is that it constantly changing. A picture taken from the same spot w the same settings will not only look different whether tak in the morning or afternoon, it may also be transformed fr one moment to the next. These subtle changes in lighting c make a big difference to your pictures. For this reason, outdo photographers can become obsessed with weather repor and the time and position of the rising and setting sun.

It is not just the direction of the sun that varies througho the day in relation to the subject. Its height changes the leng of shadows and also changes the intensity and diffusion light. Low in the sky, the sun's rays are scattered by partic in the atmosphere, creating softer illumination. This effe varies significantly depending not only on the time of year k also on the latitude. The closer you are to the equator, th fewer changes there are in the lighting between the seasor and the more steeply the sun rises. The glorious low, rakir light at dawn may last only a matter of minutes.

In temperate zones, lighting quality not only chang more significantly throughout the day, but is also mo dependent upon the meteorological conditions. A single clou can have a major impact on the lighting conditions. It mc improve things—reducing contrast and softening the color but with some subjects it may be better to wait for the cloud move. The moment you choose to take the photograph crucial; great results often require a great deal of patience.

◀ TEMPERATURE CONTROL
The warm glow that remains after sunset is caused by the sun's rays having to pass through more atmospheric particles at a low angle.

In addition to affecting the direction, diffusion, and intensity of the light, the time of day, the season, and the atmospheric conditions also have another important role to play. They directly affect the color of the light.

This has particular significance in digital photography because unlike with film, the camera provides a direct way of influencing the way in which this coloration is recorded. The white-balance system can be set to automatically counteract the changes in color temperature (see pages 58–59). Similarly, manual overrides can be used to enhance the red of a sunset, or to counteract the bluish cast of a cloudy day. However, these tweaks in electronic filtration can only go so far to help recreate ideal conditions, or to make up for poor ones. Furthermore, despite all the things you can do to change images using Photoshop and other image manipulation packages, it is very hard to significantly change the look of the lighting in postproduction. White balance or digital darkroom corrections are best used to improve the natural color of the lighting, rather than to attempt to transform it completely.

The color of natural light changes because of two principal factors. First, the way in which clouds, water vapor, and particles in the atmosphere diffuse light affects some colors of the sunlight's spectrum more than others. The reds and yellows of a spectacular sunset are caused because the purple and blue rays cannot penetrate through the atmosphere. Second, the precise color of daylight is always a mix between direct or diffuse sunlight, and reflected light bouncing off the atmosphere. Known as skylight, this reflected light is blue in color. When direct light is weaker, the visible effect of skylight is stronger—hence the bluish light on a cloudy day, or just before dawn.

◄ WAITING FOR THE LIGHT

Clouds and sunlight often work together to create a
spotlight effect—providing a patterned beam of light
that travels across the landscape. Waiting for the right

▲ SPARKLING SEA

Sometimes it is the light itself that becomes the subject for
the picture. In this seascape, a break in the dark clouds
has allowed sunlight to spill over the ripples, creating

dawn to dusk

WITH OUTDOOR SUBJECTS, such as landscapes and architecture, the time of day is critical to the photograph that you take. The changes of lighting angle will mean that different viewpoints will work better at some times than others. This is especially true if you want to show a particular element, such as form or color.

Many photographers prefer to shoot early in the day or late in the afternoon. This is not necessarily because they enjoy early starts or because there is less traffic at this time. The low angle of the light means that it is more diffuse than at midday. Furthermore, the angle is better at revealing the form of a landscape. The French town of Millau is dominated by its modern road bridge, designed by Sir Norman Foster, which powers its way across the Massif Central. I spent three days in the town so that I could photograph it at different times of the day.

◀ IDENTICAL VIEWPOINT
A few minutes can make all the difference to the landscape. In these two alternative shots, the bridge is first surrounded by shadow and fog (top). Then the clouds begin to rise and disperse, revealing a very different scene (bottom).

▼ CATCHING THE LIGHT
The clutter of buildings in the town are a stark contrast to the simplicity of the towering bridge. However, the warm tones of the early morning light go some way toward creating a golden, photogenic view.

What time you need to get up to take advantage of the early light will, of course, depend on the time of year and your location. But one advantage of avoiding the middle of the day is that as the sun rises, the lighting changes quickly—allowing you to produce a varied portfolio of pictures in a short time. This is why professional landscape photographers like to be in position before dawn, so they are ready to capture the rapid transformation. In some parts of the world, and in some months, this period of change will last longer than in others. But if you miss dawn and the sun is higher in the sky, you become more reliant on the weather to create interesting lighting effects.

▲ STANDING TALL

In overcast conditions, the types of pictures that you can take become more limited. On cloudy days, concentrate on shots that don't rely on special lighting—here, photographs capturing the tremendous height of the bridge were still possible. Shooting into the light creates a silhouette that abstracts the structure from its surroundings—turning the concrete and metal into a powerful, cruciform shape.

► MAGIC MOMENT

This is the sort of shot that makes all the waiting worthwhile. An elevated viewpoint from the mountains made the bridge seem to float across the mist in the valley, before the clouds broke to create the type of rays across the sky that are typical of an Old Master painting.

▲ SILHOUETTE IN THE SKY
This shot was taken with the sun beginning to set behind the Millau Bridge. The result is essentially a skyscape—with the silhouette of the bridge acting as a useful focal point.

◄ PATTERN OF LIGHT
Breaks in the cloud cover can create an ever-moving pattern of light—seen here over the valley; it was just a matter of choosing the right moment to shoot.

▼ AFTER DARK
Don't rush to put your camera away when the sun goes down. The lights and the shapes of cityscapes can look particularly good after dark, even if the conditions for daylight photography have been poor. Make sure you don't leave it too late, however. The best results are usually obtained just after nightfall, when there is just a touch of hue left in the sky to act as a backdrop for the color of the lights.

the impact of silhouettes

THE BEAUTY OF THE SILHOUETTE is that the technique works whatever the quality of the lighting. On miserable overcast days, in glorious sunshine, or in the confines of your own home—a simple silhouette is rarely dependent on a particular color temperature or intensity of light. The lighting angle, however, is very important.

You need to position the light so that it is behind the subject (see page 128); this is easier if you can move around the subject to the right position. With backlighting, you can only show the essential element of shape successfully, without any hint of color, form, or texture (see page 18). The viewpoint or subject orientation needs to be such that the outline created makes the subject as identifiable as possible.

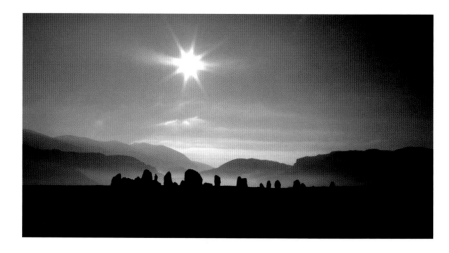

▲ STAR ABOVE THE STONES
The shape of the stones and mountains in this study are seen without the distraction of greenery. The starlike effect is created by using the smallest aperture setting.

▼ CHANGE OF COLOR
The color of sunsets can be manipulated in silhouetted shots without the side effects you'd see if you altered the light in complex scenes. Here, the blues were turned to warm hues to create a strong sunset image.

► SHAPE AND FORM
This shot is a digital montage created by joining together two different studio portraits—one emphasizing shape, and the other form. The sidelit picture of the man was taken on slide film, but scanned so that it could be combined with the modern, backlit picture of the girl, shot using a digital camera.

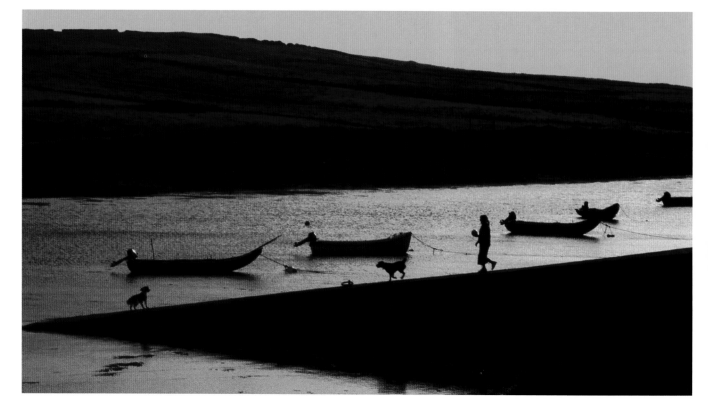

IMPROVING THE SHOT

The adage that "less is more" often applies equally to both lighting and composition. Frontal light (below) gives a detailed record shot of two men working up a telephone pole. However, the colors of their clothes, yellow tool bags, and red safety equipment are distracting and unnecessary. Shooting from the other side of the pole creates a stronger image (right); you see less detail but can still figure out what is going on.

▲ HINT OF A TINT
Twilight is a good time to shoot silhouettes—the touch of color left in the sky complements the dark shape of the subject. With stronger sunsets, any silhouette, even something as simple as a tree, gives a focal point in the frame. In low light situations such as this, a tripod is useful because it makes it much easier to get a shake-free shot.

▶ REACH FOR THE SKY
I'd been photographing this bronze statue on the Irish coast a few minutes earlier (see page 23). It commemorates all those lost at sea, and the families left behind. But as I was leaving, I saw this flock of birds passing overhead—and rushed into a suitable position to get both subjects in the same shot. The statue's hands almost look as if they are giving the birds their freedom.

seasonal changes

YOU CAN GET GOOD LIGHTING conditions at all times of the year. Contrary to what some people think, warm summer sunshine is not essential for good photography. Shooting in other seasons can be equally rewarding—if you take advantage of the more limited opportunities.

To document the changes of nature and weather, you will want to take pictures year-round (see page 224). The trouble is that in some months there can be so few hours of daylight that the chances of getting ideal conditions for a good shot simply by waiting around are vastly diminished.

In summer, you have the option of starting to shoot before most people are up—or waiting until they have gone home in the evening. The added advantage is that the light is also often best early and late in the day. However, winter cold will often keep many people away. And, just as lighting changes throughout the day, it also alters in quality through the seasons—the low, golden light of winter can create superbly lit scenes.

◀ CHESTNUT GLOW
The low-angled, warm light of fall is great for picking out the textures of a forest floor—as in this macro shot of sweet chestnuts.

▼ DEAD AND ALIVE
The brilliant colors of fall can look as good in indirect light as they do in direct light because it creates a subtler combination of shades.

Because Earth is tilted on its axis, the sun does not rise to such a high point in the sky during winter as it does in summer; this effect is more pronounced the farther away from the equator you get. The lower angle of light means that photographers outside of the tropics are able to take successful pictures even in the middle of the day in winter. The low-angled rays have to pass through a much greater mass of atmosphere, diffusing the light and making it likely that it will pick up the golden glow that can suit many photographic subjects.

It is also worth noting that in most places, the sun rises and sets at a slightly different point depending on the season. This inevitably means that some natural sites and buildings are better photographed at a time of year when the sun highlights their best features.

▼ SPRING
Early spring is a time of great change in the countryside. It also provides a better balance between low-angled lighting and the total number of daylight hours than fall or winter. This close-up of horse-chestnut buds was taken using the diffuse light of an overcast day.

▲ FALL
Even on the dullest days, you can still take successful pictures. I liked the strong shape and bright tone of this fallen leaf, shot in late fall, which contrasts with the small green leaves and reflections that surround it.

► WINTER
In winter, the low angle of direct sunlight can create long shadows even in the middle of the day. In this abstract shot, the snow has become a simple canvas, which has been painted with a pattern of shadows.

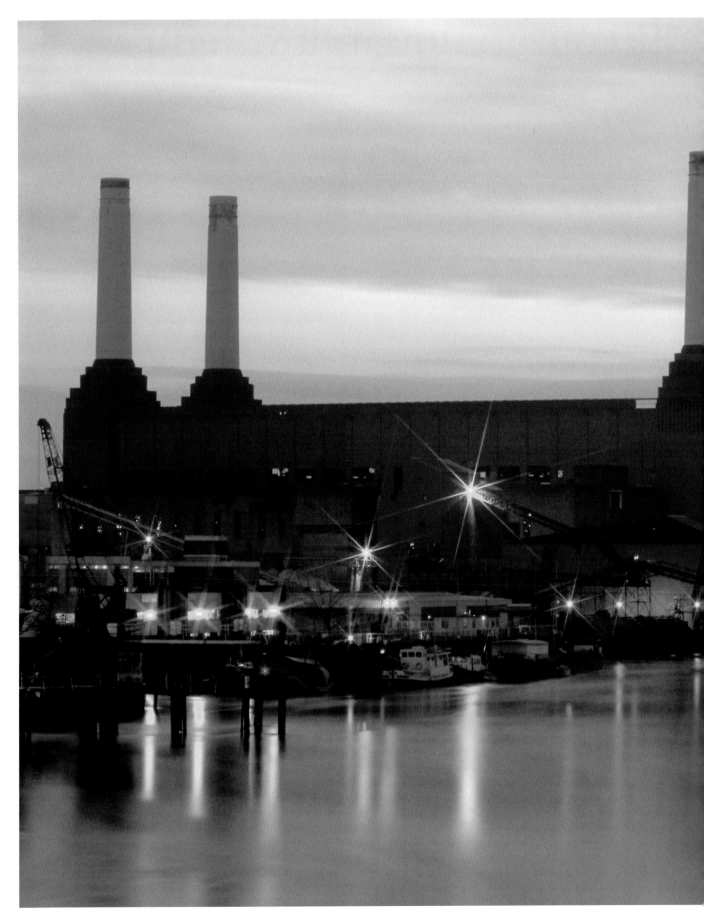

photographing in low light

ALTHOUGH IT IS ULTIMATELY the quality of light rather than the quantity that makes a successful picture, low light does provide challenges that you don't face in bright conditions. In particular, the resulting slow shutter speeds mean that camera shake can become a significant problem.

The simple solution is to use a tripod. Despite the inconvenience, a stable three-legged support allows you to use any aperture you like, without worrying about how slow the resulting shutter speed will be. Digital cameras are much better at adapting to low light than film cameras, thanks to their white balance control, and a tripod allows you to take full advantage of this fact. When a tripod is not available, or if the subject is moving, digital cameras allow you to increase the ISO setting (sensitivity) of the sensor. Although this can mean slightly grainier pictures, it is preferable to missing the shot, or ending up with a blurred image.

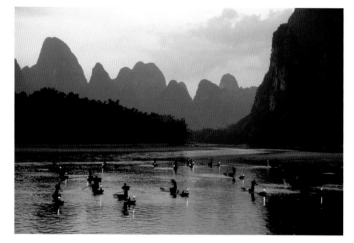

▲ SOLID PLATFORM
The lanterns of Chinese fishermen create a photogenic foreground for the spectacular scenery. If you don't have a tripod with you, find a surface to rest your camera on and use the self-timer to fire the shutter.

◄ DEPTH OF FIELD CONTROL
Shooting hand-held in low light is possible—but forces you to compromise on depth of field. A tripod lets you keep everything sharp if you want to.

▼ COLORED LIGHTS
Low-light scenes are often lit by sources with different color temperatures. Below, the dull daylight creates a blue landscape, while the car lights are red.

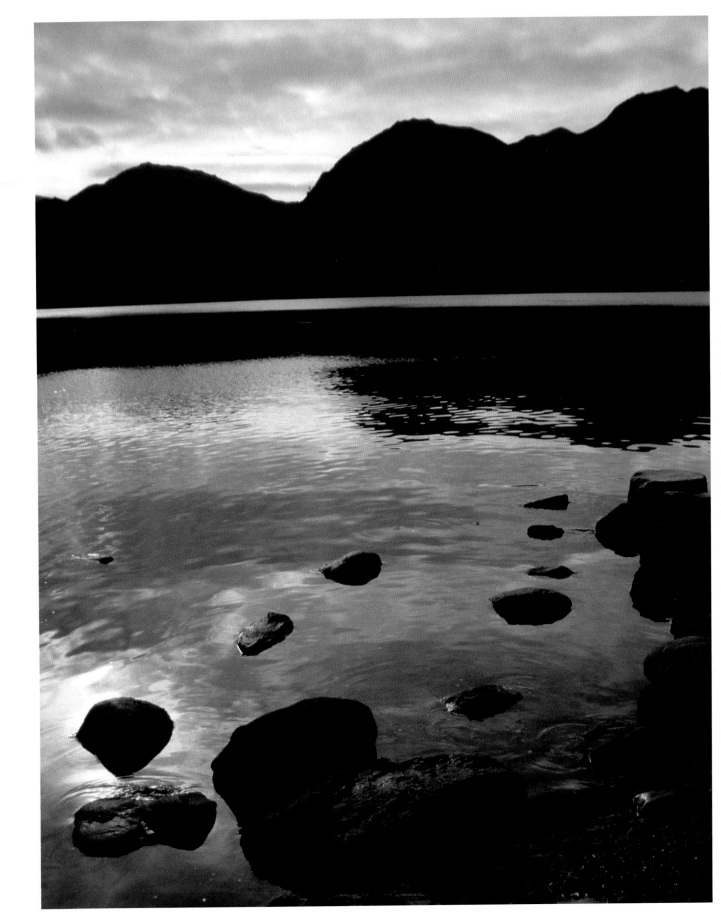

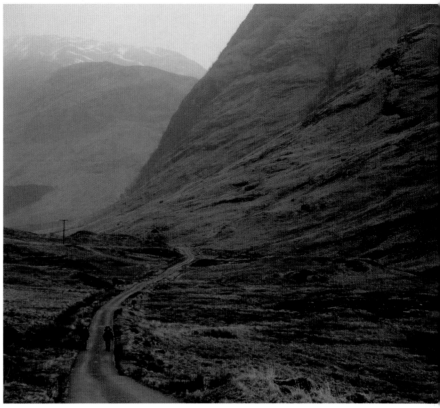

◄ STARBURST
Using a tripod extends your shooting day. This view of the Battersea Power Station in London, England, was shot using a cross-screen filter that turns streetlights into stars.

▲ ATMOSPHERIC VIEW
Gray, misty weather may not be the easiest in which to shoot landscapes, but graphic compositions work well in all lights. The bleak conditions particularly suit this mountainscape.

STREAKS OF LIGHT

Moving subjects do not always need to be frozen by the camera. In fact, for some nighttime images, the more blur you can introduce, the more atmospheric they look. This is particularly true with bright moving highlights, such as those created by fireworks, or by the headlights and taillights of flowing traffic. In both cases, you want to create long streaks of colored light across the frame. For moving traffic, you will usually find that you need an exposure that is of 30 seconds or more. For fireworks, try an exposure setting of around 10 seconds. With both, use a low ISO setting to avoid excessive picture noise. A tripod is vital for slow exposures.

dramatic light

LIGHT IS NOT JUST A TOOL—the right lighting can work magic on a scene, turning the mundane into the sublime. Light can unveil form, change color, and reveal details through the pattern of shadows that it casts. It can also become a subject in its own right—effectively providing the focal point of the picture itself.

The first problem is that shooting into the sun itself is dangerous. Looking directly at the sun through a lens can damage your eyes—make sure you compose such pictures using your digital camera's LCD screen to avoid any danger.

The next problem is flare. With the sun in the frame—or even if it is just out of shot—light can bounce around inside the lens in unwanted ways, creating telltale patterned streaks across the picture. Usually, photographers try their best to avoid this "fault" with the use of lens hoods, or simply by altering the composition. However, the flare can be used creatively and add to the atmosphere of a composition.

In bright light, shooting into the sun can also create problems with exposure. Whatever you do, the sun itself is going to end up a burned-out circle of white in your picture—and this glow will seep across to surrounding pixels, robbing the detail from the sky. Shooting into the sun, blues can become almost black—but by using exposure compensation or your camera's exposure lock, you can ensure that there is some hue left in the sky.

The brightness of the scene is likely to be such that you will find yourself using one of the smallest apertures that your lens has available—but this brings advantages. At small apertures, the blades of the iris opening turn the bright highlights of the sun into a multi-pointed star shape. This provides a stronger focal point for the picture—but the composition will still benefit by including some other recognizable shape within the frame, which will be transformed into a silhouette by the high contrast in the scene (see page 140).

◄ ▼ INTO THE SUN
This sequence of shots is of a girl on a bungee bouncer. Framing the shot with the light just behind her, the sun has become a key part of the composition. Of course, timing is crucial when your subject is constantly moving.

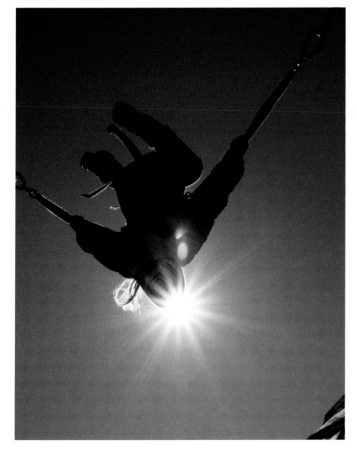

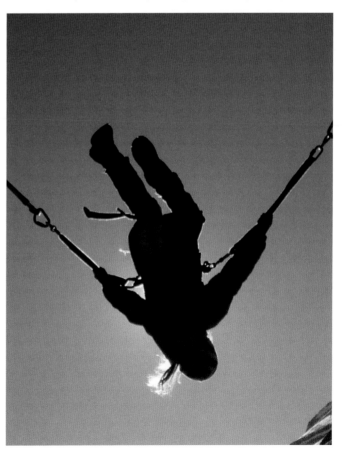

Shooting directly toward the sun is made less difficult if it is obscured by clouds. But if you are interested in capturing dramatic light, you need to risk waiting for those precise moments when the sun starts to break through the clouds—or is just about to be hidden by them. Remember to use the LCD screen on your camera for these compositions to avoid damaging your eyes.

Clouds do not just act as diffusers, they are also masks—creating a patchwork of holes for the sunlight to pass through. At the right moment, these gaps only allow a small amount of the sun to penetrate—and this can create visible rays in the image. Such shafts of sunlight are like the beam of a searchlight illuminating random areas on the ground. The strong diagonal lines are also a dramatic addition to the composition itself. You need to be ready, however, if you are going to capture the effect. The beams of light are likely to be visible only for a second or so—all too soon, the full power of the sun is unveiled, or completely obscured. The effect is at its most dramatic when the rays are juxtaposed against a bank of dark clouds.

► WARM GLOW
Shooting into the sun is safer late in the day, when the rays are less intense. In this sunset scene, the dramatic beams of sunlight have taken on an orange hue, giving a warm tone to the seascape.

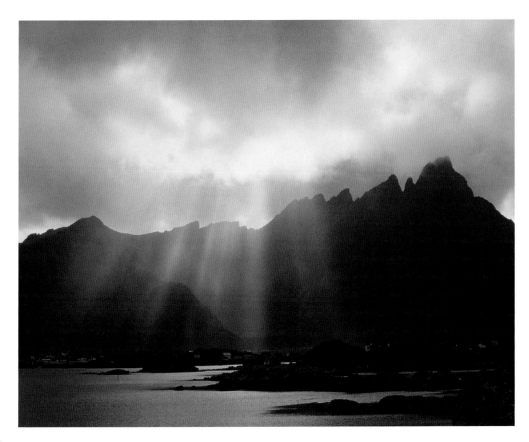

◄ ANTICIPATION

Scenes such as this do not last for long—if you are going to get the picture, you need to anticipate the lighting conditions. Keep a close eye on the clouds, so that you can be ready for the precise moment that they break. Here, the dark clouds and the theatrical light suit the jagged mountains of Norway's Lofoten Islands.

▼ LIGHT AND DARK

Sudden breaks in the clouds can look spectacular over water, because the light reflects off the surface. The extreme contrast of such scenes can make accurate exposure difficult. Try to take several shots quickly at different exposures—use your camera's exposure compensation or bracketing controls.

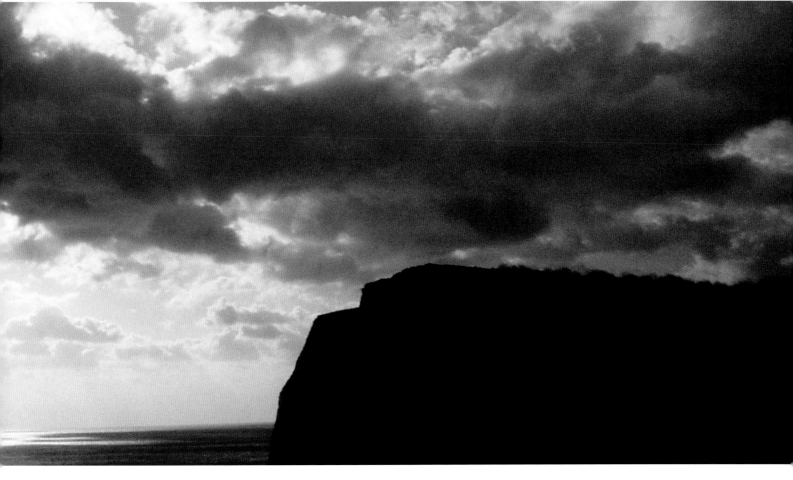

using shadows

IT IS TEMPTING TO THINK of shadows as simply the by-product of a particular type of lighting. However, they are often necessary to define shape, texture, or form. They can also be used to disguise areas you don't want to be clearly seen in a composition—waiting for the subject alone to be spotlit by breaks in the passing clouds.

Shadows can also make powerful subjects in their own right. With either sidelighting or backlighting, they can create a perfect two-dimensional copy of the subject's outline. And just as with a silhouette (see page 140), this shape, although lacking detail, can be enough to identify the subject if the angles are right. The length of the shadow, of course, is increased at certain times of the year and the day—when the sun is low in the sky. The longer the shadow, the more prominent it becomes—sometimes dwarfing the subject itself.

The interest to the photographer is that shadows on their own can provide a different, less direct and more abstract, way of capturing a subject. However, you have to be patient to capture a shadow from just the right viewpoint.

▼ FLYING OBJECT
Shadows provide unusual ways of seeing everyday subjects. We immediately identify the outline of a helicopter, but it takes just a fraction of a second to work out that the shadow is being cast from above.

► SEEING DOUBLE
At the right lighting angle, a subject and its shadow have the same proportions. Here, the symmetry created by the mirror image of each player creates an intriguing view of a hockey game.

snow and ice

FREEZING TEMPERATURES and all-white landscapes provide particular challenges for both you and your camera. But regardless of whether icy conditions are frequent or unusual in your area, such conditions almost always create spectacular scenery to shoot.

A white blanket of snow can transform a landscape—often hiding unwanted details, such as road markings. Since snow is such a good reflector of light, it provides an unusual, even lighting that can be very good for photographing architecture or portraits. The main difficulty is one of exposure. Automatic exposure metering systems assume an average mixture of tones—so white snow can often end up appearing grayish. The solution is to deliberately give the scene between half and two stops more exposure, using a setting between +0.5 and +2.0 using the compensation control. The exact amount will depend on how direct the light is, and on how much of the frame the snowy landscape actually fills. The other difficulty is low temperature. Batteries will run down more quickly than usual, so you need to carry spares or keep power packs warm between shots.

▲ MAKING TRACKS
With an all-white subject, such as this fresh footprint caught after a snowfall, you need to make sure that the shot doesn't end up underexposed.

◄ CAUGHT IN THE ACT
Snow usually looks at its best in photographs just as it has finished falling, and when it is lit by direct, frontal light. However, when it snows during daylight, it can be interesting to capture the flakes as they flutter down. The soft, even lighting from the clouds is balanced by light reflected from the snow on the ground. Here, a shutter speed of around 1/15sec has ensured that the flakes are blurred, helping to convey the fact that they are falling.

▲ FEELING BLUE
To enhance the feeling of a cold morning, you can try altering the white balance (see pages 58–59). A blue color cast can be set, for instance, by using a manual white-balance setting meant for use with indoor tungsten bulb lighting.

◀ UP CLOSE
Use the camera's macro setting or special macro equipment to get in close to the patterns created by the frost and ice. Delicate structures such as these may not last long, so you need to hunt them out and photograph them soon after sunrise.

high and low key

MOST IMAGES CONTAIN a full range of tones, from the very dark to the very bright. Occasionally, however, dramatic results can be obtained with scenes that are predominantly white or black.

These effects rely heavily on lighting for their success—but the subject matter is equally important. So called high-key lighting is used to produce images that have a preponderance of bright tones. But in order to do this, the scene needs to be constructed so that much of the frame is filled with white, or light-toned subjects. The classic shot is of a pale-skinned blonde-haired model, dressed in white, posed against a bright background. Snow scenes also lend themselves to the high-key approach. In order to keep the picture from looking too flat, and to provide a focal points, it is helpful to have small areas of dark tone; in a portrait, these are usually provided by the eyes. Lighting should be soft—so that the scene is evenly lit without dark shadows. Slight overexposure may also be used to create the over-bright look, although in the interests of avoiding burned-out highlights, it may be better to do this using a Curves adjustment in postproduction.

Low-key shots are set up using mostly blacks and dark tones. A small area is usually lit with highly directional light, such as a spotlight, or overhead window. Exposure verges on the side of underexposure to ensure the theatrical look.

◄ HIGH KEY
Diffused frontal lighting in the studio and a sea of white balloons create a high-key set for the portrait of the little girl. It is the dark areas of the eyes that provide the focal points for the picture.

▼ LOW KEY
Strong sidelighting from a studio light and a dark, unlit background create an image where much of the picture is pure black. Just a fraction of the face, hair, and mask can be clearly seen.

subjects
& styles

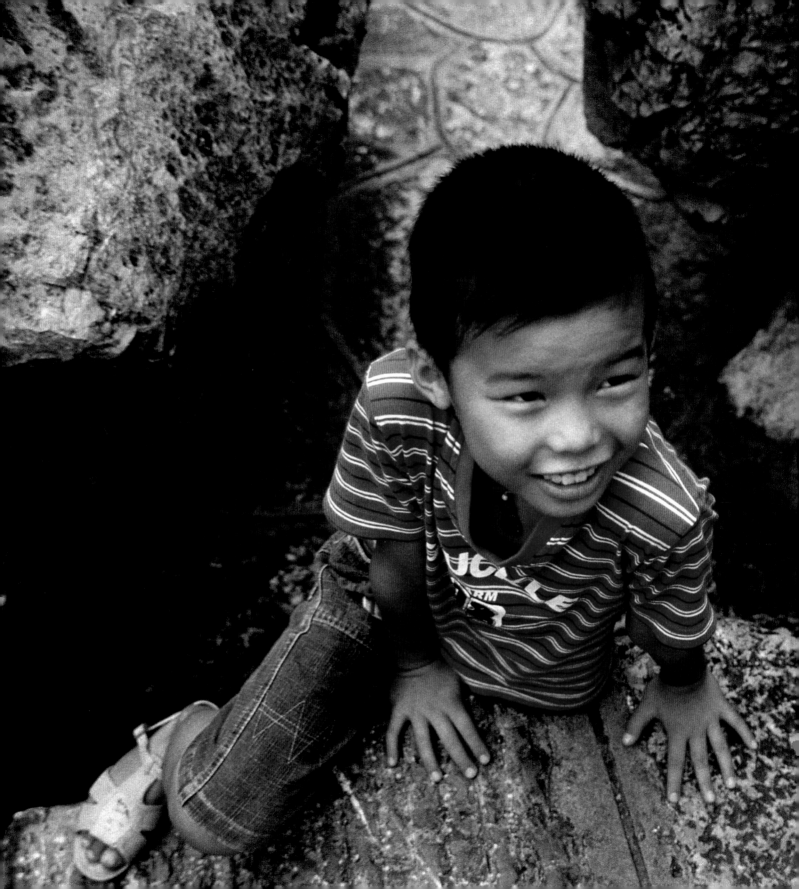

PEOPLE

◄ GAINING GROUND
Children are usually happiest when they are playing, and a happy child is easiest to photograph. The rock this boy is climbing also provides an effective natural backdrop.

▼ CATCH OF THE DAY
Getting a fish farmer to pose with a salmon by the waterside helps provide a more complete picture of the man and his life than a straight portrait would have done.

Even if it is only to take pictures of family or friends, portraiture is the one photographic subject that every camera owner tries to tackle at some point. Whether it is with a camera phone or a top-of-the-line SLR, a portrait does not just capture a moment in time—it can capture something of the person's personality and tell you about their way of life. Digital imaging makes the whole process so easy, since even without flash you can get good images in minimal lighting. Variable ISO means that you can boost the sensor sensitivity to suit the conditions—and the white balance system means that skin tones will look accurate whatever the lighting.

▲ MAKING WAVES
You don't need to see the face to get a great portrait. The splash of water and the breaking waves bring this picture of a little girl alive. The shot sums up the timeless appeal the seaside has for all children.

► DOUBLE EXPOSURE
This portrait of two men is not what it seems. It is actually two pictures. The close-up taken with fill flash has been combined on the computer with the shot of the man standing at the saloon door.

There are many different styles of portraits. Pictures can be carefully planned and posed—or you can take a candid approach by waiting for the right moment to fire the shutter unannounced. The picture can be composed to show the person alone—or you can give extra clues about their life by revealing what they are doing, and their surroundings. Certainly, capturing people as they work or play can often make them appear more relaxed—and a familiar environment can also mean that you avoid the artificial feeling of a formal portrait. The advantage of using a managed environment, however, is that you have much better control over the lighting and the background.

striking a pose

WHEN TAKING PICTURES OF PEOPLE, getting the lighting and the composition right is not enough. Unlike architecture or landscape photography, for example, the subject takes an active role in the success of the photograph. He or she makes or breaks the picture by their expression and pose. The way they smile, how they stand, and what they do with their hands—every subtle variation counts.

However, part of the responsibility for getting a good portrait lies with the photographer. If you can get your sitter to feel relaxed, the pose will look more natural. Similarly, you can learn where to ask your subject to look and place their hands so that their portrait does not look awkward. And because people blink, twitch, and continuously move, it always pays to take more pictures than you think you will need. Some people are definitely better at modeling than others—that's why top professional models can earn good money simply by standing in a studio. Even so, you must be good at communicating, and giving positive feedback, if you are going to get the best out of this two-way relationship.

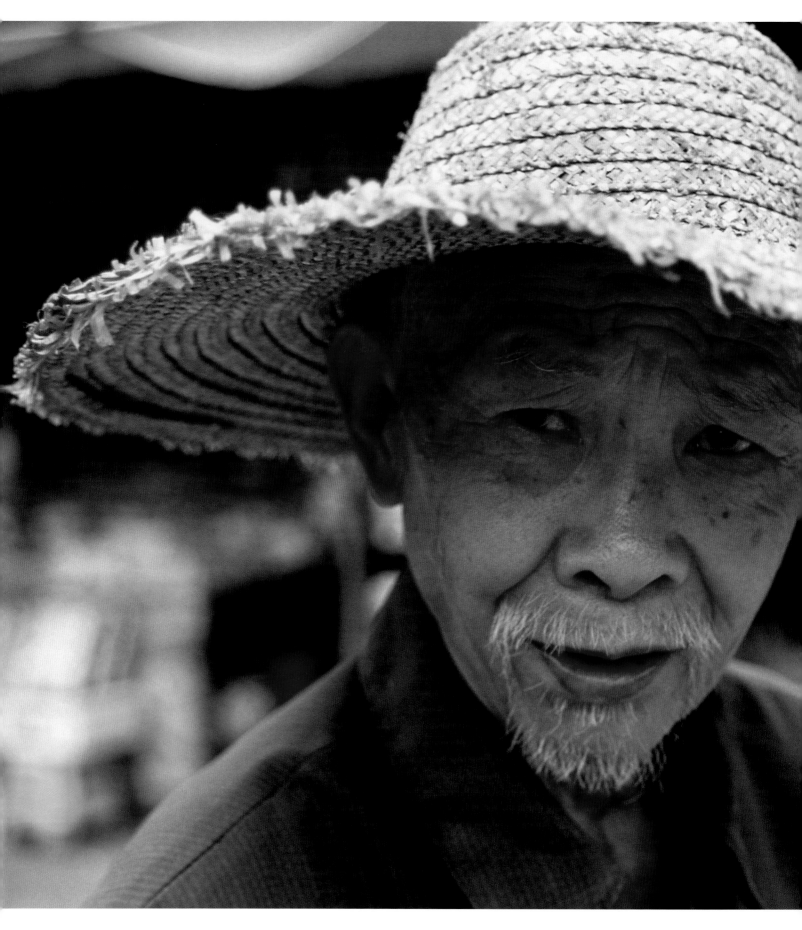

isolating faces

YOU CAN TAKE SUCCESSFUL PORTRAITS with any zoom setting or lens. However, as a general rule, it pays to avoid the more extreme focal lengths. To ensure that features aren't distorted, a short telephoto lens is generally considered the best choice for most forms of portraiture.

Wide-angle lenses should not be used when shooting close-ups of people's faces. The close distance and the resulting perspective mean that noses and chins appear elongated. It is therefore better to shoot from farther away—so that the perspective compresses the features in a more flattering fashion.

Although zooms and other lenses are generally compared by their focal length, this measurement can cause some confusion with digital cameras. A 50-mm lens setting on one camera may give a much wider angle of view on one camera than another. This is because the sensors used by digital cameras come in all sizes—and the bigger the sensor, the longer the focal length needs to be to give a particular angle of view. To help comparison, an "effective focal length" is given, which converts the actual focal length to that needed to give the same visual effect with 35-mm film (or a sensor measuring 24 x 36 mm).

◄ LOST CITY
A telephoto lens setting and a wide aperture throws the busy street in the background out of focus so you can concentrate on the man's face.

▼ FUNNY FACE
Children love to make faces. This radical composition zooms in on the girl's little nose and the wavelike line created by her sucked-in cheeks.

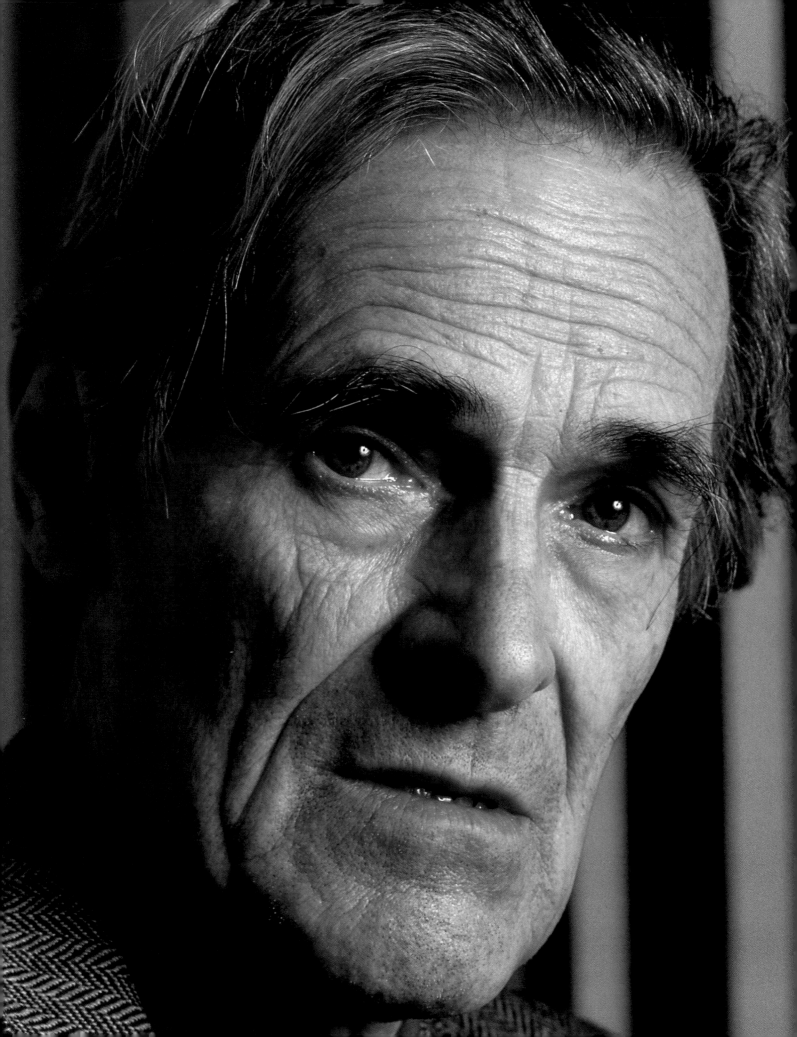

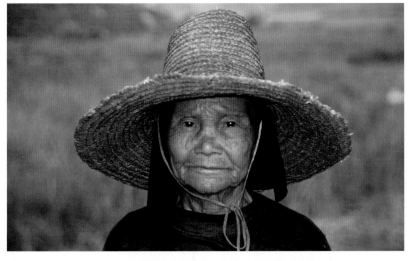

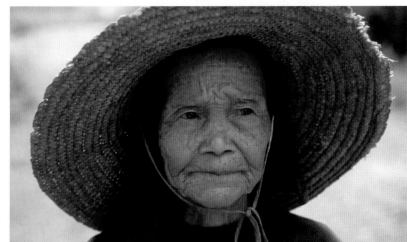

Using the effective focal length principle, the ideal lens setting for shooting close-up portraits without distortion is around 100 mm. In practice, any setting from 70 mm to 200 mm can be safely used. Anything significantly longer makes you too distant to communicate effectively with the subject, and runs the risk of flattening the features too much. Anything shorter will produce exaggerated features.

A telephoto lens also brings an added benefit to close-up portraits—its limited depth of field means that it is possible to throw the background out of focus, isolating the head from distracting surroundings. This is not always necessary—but often a wide aperture ensures that the subject's face is the only focal point in the frame. The wider the maximum aperture of your lens, the more flexibility you have—but lenses with wider-than-average maximum apertures are usually very expensive to buy.

There are some rules for composing a portrait that you should learn—although they can be broken on occasion. You need to be careful where the edges of the frame cut through the body. If it cuts through joints such as the knees, the portrait can look truncated. A head-and-shoulders composition should include the tops of the shoulders rather than cut through the neck, and some space above the head, although sometimes a closer crop can be more effective.

▲ FILL-IN FLASH
Using flash in daylight can be useful for close-up portraits. The artificial light adds color and contrast on a dull day—or eliminates shadows on a bright day. In this sequence, the fill-in flash creates a punchier portrait (top). Without the flash, the face is totally in shadow (above).

◄ ALL IN THE EYES
Converting an image to black and white can be particularly rewarding with portraits. The absence of color allows you to concentrate on the texture and the form of the features. When shooting close-ups such as this using wide apertures, you need to ensure that the eyes of the subject are in focus. If these are sharp, it doesn't matter if other parts of the face are slightly soft.

BACKGROUND CHECK

Even using the widest aperture you can, and a telephoto lens setting, it is not always possible to make the background as blurred as you want it. These two shots are of Senator Yeats—son of the Nobel Prize–winning poet W.B. Yeats. They were taken outside a hotel in Ireland, taking advantage of the soft sidelighting provided by the late afternoon sun. Using an aperture of f/4—the maximum available with the 70-mm setting of the zoom—the walls of the hotel in the background are out of focus, but the windows and the doorway can still clearly be made out (top). This amount of detail proves a distraction in the picture. One solution in this case was to zoom in closer—to lose as much of the backdrop as possible (bottom). The crop provides a much cleaner portrait of the elderly statesman and his mane of long, flowing white hair—even if the view is not a conventional one. An alternative would have been to further blur the background on the computer (see page 85).

people in their environment

ALTHOUGH TELEPHOTO LENSES and wide apertures are the norm for pictures of people, wider lens settings and smaller apertures can be useful if you also want to show their surroundings.

This documentary approach allows you not only to see what a person looks like, but also to understand something of how they live. It can be an effective way to show a person's home or place of work, giving a more detailed picture of their life. The secret to a successful composition is to control the angle of view to ensure that the shot doesn't end up too cluttered, and the subject remains the clear focus of attention.

► SETTING THE SCENE
It was the rugged face and bushy beard that made me want to take a picture of this gentleman. Placing the face off-center, and using a wide lens, meant that the rocky ground, simple hut, and open sky could be shown to help set the scene for this artisan's way of life.

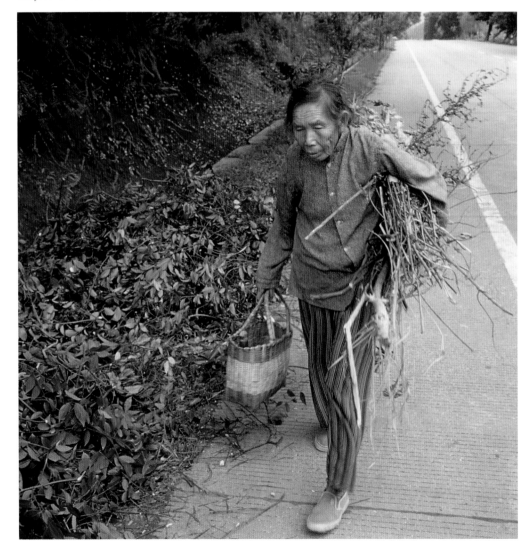

◄ LONG WAY HOME
Sights like this are common in rural China. Despite her age, this woman is still collecting and carrying her firewood. The wide composition gives an idea of the distances she must travel.

► EXPLAINING THE POSE
In this shot, taken with fill-in flash, the inclusion of the setting helps put the girl and her furry hat in context. Even though it is out of focus, we can still tell that the background shows a ski resort.

candid camera

ALTHOUGH MOST PORTRAITS are taken with the knowledge and agreement of the subject, there are occasions when surprise pays. The unseen camera can capture expressions a posed picture cannot.

The truth is that, whether consciously or not, people's behavior is influenced by the presence of a camera. Some ham it up, giving a performance that, although entertaining, is not true to life. Others turn shy and introverted in front of the lens—and no amount of coaxing will make them appear natural. People become conditioned to act in a certain way when photographed, whether it be to smile or frown. The candid approach allows you to catch people as they really are.

Candid photography does not necessarily mean being furtive. It is usually enough to act quickly so as not to draw attention to yourself—and to use a long lens so as to keep well away from your subject. As a general rule, a telephoto lens with an effective focal length of 200 mm to 300 mm is more than sufficient—particularly if you are shooting in a busy street or a crowded room. At these distances, flash is not an option, so to avoid camera shake you will need a shutter speed of at least 1/250 sec. Accurate focusing is critical in all but the brightest of lights, since the resulting aperture will limit depth of field. This approach allows you to capture naturalistic close-ups of people going about their daily business, without invading their personal space. Nevertheless, some people may not want to be photographed, and you should respect their wishes. You may need your model's consent to publish your pictures.

◀ SEEN FROM A DISTANCE

A Spanish market trader in his beret smiles in a way that looks natural and unforced. Capturing strangers looking relaxed usually means shooting from a distance with a long telephoto lens.

▼ FEET UP

A construction worker takes a quick break in his car, providing an amusing view that could only be captured by an unseen camera. Such shots have to be taken from a distance; get any closer and the pose may be lost.

children and babies

EVERY PARENT AND GRANDPARENT wants to keep an album that charts the children in the family as they grow from babies to toddlers, and then to teenagers. The liveliness of expression and movement of youngsters brings both challenges and rewards to the photographer.

With young children in particular, if you are going to have any time at all to take a series of pictures, you need to find a way of keeping the youngster occupied and amused. Shooting portraits as they are playing their own games is one solution, but so that you have more control over the situation, it is often better to elicit their help. Ask them to suggest an outfit that they might wear—or a favorite toy or other prop that they might hold. To get the style of photograph that you want, you could offer a selection of clothes to dress up in—such as wigs, hats, and other costume items—turning the photographic session into a game.

With babies, you will almost always need the help of the mother (or another close member of the family) to stand just out of shot so as to keep the child happy, and to get him or her to look in the right direction at the appropriate moment.

▲ PLAYING THE PRINCESS
Get children to put on their favorite dress-up clothes—or provide costumes yourself. This will not only make the picture look more interesting, but will also make it fun for the child and help you gain their cooperation.

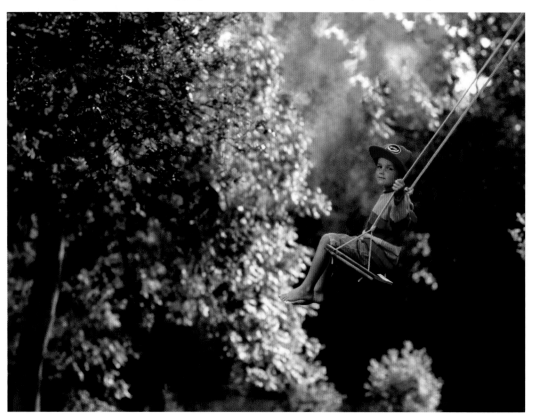

◄ CAPTURING MOVEMENT
Activities can be used to keep a child occupied while you shoot. Here, the shot was taken as the child reached maximum height on the swing, creating a strong diagonal that gives a sense of movement (see page 100). Also, at this moment, the swing is not moving forward or backward, so you don't need to worry about what shutter speed is needed to freeze the subject.

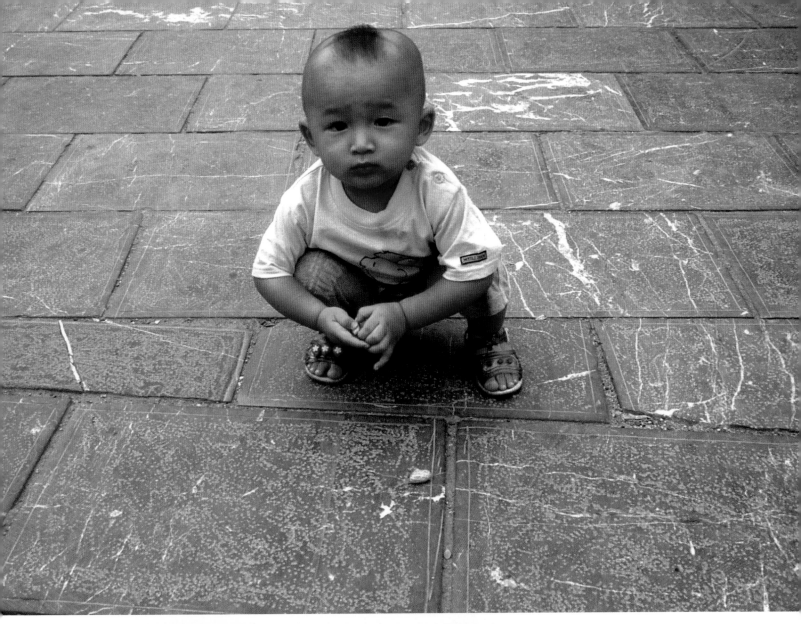

▲ SIMPLE BACKGROUND

One of the advantages of photographing a child from above is that it allows you to use the floor or ground as a backdrop. Here, this approach simplifies the image, since other people and buildings are banished from the frame. However, I was still careful to crouch down, so that I did not tower over the little boy too much.

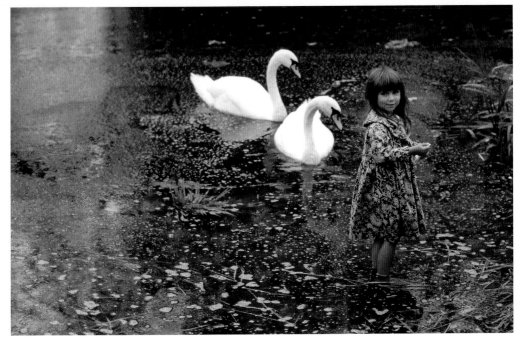

◄ FEEDING TIME

This little girl has waded into the lake to feed the swans. By calling out to her, she turns to acknowledge the camera, letting us see her face and the scenery at the same time.

The difference in height between subject and photographer should be taken into account when taking portraits of children. If you shoot from your own eye level, you will almost inevitably point the camera downward in order to frame them. Although occasionally necessary for compositional reasons, this high vantage point rarely gives a particularly flattering picture. You should try to get down to the child's level for the majority of your shots—even if this means kneeling or lying down—to provide a more natural-looking photograph. For powerful portraits that make a child gain stature and look more confident, occasionally try a low-angle viewpoint—so the camera is actually looking up at them (see pages 90–91).

Finally, always try to keep portrait sessions with children as short as possible, getting as much ready in advance as you can, so you don't discourage your subjects from posing another time.

◀ **EXTRA LIGHTING**
To get the soft lighting needed to illuminate this complex scene evenly, a 500-watt halogen lamp was bounced off the white ceiling.

▼ **MOTHER'S HELP**
The mother needs to stand near the camera, encouraging the child to look in the right direction, while you take the picture.

group portraits

AS SOON AS YOU TRY to take portraits with two or more people in the frame, your problems multiply. It is much harder to get a shot where everyone looks relaxed and has their eyes open. Lighting options become more limited, since you will not want one person to cast shadows over the face of another.

However, not all group portraits need to be arranged formally so that everyone is equidistant from the camera and looking straight at the lens. This is fine for weddings—but the danger is that the people look as if they are waiting for a bus. An alternative approach is to arrange everyone so that they are different distances away, or doing different things, to make a more interesting composition.

Take as many shots as quickly as possible to maximize success. But don't delete shots too hastily—often a face from one shot can be merged with another in postproduction to create the perfect portrait.

▲ TWO'S COMPANY
With two people, here a parent and child, try to arrange them so that an imaginary line between their heads creates a diagonal path across the frame.

► MANY HANDS...
To photograph small groups, try to get everyone to stand at slightly different distances away from the camera. Props and a common activity can be used to help create a feeling of unity.

▼ STANDING ON CEREMONY
For formal group shots, everyone will expect the traditional lined-up approach. This group was shot at a parade to open a photo festival in China.

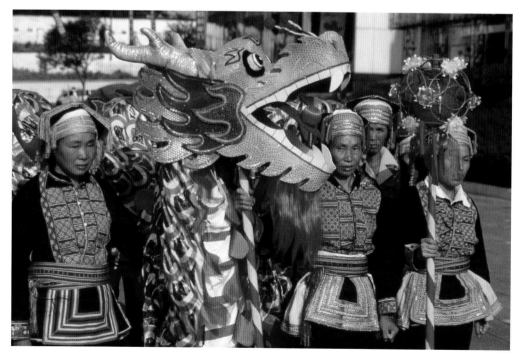

group portraits

AS SOON AS YOU TRY to take portraits with two or more people in the frame, your problems multiply. It is much harder to get a shot where everyone looks relaxed and has their eyes open. Lighting options become more limited, since you will not want one person to cast shadows over the face of another.

However, not all group portraits need to be arranged formally so that everyone is equidistant from the camera and looking straight at the lens. This is fine for weddings—but the danger is that the people look as if they are waiting for a bus. An alternative approach is to arrange everyone so that they are different distances away, or doing different things, to make a more interesting composition.

Take as many shots as quickly as possible to maximize success. But don't delete shots too hastily—often a face from one shot can be merged with another in postproduction to create the perfect portrait.

▲ TWO'S COMPANY
With two people, here a parent and child, try to arrange them so that an imaginary line between their heads creates a diagonal path across the frame.

▶ MANY HANDS...
To photograph small groups, try to get everyone to stand at slightly different distances away from the camera. Props and a common activity can be used to help create a feeling of unity.

▼ STANDING ON CEREMONY
For formal group shots, everyone will expect the traditional lined-up approach. This group was shot at a parade to open a photo festival in China.

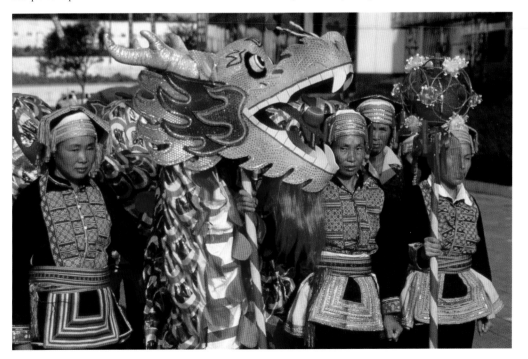

OUT OF THE SHADOWS

To avoid strong shadows across your model's face on a bright, sunny day, it is often a good idea to shoot portraits in the shade (see pages 122–23). However, the resulting picture runs the risk of looking rather dark and lacking in detail (right). Such shots can be rescued in postproduction. Here, Photoshop's Shadow/Highlight controls were used to make all of the necessary tonal corrections (far right).

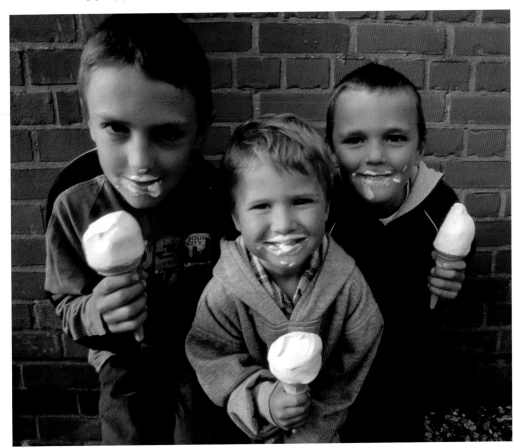

◄ SMALL DETAILS
You don't always need to show the face when photographing people—other close-up details can create interesting studies. Children's small, often chubby, hands and feet can be particularly rewarding. In this shot, the girl's colorful top makes a great backdrop for a closely-cropped shot of her hands as she holds them behind her back.

▼ HAPPY FACES
Children eating ice-cream cones in their characteristic messy style is an obvious seaside shot. But conventional poses such as these often work well. Here, the setup creates an amusing group portrait.

► OFF-CENTER COMPOSITION
Don't compose all your pictures so that the figure or face fills the whole frame. Here, the boy is placed strategically off-center, and the net creates a bold diagonal line across the frame.

The difference in height between subject and photographer should be taken into account when taking portraits of children. If you shoot from your own eye level, you will almost inevitably point the camera downward in order to frame them. Although occasionally necessary for compositional reasons, this high vantage point rarely gives a particularly flattering picture. You should try to get down to the child's level for the majority of your shots—even if this means kneeling or lying down—to provide a more natural-looking photograph. For powerful portraits that make a child gain stature and look more confident, occasionally try a low-angle viewpoint—so the camera is actually looking up at them (see pages 90–91).

Finally, always try to keep portrait sessions with children as short as possible, getting as much ready in advance as you can, so you don't discourage your subjects from posing another time.

◄ EXTRA LIGHTING
To get the soft lighting needed to illuminate this complex scene evenly, a 500-watt halogen lamp was bounced off the white ceiling.

▼ MOTHER'S HELP
The mother needs to stand near the camera, encouraging the child to look in the right direction, while you take the picture.

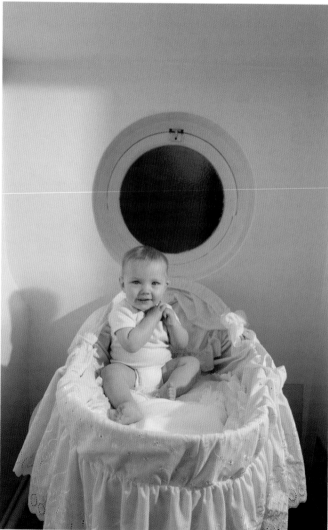

▲ BALANCED LIGHTING

In order to light both the girl's face and the large vase adequately, two different lights were used. The main light was placed to the left of the camera, with a second fill light at a lower power setting to the right. The difference produces just enough modeling, without detail being lost in the shadows. The unusual pose mirrors some of the elements of the piece of pottery.

CORRECTING RED EYE

The built-in flash provided by the camera rarely gives great lighting for portraits in low light. But its convenience means that it allows you to take pictures where other artificial lighting is not feasible. Another problem is that an integral flash provides frontal lighting at an angle that is very close to that of the lens. This means that the light reflects from the back of the retina of the subject's eyes, creating a characteristic "red-eye" effect (right). Although automatic flash modes can be used to reduce the effect, the red pupils can easily be retouched on the computer (far right).

studio portraits

TAKING FORMAL PORTRAITS indoors used to mean having to invest in expensive studio flash equipment. With digital cameras, less expensive and easier-to-use solutions can be used very successfully.

The white-balance system means that a variety of light sources can be used without any color temperature problems. Tungsten bulb, quartz halogen, and fluorescent tube lighting setups provide a cheaper alternative to the traditional flash systems. They provide continuous light, rather than a short burst, so you can see where the shadows and reflections fall before you shoot. However, a disadvantage of this type of lighting is that it can generate a lot of heat.

To get fast enough shutter speeds to photograph a moving subject such as a person, an output of 500 watts or more is useful—because studio lights often need to be heavily diffused to provide soft illumination. Two lights are handy, but you can get by with one if it is used in conjunction with a reflector.

▲ SOLID SUPPORT
Use a tripod in the studio, especially for photographing groups. You can then make small changes to the position of the lights, or ask subjects to change pose, without having to keep checking focus and framing.

► SOFT SIDELIGHTING
The lighting for this shot was provided from a single studio lamp. Placed to the right side of the camera, its output has been diffused using a clip-on accessory called a "softbox," designed to provide windowlike, even lighting. A large wooden board, painted white, was placed on the right side to act as a reflector—bouncing some light back to soften the shadows.

human form

THE NAKED BODY has always been a source of inspiration to artists, but it can be a difficult subject to photograph successfully. Unlike the paintbrush, the camera is not capable of ignoring imperfections or awkward poses—making the choice of model, lighting, and background crucial.

◄ ALL WHITE
Try to keep the setting simple. Here, a white blanket ensures that the sofa blends in with the white roll of paper used for the background. The pose accentuates the hourglass shape of the model's back.

▲ RIM LIGHTING
A suspended sheet in this shot not only functions as a plain backdrop, but also acts as a diffuser for the main light. The backlighting creates a rim effect that outlines the curves of the model's body.

▼ RELAXED POSE
Give your models continuous encouragement, and try to keep them as relaxed as possible—by playing suitable music, for example. Make sure the room is warm to keep them comfortable and to avoid goosebumps.

Probably one of the simplest ways of getting started with nude photography is to adopt an abstract style. By showing just part of the body, you can isolate the best features—and provide a degree of anonymity to the person who you have persuaded to pose for you. The approach is to crop in on the curves and look for interestingly shaped outlines.

Sidelighting is usually used—to provide a degree of three-dimensional form. For flattering results, this is usually kept very soft—although with more athletic bodies, and when shooting for black and white, you can afford to make the lighting more directional.

STILL LIFE

Shooting still-life subjects is probably one of the best ways of learning about photography. By photographing things that do not move, you can use a variety of apertures and focus settings to experiment with depth of field. Since the subjects are often small, they are relatively easy to photograph in the home—allowing you to develop a feel for different studio lighting setups without having to invest in expensive specialty equipment. The subjects can be moved around, so you can experiment with different arrangements, backgrounds, and props until you have exhausted all the compositional possibilities.

Artists have been drawing wine bottles and bowls of fruit for centuries, as a way of training the eye and the hand. A traditional still life can also be an excellent way to learn how to take a good photograph. Setting up a shot of glassware so that it does not have unwanted reflections can be a challenge. And working out how to photograph a pear to best show its form, or how to light a melon to reveal the texture of its skin, can require more experimentation than you would at first suspect.

Unlike with film, you can learn fast from your mistakes. By constantly reviewing what you have shot—preferably on a computer monitor so that you can really see the detail—you can keep making adjustments to the lighting and the camera settings until you get the effect you desire.

◄ A SPLASH OF WATER
Droplets of summer rain or morning dew can be recreated in a home studio to give fruit, vegetables, and flowers a fresh look. Simply use a hand sprayer filled with water, and set the nozzle to give a fine mist.

► ODD ONE OUT
The plain white kitchen dish, placed on a white background, acts as a natural frame for this arrangement of freshly picked cherry tomatoes. The single tomato without a stalk becomes the focal point for the picture.

Shooting great pictures of everyday objects was once an area of photography that was left to the professionals. But the growth of the Internet has changed all of this. Now everyone wants to take pictures of "things"—so that they can show them to people around the world; even those wanting to sell a single item on eBay need to photograph it well, so it attracts the attention of prospective buyers.

With a digital camera, there is no real need to use sophisticated flash equipment. Simple bulb lighting from a household lamp is fine—the camera's white-balance system will produce accurate colors. With such low-output lighting, however, it is essential to use a tripod. This will allow you to secure the camera in position so it doesn't move while you make small changes to the composition and lighting—and will allow you to use exposures that are seconds long, if necessary, so that you can use small apertures.

▼ STUDY IN BLUE
There is no need to make your setups too elaborate. These two pieces of blue glassware were arranged on a sheet of background paper of a similar color, then photographed with light from a window.

► CAR ON THE COAST
With bigger objects, such as cars, you have little choice but to photograph them outdoors using natural light. However, even away from the studio you can choose backgrounds and foregrounds that work well with the main subject.

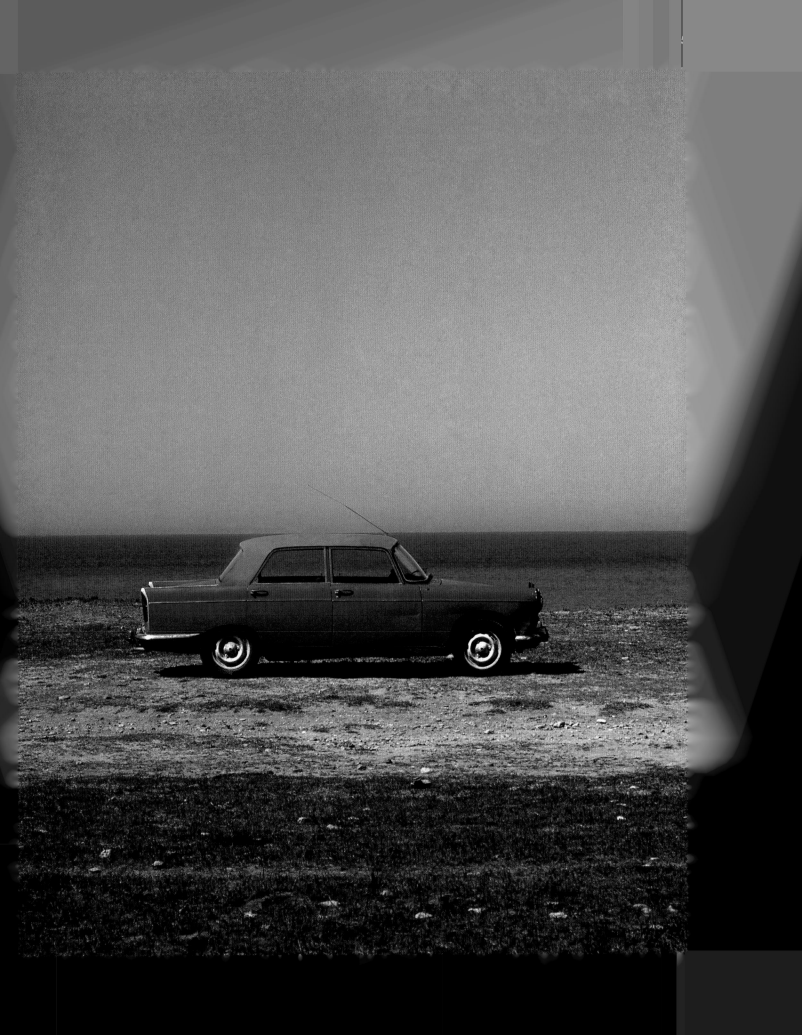

simple setups

ONE OF THE GREAT ATTRACTIONS of still-life photographs is that you do not have to find them or wait for them to happen. You can construct the whole scene yourself, which gives you complete control over the image. It is not just the subject you choose; you can also set it up exactly as you wish and select the surroundings.

Although such still lifes are set up in a studio-like environment, a specially built space is not essential. In fact, because the subjects are generally small and portable, it is often much easier to move them to use a particular wall as a backdrop—or to take advantage of the window that is providing the best lighting at that moment in time. Your "studio" space can be any tabletop or shelf in your home.

On dull days, or after dark, you can still take pictures. A desk lamp can be used to provide the lighting—a strategically-placed sheet of paper will soften its effect. Since shutter speeds may be seconds long, it does pay to use more powerful lights if you can—which will allow you to use slightly shorter shutter speeds and more diffusion.

◄ **BASKET WORK**
Keep a lookout for interesting backdrops to use. A wicker picnic basket creates an interesting surface on which to shoot these ornate pieces of cutlery and a decorative plate. The whole setup was moved to take advantage of light from a window.

► **WHITE WALLS**
A corner of a white room, lit from a window, creates a timeless setting for this shot of old wooden tools. The texture of the walls is more natural than a paper background—but there is not so much detail that it distracts from the interesting shapes and textures of the artifacts.

◄ **BUILDING A SET**
Try to set a scene for your subjects that looks natural and believable. This basket of eggs was arranged to look as if it was in a farmhouse kitchen. A rough wall was used as a backdrop, and a plank of textured wood put into position to use as a shelf. A studio light was placed to the left to simulate light from a window, with a reflector to the right to provide fill-in.

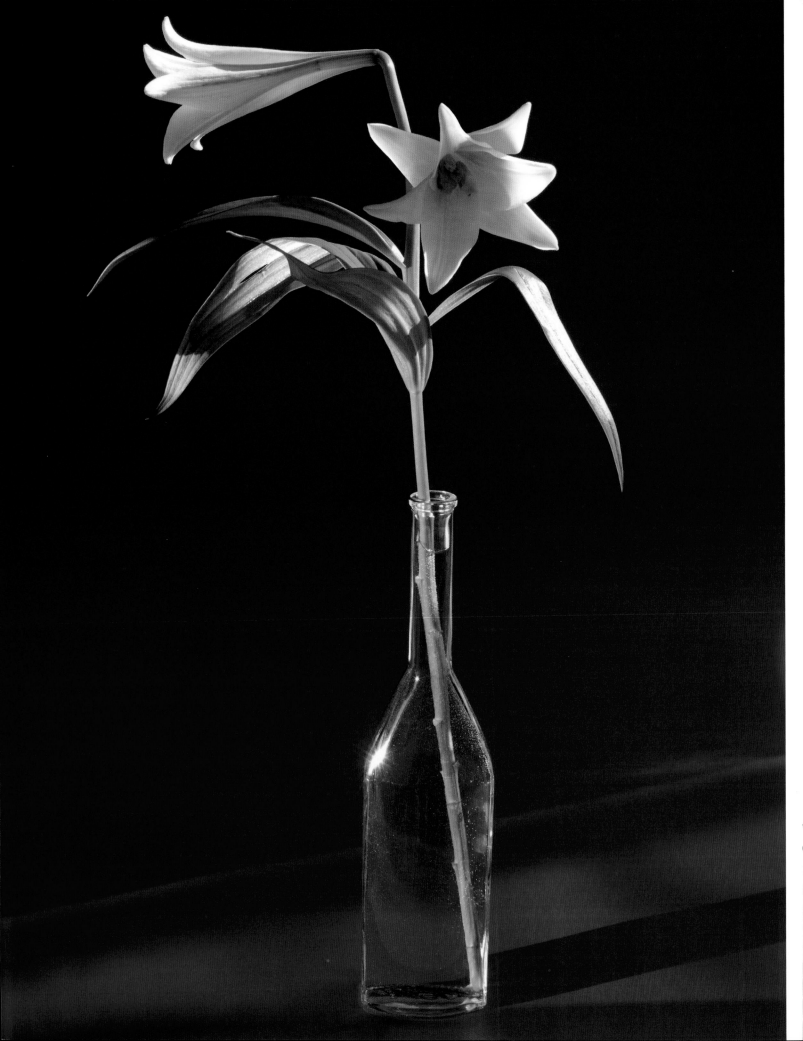

Still-life compositions can be complex, but it is best to build them up slowly. Start off with a background that is plain, or that complements the chosen subject. If photographing a group of things—such as a collection of bottles or a bowl of fruit—begin with small numbers. It is easier to get a successful composition with one, two, or three items, than when using everything you have available. You can then progress to more complex setups—adding an element at a time. The more items you use, the harder it is to get the lighting right—this is when specialty lighting gear comes into its own. Before you begin to shoot, assemble some additional props to try out with your setup.

◄ BLUE COVE
These lilies were shot using a "cove." Made from a piece of material, in this case paper, a cove is curved in such a way that it can form both the foreground and background of the picture, without any seams in the middle.

▼ EXTENSION TUBES
Everyday objects can look intriguing when photographed close up. Here, an "extension tube" was used between the lens and camera, making it possible to focus much closer on the egg than would otherwise have been possible.

▲ SQUARE DEAL
In this shot of a bowl, the background has been constructed to reflect the subject—the large blue square echoing the smaller squares on the antique bowl.

◄ TRUE BLACK
Black backgrounds can often end up looking
disappointing in photographs, because they reflect more
light than you expect, making them appear gray in the
shot. The secret is to use black velvet or velveteen, which
is not reflective—used in this shot of a zucchini flower.

► COLOR AND FORM
A fruit and vegetable market can offer a huge variety
of still life subjects to experiment with—each with their
own form, texture, and color. These pimentos were shot
on a sheet of plexiglass to give a subtle reflection.

◄ TEXTURED SURFACES

Close up, many fruits and vegetables offer amazing textures and patterns—and provide even more options when cut open. Using sidelighting from a diffused desk lamp, the very different textures of both sides of the cabbage leaves can be clearly seen.

PROPS

Still-life photographers build up extensive collections of props, from pieces of weathered wood and slabs of stone, to scraps of textured or patterned fabric. A variety of receptacles, such as bowls and vases, are useful for dressing setups. Here, decorative plates are used to frame small collections of items—creating unusual and interesting images.

abstracts all around

ALTHOUGH YOU WILL SET UP most still life shots yourself, some are unwittingly arranged by others. The ornaments on a mantelpiece, the display in a store window, or tools stacked in a shed—all are still lifes ready to be shot. There are also more abstract alternatives.

A still life doesn't need to be carefully arranged at all. Rather than finding items that have been stacked or set out together, you can simply use the camera itself to create the still-life composition. By using the camera angle and viewpoint creatively, you can get interesting images out of what at first seem to be mundane, everyday objects.

It is simply a matter of seeing things in a new light—and creating a new and unexpected context for the elements that you find. Inevitably this means trying to hunt out interesting pattern, shape, form, or texture in even the least promising settings. If you try to simplify the composition as much as possible, you can end up with an almost abstract image. Ideally, although carefully planned, the finished picture should look almost accidental. The subject is familiar—but the scene has been revealed in an unfamiliar, artistic way.

► ABSTRACT PAINTING
The bigger the road, the more elaborate the road markings become. However, they are designed to be bold and to be seen from a distance. Seen from close up with a wide-angle lens, the thick lines and bright paint at an intersection almost look like the work of a modern-art painter.

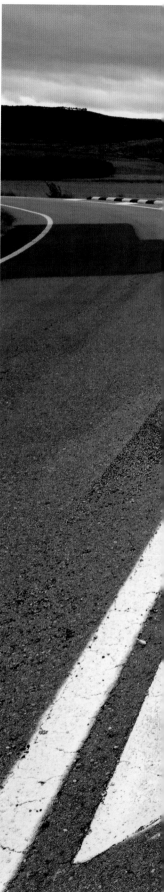

▼ FRAMES WITHIN FRAMES
Propped up in the corner of an empty room in a country mansion, the framed painting becomes a simple shape centered between two doors. It is a deliberately enigmatic picture—which takes advantage of the fact that something has been left out of place in what seems to be a well-kept, orderly household.

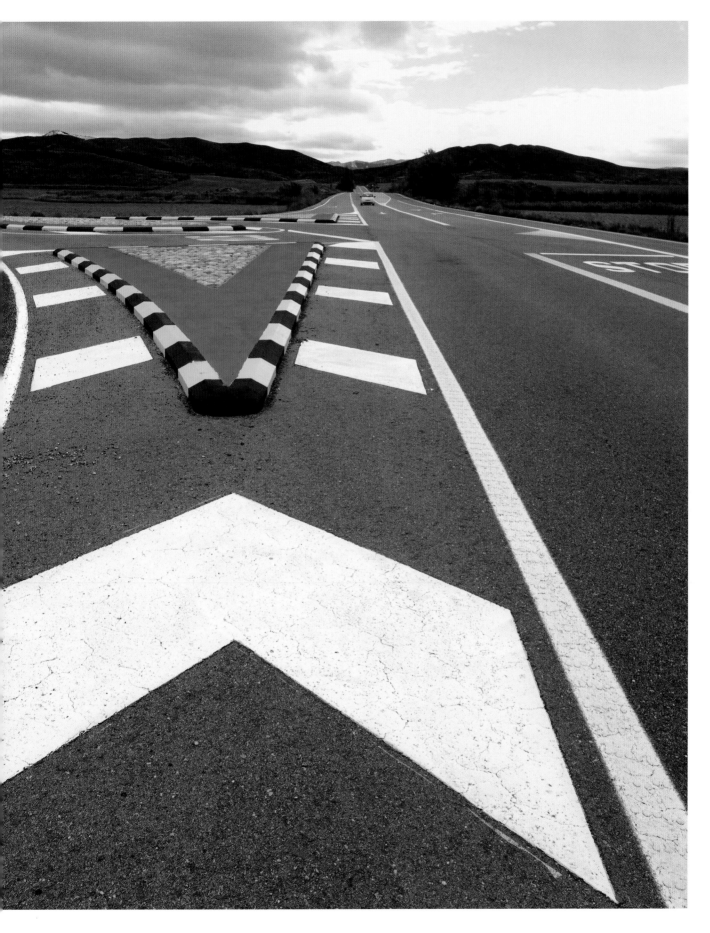

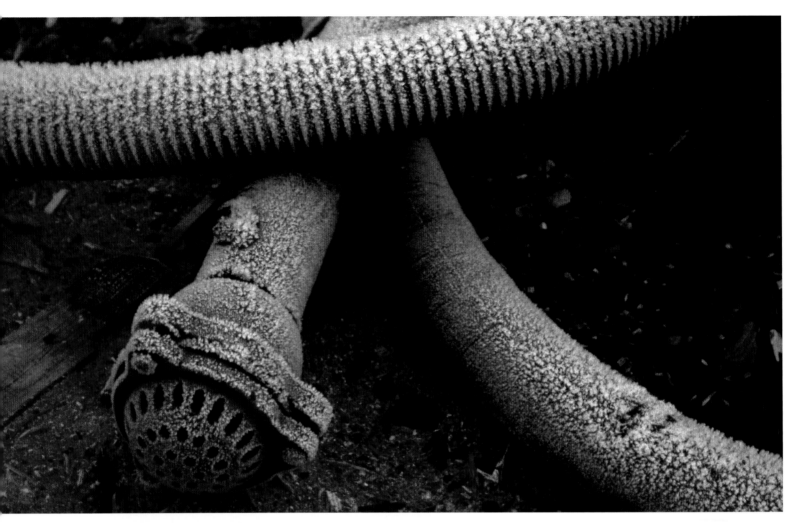

FASHION STYLE

Although the abstract style of
still-life photography is mostly
used with inanimate objects,
the approach can also be
used with human subjects. In
fashion photography, the aim
is always to find a way in
which to show clothes and
accessories in interesting ways.
This nearly always means using
models. In this shot, only the legs
of the model are shown; the
legs, together with the chair,
create strong lines across the
frame. This semi-abstract
approach produces an arresting
image of the red shoes.

▲ TRASH ART
Seen in close-up, even discarded
pieces of piping can appear
interesting. Here, the curved lines
have a snakelike appearance—and
the composition is made more
intriguing by the texture of the
early morning frost.

▶ SEA SIGNAL
This cross-shaped marker makes a
great abstract shape when isolated
against the sky by a telephoto lens
setting. The camera angle has been
deliberately engineered so that
the sign sits on the line created
by the horizon.

ARCHITECTURE

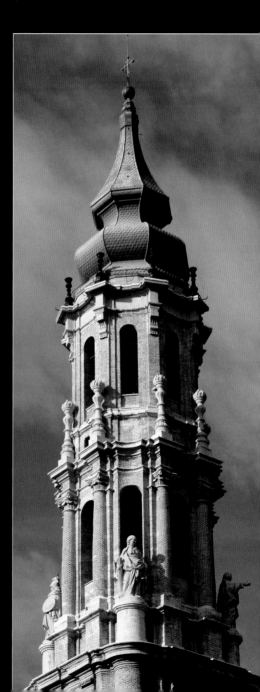

Man-made structures and buildings can provide unique challenges—simply because you have far less control over the picture than you do with some other subjects. You cannot move them into position—and you are forced to make do with the existing light. Your main chance of getting an interesting composition is to change vantage points—but since buildings are so often in built-up areas, the number of places you can choose to stand or place a tripod is severely limited.

Architectural photography frequently means that normal wide-angle lenses are not sufficient to fit the whole structure into the frame. Not only are buildings big, but you frequently have to stand relatively close to them. This means that wide-angle converters or super-wide-angle lenses are useful—and for interiors, even essential.

Using a wide-angle lens in these circumstances does have disadvantages. Because you are forced to tilt the camera upward, vertical lines that should appear parallel seem to converge. The effect can, on occasion, be dramatic, but it is not always welcome. It is possible to correct this optical distortion on a computer (see page 225). However, you can minimize the problem at the shooting stage—stand farther back if possible, to reduce how much the camera needs to be tilted. Alternatively, find a higher vantage point facing the building you want to photograph.

◄ **REACH FOR THE SKY**
The converging vertical lines created by a close vantage point and a wide-angle lens seem to suit the architectural style of this modern office block.

► **LESS TILT**
A more distant vantage point and a longer zoom setting ensure that verticals do not appear to converge unduly in this shot of an ornate church spire in Zaragoza, Spain.

Although there are no rules, the style of architecture inevitably influences the photographic style that is more likely to work most successfully. Classical styles use strong forms that suit being photographed in sunlight, from an angle that provides a compromise between the detail of frontal lighting and the shading of sidelighting. Older architecture is also full of interesting elements that can easily be picked out with a telephoto lens. Modern architecture uses glass and steel to make huge blocklike structures—which provide a good basis for abstract shots showing pattern.

▼ BLEAK HOUSE
Buildings don't need to be beautiful to make a good shot. This abandoned farmhouse is typical of those found in Ireland. The drab lighting adds to the bleakness, and the buoy in the foreground gives a touch of mystery to the scene.

► ROOM WITH A VIEW
To show the whole interior demands a wide lens—an effective focal length of 16–21 mm is highly desirable. But if you show just a detail, as in this shot of a Spanish courtyard, such a wide angle of view is not necessary.

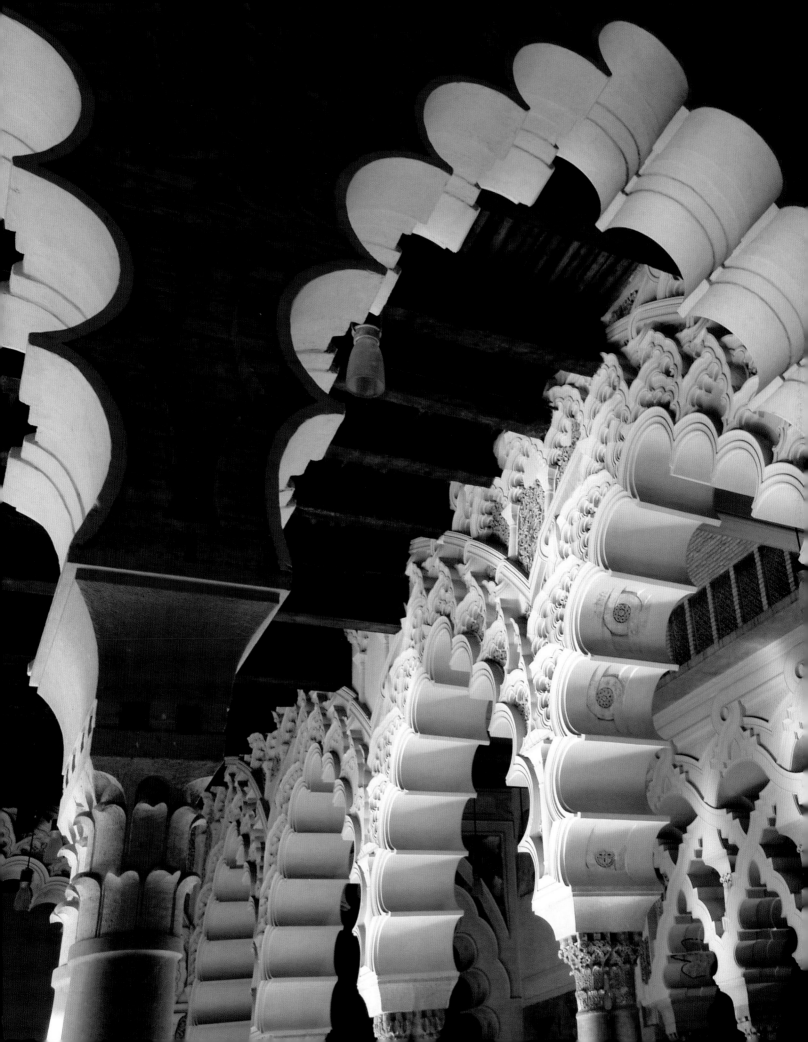

gallery of doors

TAKING PICTURES OF BUILDINGS is not just about using super-wide-angle lenses in order to fit the whole structure or room into a single frame. There is plenty for the long lens to shoot from close up, too. Often the detailing in architecture can be as fascinating as the whole.

Rather than shooting solitary details, however, it can be even more rewarding to shoot a series of similar close-ups. You could shoot a portfolio of the gargoyles of an old cathedral, or a series of shots capturing hand-painted pub signs, for example—choose any feature that you find inspiring.

On these pages, you can see pictures of wooden doors shot during a stay in a German town—each showing very different patterns. Such a series can be assembled together on the computer to make a decorative mosaic, like the ones often used for picture postcards and posters.

buildings in their surroundings

LOCATION, LOCATION, LOCATION... As Conrad Hilton, founder of the Hilton chain of hotels, observed, a building's setting can be more critical than its design—and this is as true for a photographer as a property developer. Close-cropped shots don't always make the best image. A building's character may be better revealed by a wide framing that shows its surroundings.

Composing the shot to include more of the foreground and background provides valuable contextual information—it shows you the neighborhood or landscape in which the structure sits. This approach also lets you incorporate other elements into the image to create a stronger composition. The amount of sky included, for instance, can help create atmosphere—with dark clouds creating a dramatic picture, and blue skies giving a more romantic interpretation. A foreground detail can also be a valuable way of adding color, or a sense of scale, to what is otherwise a simple geometric structure. This looser style of composition was used to photograph these buildings in Ireland.

▲ RIVER SETTING
Rather than zooming in close to the neoclassical columns and dome of the Four Courts building in Dublin, a wider shot allows us to see the position of the courthouse on the banks of the Liffey River.

► SECLUDED SPOT
This grandiose gothic building is actually a Benedictine abbey. The vantage point allows you to see its isolated setting, nestling between the waters of Lough Kylemore and the Connemara Mountains.

USING PERSPECTIVE

The size and prominence of foreground elements can be controlled by getting closer to or farther away from them, and by using the zoom to accentuate linear perspective. These three shots are of Lissadell House in County Sligo. Getting the camera closer to the steps increases the prominence that they have in the picture. Using the lens to make the verticals of the house converge away from the steps has a similar effect.

An advantage of including more of the context when photographing architecture is that it allows you to create different images of a building. Even when shooting the most famous castles, cathedrals, and skyscrapers in the world, clever use of surroundings can create a unique image. A market stand, a passing cab, a clump of wild flowers—all can be pressed into service to provide an eye-catching foreground. Such additional elements work best if they don't just add visual interest, but say something about the location.

You can also use loose framing as a way of playing down the significance of the building itself—to create a more abstract interpretation. This works particularly well if the building is isolated. A wide-angle lens used from a distance allows you to accentuate the space around it. Even in crowded cities, this approach can be used simply by getting down low and using the sky to fill more of the frame.

◄ DOT ON THE LANDSCAPE
Sometimes the setting is more interesting than the building. This house is small and plain, but it is the spectacularly craggy terrain surrounding it that makes the picture.

▲ GIVE US A CLUE
A careful choice of foreground can help tell you more about the building and its location. Here, the watery environment and the reeds help to suggest that this particular windmill is on the Norfolk Broads in England—an area where reeds are traditionally grown for use in thatched roofing.

◄ ROMANTIC STYLE
Foreground can help set the style and mood for a picture. This is a shot of the German town of Lübeck. The river and trees create an idyllic pastoral scene. Taken from another viewpoint, trucks and litter could have been the setting for the church, and would have resulted in a very different picture.

night lights in the city

BECAUSE MANY LANDMARK BUILDINGS are floodlit, you can keep photographing them after dark. Nighttime shots create strong architectural images that look significantly different from those taken in daylight—and they can make a success of dull photography days.

The best time to photograph nightscapes is just after dark—so that there is still some color in the sky, and the outlines of the buildings are still clear. A tripod or a solid platform to rest the camera on is essential—and to avoid camera shake, the shutter should be fired with a remote release or using the self-timer function. It is likely that you will be using shutter speeds that are seconds long—the longer the better if you want to blur the lights of moving cars. Keep an eye out for neon signs, since different tubes tend to be turned on in sequence—these are also best tackled with a long exposure to get the full effect.

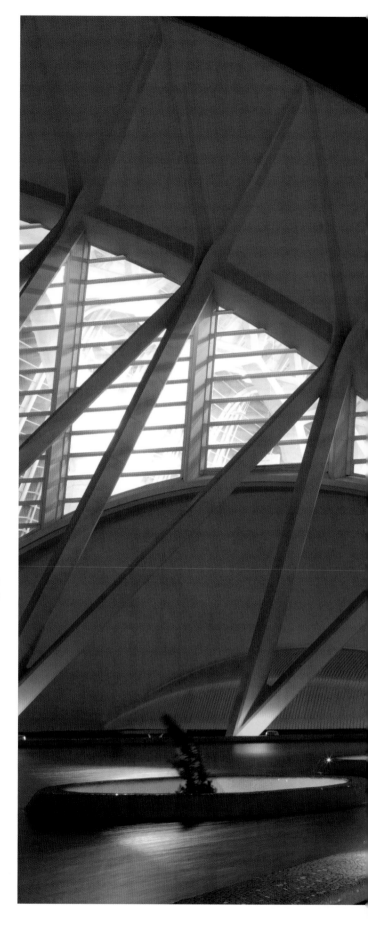

◄ STOP AND GO
All the lights of this traffic light appear to be on together in this unusual shot of Big Ben in London, England. The illusion is created by the 20-second exposure used for the shot. When using shutter speeds that are this long, you will find that the camera takes more time to process the data than usual—creating a noticeable delay before you can take further exposures.

► NIGHT VISION
As with many modern buildings, the science museum in Valencia, Spain, was specifically designed to look as impressive at night as it is in the daytime. A small aperture of f/22 was used, which has had the effect of turning the streetlights in the distance into miniature stars.

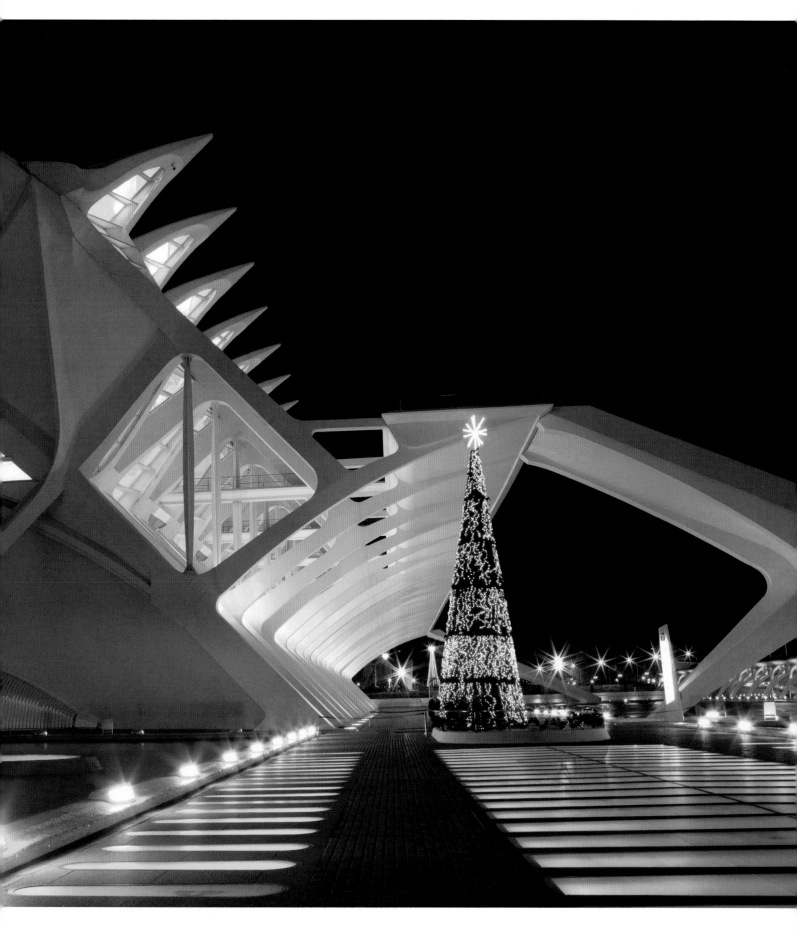

abstracts and patterns

ZOOMING IN on just a small part of a building is not simply a useful technique for isolating particular architectural features. It can also be a way of producing intriguing, abstract images.

Although a selected view can be chosen to pick out the patterns that are found within any building, this approach is particularly suited to shooting modern architecture. The less formal design of new buildings means that close-ups are often more interesting than seeing the whole elevation. Repeating elements are a particularly striking feature of modern glass and steel structures—and the reflections these materials create provide yet more opportunities for original compositions. By zooming in on simple geometric designs, you will find countless picture possibilities in a single building.

However, don't restrict your use of this technique to modern architecture: it can work well with any building—particularly those that are usually easily recognized. A telephoto shot can tease—challenging the viewer to think about whether they can identify the structure or not. There is also often a compositional advantage for showing less of the building. A close-up not only simplifies the scene, but allows you to cut out wires, burglar alarms, signs, parked cars, and crowds of tourists that would otherwise get in the way of the picture.

◄ CROOKED HOUSE
Close-ups can reveal interesting features of the construction. The clapboards of this hut seem to have been nailed on in a random pattern, creating a rippling texture that is picked out by the sidelighting.

▼ LEANING LINES
A telephoto lens setting is not always needed. This shot of a modern building was taken using a wide zoom setting. The close vantage point strengthens the angles of the diagonal lines of the structure and the shadows.

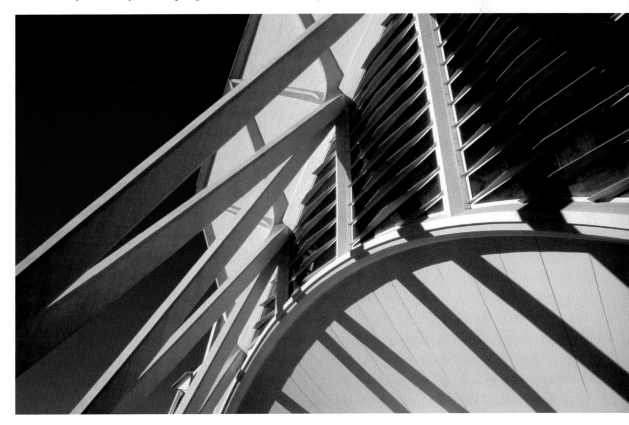

A selective or abstract approach to architectural photography can also provide a neat solution to the problem with lighting. Often you end up visiting a place at what turns out to be the wrong time of day. The building you would like to shoot is in deep shadow, or the scene presents too much contrast to get a successful shot, or the background sky is too drab—so you come away empty-handed. Instead of restricting yourself to photographing only at sites where the light is right, or making do with uninspiring, poorly lit shots, take some time to look for selective abstracts. This way you will greatly increase the number of successful pictures you take—since only part of the building needs to be well lit.

▶ BOLD BUTTRESSES
Even the simplest of compositions can create an interesting shot. Four white buttresses soar across the frame, creating an abstract that disguises the location. A more general view of the building would be difficult in the high-contrast lighting of the midday sun.

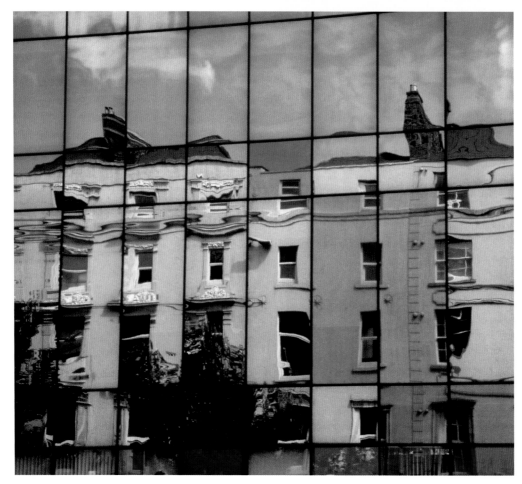

◀ OLD AND NEW
The vast glass facades of modern office buildings can not only be used to create close-up patterns; their reflective surfaces can produce a mosaic image of the neighboring buildings. The indirect view creates a semi-abstract study. In this shot, the approach has been used to juxtapose the architectural style of the old town houses with a modern monolithic tower. Ponds, rivers, or puddles will also provide distorted reflections of surrounding buildings.

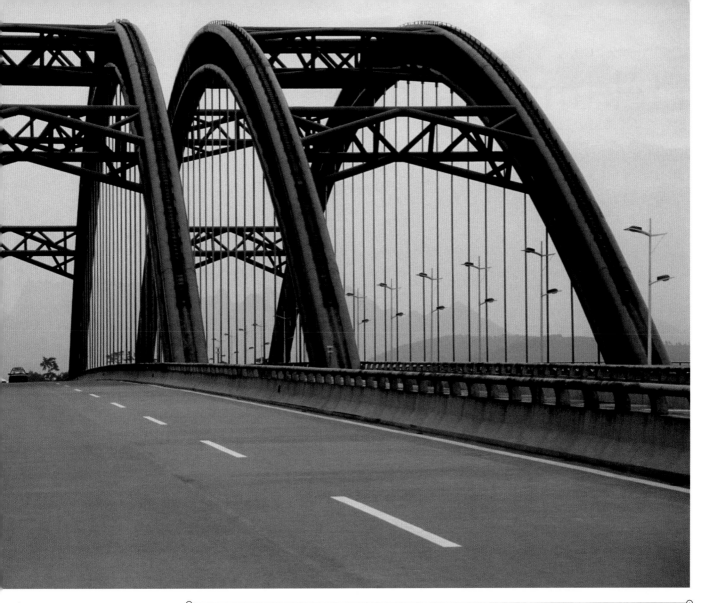

▲ CURVES OF STEEL

It is the contrast between the straight lines of the road and the parabolic curves of the steel bridge that create the visual excitement in this picture. Although the subject matter is clear to see, the shot still has an abstract quality to it.

STRETCH WORK

Converging verticals are almost inevitable when shooting big buildings. However, you can correct these using image manipulation. Stretch the image from the corners until the lines are straightened and run parallel with the sides of the frame. Superimposing a grid over the image as you do this ensures precision. A drawback is that the image then needs to be cropped to create a rectangular shot—so there is a danger that key parts of the composition will be lost. Ideally, you should plan for the computer correction when you compose the shot, and leave extra space around the building to allow for cropping.

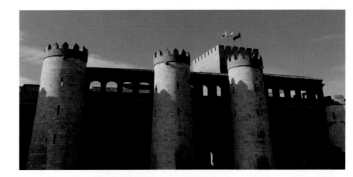

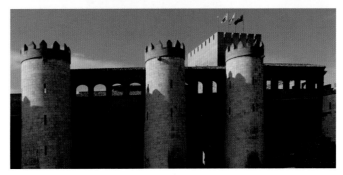

tackling interiors

WHETHER YOU ARE SHOOTING in the grand interior of a large cathedral or your own living room, you need to overcome two key problems. The first is getting a wide enough angle of view; the other is ensuring that there is adequate lighting across the scene.

While super-wide-angle lenses are useful for exteriors, they are essential for shots of most rooms because the number of possible vantage points is so restricted. Fortunately, such lenses are now available without great expense for all popular digital SLRs. "Fisheye" wide-angle converters can be attached to the built-in lenses of many compact cameras.

Lighting is more difficult. Low light levels are not a problem since slow shutter speeds or high ISO settings can be used. The difficulty is the high contrast—with window areas appearing very bright, and shadows appearing very dark. Artificial lighting can be used, but it is hard to achieve even illumination. Choosing the right time of day or weather conditions, therefore, is crucial.

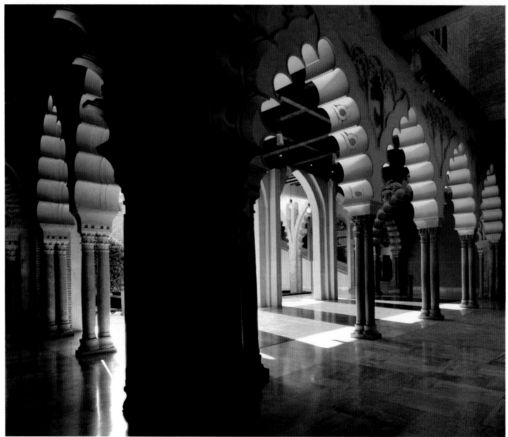

▲ SENSE OF SCALE
The woman gives scale and a focal point to this super-wide-angle interior shot. With such lenses, it is important to keep the camera completely upright to avoid excessive image distortion.

◄ LIGHT AND SHADE
Although high contrast can be a disadvantage, here the afternoon sun creates interesting pools of color across the scene, while the elaborate curves of the Moorish arches are also picked out by the light.

► LONG EXPOSURE
This modern gallery is designed to provide diffuse natural light for its exhibits. However, a tripod and shutter speed lasting two seconds were needed to provide the image with lots of depth of field and blur the gallery visitors.

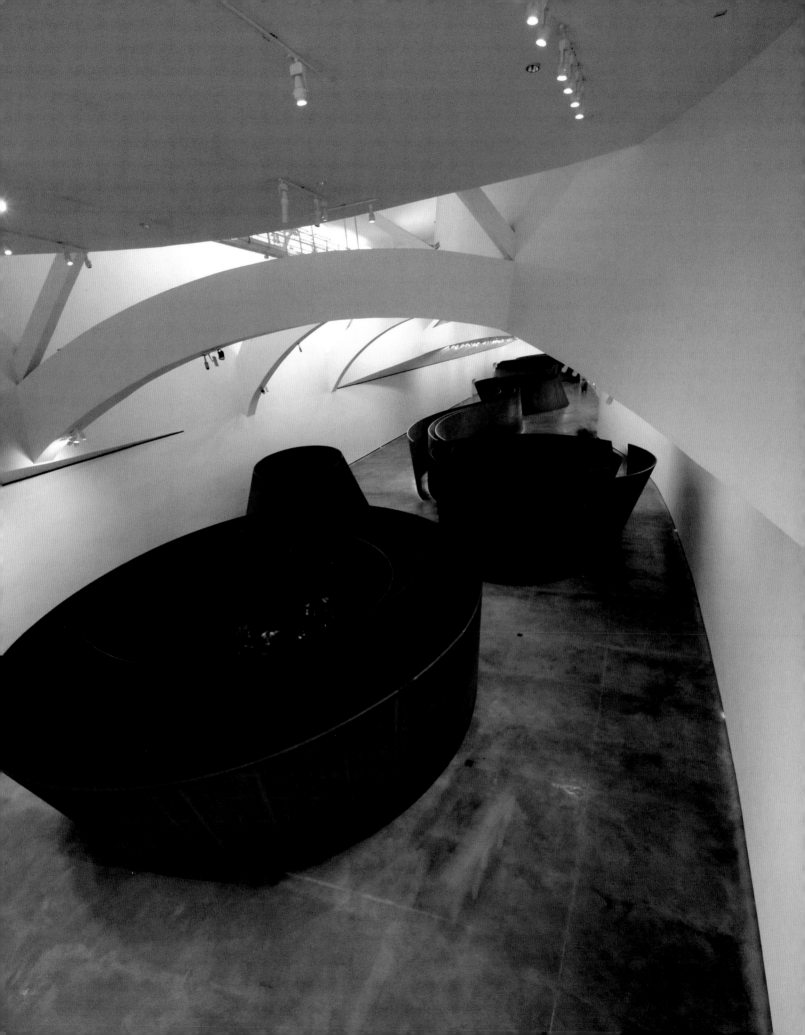

LANDSCAPES

You may not be able to move mountains, but it is wrong to think of landscapes as being static photographic subjects. Much of their appeal comes from the fact that the scenery around us is constantly changing—from moment to moment, and from season to season. But as well as the changes in lighting, weather, and vegetation, there is often also movement within the frame that restricts the free choice with shutter settings that you would have with still-life photography, for example. Branches swaying in the wind, birds passing overhead, and rolling clouds mean that you must be aware that different shutter speeds may have different effects.

Wide-angle lenses are inextricably linked with landscape photography. The wide-open spaces make it seem that short focal length lens settings are the perfect choice. This is only partially true. Unlike with architectural photography, where you are hemmed in by nearby buildings, landscape offers a far freer choice of camera position. You can choose to stand close to a particular geographical element in a scene—or to stand far away from it. This means that even very long telephoto lenses can be used successfully. These allow you to pick out distant details, such as a tree in the middle of a field. In addition, the way they make subject elements at different distances seem much closer to each other than they actually are can have enormous compositional potential.

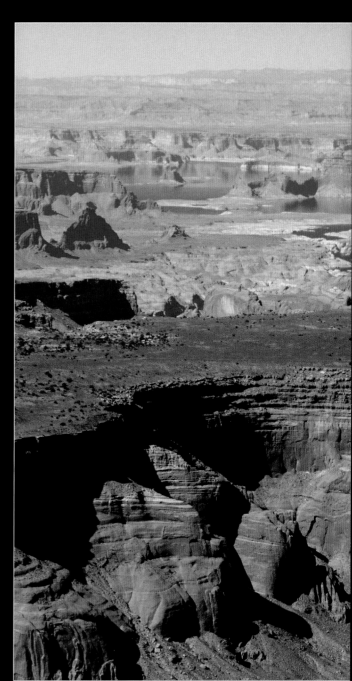

◄ LOW HORIZON
Where the horizon falls in the frame depends on the scene. Here, the dark clouds and warm glow of the sun are the main subject, so the sky occupies most of the frame.

► HIGH HORIZON
This aerial shot has been composed to give the viewer an idea of just how wide America's Grand Canyon is—so only a very small strip of sky is included in the frame.

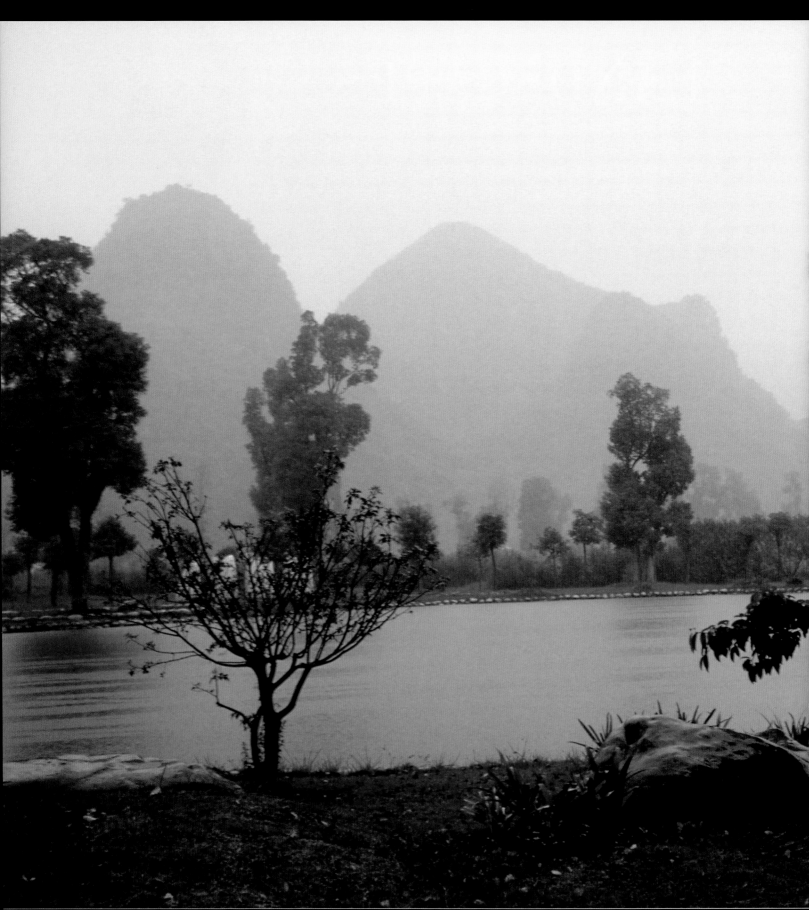

Wide-angle lenses come into their own for creating a feeling of depth in a landscape, but to use them successfully, you have to think about the composition carefully. To give a strong feeling of distance, you need to find foreground interest to contrast with the large-scale scenery that is found toward the horizon. Small changes in viewpoint can make all the difference. A flower at your feet, an overhanging branch, or an interesting boulder can fill what would otherwise be an empty space in the foreground—and provide a focal point that helps create a strong three-dimensional feeling. Inevitably, this means that low camera angles are common. For this reason, landscape photographers often favor tripods that allow all three legs to be angled independently, and can be splayed and adjusted to offer a much lower camera angle than most conventional supports. Such accessories can ensure that you have a free choice of aperture, whatever the time of day or weather conditions you are shooting in—giving you complete control over depth of field.

Despite the importance of camera position, the secret to great landscape photography is patience. It is lighting that transforms a landscape snap into a winning shot. You can maximize your chances of success by analyzing the weather reports, or by getting up early to take advantage of the fast-changing early hours of sunlight. But however well you plan your outing, there can still be a lot of waiting around if you want to be in position for the perfect shot.

◄ SETTING THE MOOD
The majority of landscape pictures offer a romantic view of the scenery, using perfect weather conditions to create a photogenic picture. But poor weather can create a more moody and dramatic view of the land—as in this misty, low-light shot of a lake in China.

▲ FALL IN CUMBRIA
Although the trees haven't yet lost all their leaves, the bracken on the lower fells has turned a warm golden brown, making it an excellent time to photograph England's Lake District. A sunny, windless day offers the added attraction of near-perfect reflections on the water—adding to the color and the feeling of tranquillity.

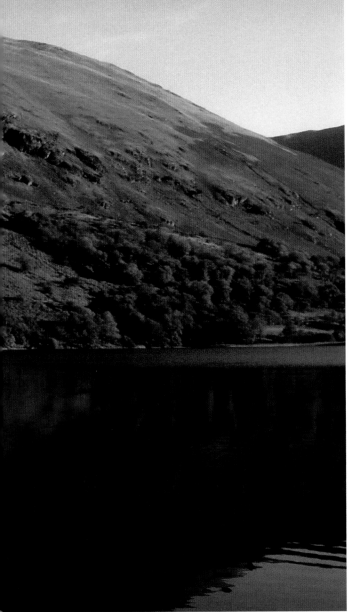

capturing the seasons

THE TIME OF YEAR has a significant effect on the appearance of most landscapes. The alterations in the lighting (see pages 144–47) are important to the photographer, and these bring with them a cycle of changes to the meteorological conditions and plant life that also affect your pictures.

All landscapes change with the seasons, and some are at their most spectacular at a particular time of year. Mountain ranges, for instance, often look at their best in early winter—when there is the first sprinkling of snow on the peaks, but there is still some color left in the dying vegetation. An alpine meadow, meanwhile, is at its most colorful at the height of summer when its wild flowers are in full bloom—but will be completely transformed during the snowboarding season.

Although different conditions are often assigned to a whole season, they are often much more short-lived than you might assume. The deciduous forests of New England are world-famous for looking at their best in fall, when the maple leaves turn their various shades of orange, yellow, and red. However, the peak conditions in a particular area may only last a few days, before the riot of color is decimated by a rainstorm.

◄ WINTER IN SCOTLAND
The sculptural lines of the long grass next to this Scottish loch create strong foreground interest. The early morning frost adds to the wintry feeling, already suggested by the snow on the peaks above the castle.

► SUMMER IN ITALY
Colorful wild flowers surrounding ancient olive trees are a common sight in summer in the Mediterranean. These blooms are short-lived, and you have to be in the right place at the right time to capture a shot like this.

Each season has its own treasures to seek out. Spring is a time of rapid change to the scenery. The lengthening days bring a succession of different plants and trees back to life. Wildflowers carpet deciduous forests, shoots emerge from the soil, and tree blossoms bring a blush of color to both parks and orchards that looks almost surreal.

Many plants and flowers, both wild and cultivated, produce their best in the long days of summer. Natural displays, particularly the flowers of the North American prairies or British meadows, are at their most colorful during summer. Public parks are planted with richly colored tapestries of bedding plants, and private gardens are at their peak. Meanwhile, fields of golden ripening corn, sunflowers, or fluffy white cotton can result in a patchwork of colors across agricultural landscapes.

Fall sees many plants beginning to die off or prepare for dormancy. Some do this discreetly—others do it with a spectacular swan song. The fiery tones of deciduous trees in parks and ancient woods are often the major attraction—but the browning of the bracken on moorland can also appealingly transform the landscape.

Winter is not just about frost and snow (see page 158). The subdued color of the landscape can be somber, but the lack of leaves on deciduous trees offers new vantage points, revealing panoramas that are hidden during the rest of the year.

▼ WINTER IN ENGLAND
The sculptural shapes of the leafless trees are emphasized by a layer of snow—creating an almost monochrome image in the low light.

► FALL IN SPAIN
This municipal garden has been designed for all seasons. The planting and hard landscaping lead your eye along the borders.

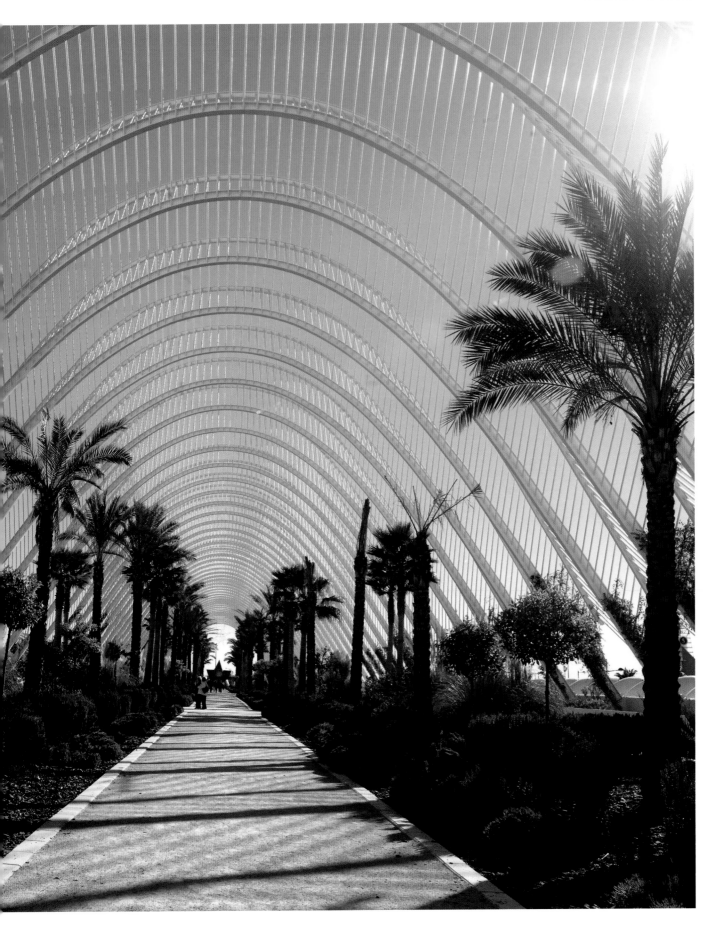

skyscapes

ALTHOUGH LANDSCAPE SHOTS are by definition about capturing the scenery, nearly all also contain a certain amount of sky. The sky can often provide that crucial element that turns a mundane shot into a great one. The red and yellow hues of a sunset can provide a magical touch that transforms even everyday views into captivating ones. The pattern of clouds can often produce strong visual interest.

One of the key compositional decisions that has to be made when shooting a landscape is where to place the horizon. The line where the sky ends and the land begins is an important focal point in any outdoor picture, but this is particularly the case with landscapes. Right away, it divides the image into two distinct areas. But it can be successfully placed at any point in the frame—or can even be left out entirely.

Conventional picture composition would suggest that you place the horizon so that the sky occupies the top third of the picture (see page 109). But if the sky is more interesting than the land, it can take up much more of the frame—how much depends on how radical you want to be.

▼ THREE QUARTERS SKY
In this sunset shot it is the colorful shapes of the clouds and the orange-toned sky that make the picture, so the horizon has been placed to give these emphasis.

► EXPOSED TO THE ELEMENTS
Two windswept trees stand isolated on the moors. This silhouette shot is composed so that the sky fills most of the frame to create a dramatic visual effect.

One disadvantage of including more sky is that it becomes harder to get a balanced exposure. The land is often silhouetted, although detail can be restored, if desired, on the computer. Alternatively, a graduated filter can be effective. This square filter is placed over the camera lens and then shifted within its frame, so the masking matches the horizon line. This allows more exposure at the bottom of the image than the top. Although sold in all hues, a gray "grad" is ideal, since this simply reduces contrast, and color can then be easily added later in postproduction.

◀ REFLECTIONS
Because water mirrors the color of the sky, you can leave the horizon high in the frame in seascapes and still fill the composition with the orange tones of the setting sun. The land is left silhouetted.

▶ LONE COTTAGE
To avoid ending up with a silhouette, a graduated gray filter was used to balance the brightness in this shot of a French house used by Breton oyster farmers. The dramatic lighting makes the shot.

▲ AFTERBURN
Sunsets frequently look at their most glorious after the sun itself has just disappeared over the horizon. The resulting reduction in contrast in the sky means that colors appear richer and more saturated.

panoramas

WIDE PANORAMIC VISTAS can easily be fitted into the fixed rectangular frame provided by a digital camera. The difficulty is that a wide-angle lens extends the field of view in the vertical as well as the horizontal direction. Including lots of sky or foreground is one answer—but the main subject may simply get lost in the frame.

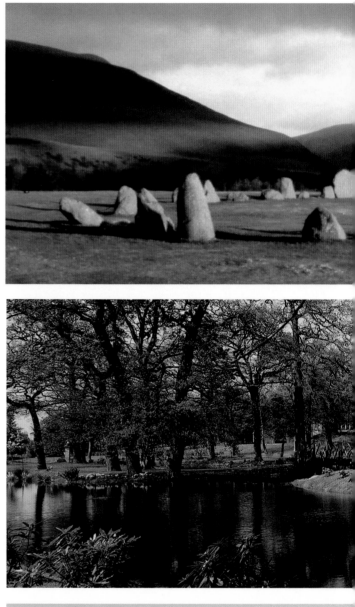

A straightforward solution is simply to crop the image, losing areas that are unnecessary to show the spectacular view. This is easy enough to do using a "scissors tool" in image manipulation software (see pages 96–99). However, because a typical panoramic image is three or more times wider than it is tall, this means losing at least half of the original picture area. Even if you shoot at your camera's maximum resolution settings, this may not leave you with enough pixels to make a decent-sized enlargement. The best way to create a panoramic picture is to take a series of shots of one section of the view at a time, then "stitch" them together on the computer to make a seamless whole. As a result, you get a picture with far more pixels, and more detail, than your camera could capture with a single shot. You can also shoot a far greater angle of view than any lens could provide—the technique can even be used to create a 360° view. Use a non-wide zoom setting, or standard lens, to avoid distortion, and ensure that each frame in the sequence overlaps the last by about one third. A tripod with a panning head will help keep the horizon at the same level, but is not essential.

STITCH UP

Once the frames in the panoramic sequence have been shot, stitching them together on a computer is relatively straightforward. Programs such as Photoshop and Photoshop Elements offer facilities that will merge selected files automatically, and low-cost software designed specially for photo-stitching is also available. Although these applications will usually put the pictures in the right place (below), you will need to do some manual retouching work to completely hide the seams. The resulting panorama (right) will also need to be cropped to straighten the edges.

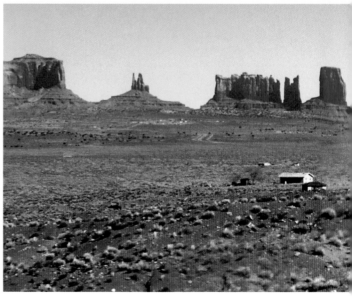

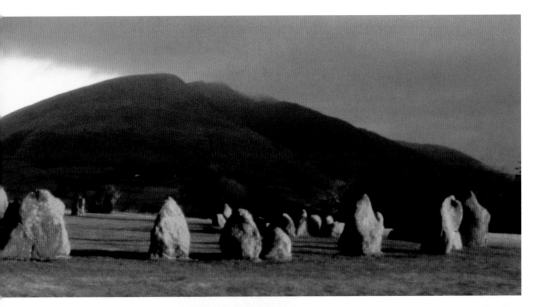

◄ PERFECT CIRCLE

A patient wait was rewarded with a splash of warm, late afternoon sun illuminating this ancient circle of stones near Keswick in the English Lake District. An uncropped single picture would have included too much grass in the foreground, and too much gray cloud, diluting the impact of the perfect light.

◄ HORIZONTAL VIEW

The panoramic format doesn't just work for the obvious breathtaking views over the countryside or a city. Here the letterbox format helps to simplify the composition so that it can focus solely on this grand lake in a country garden.

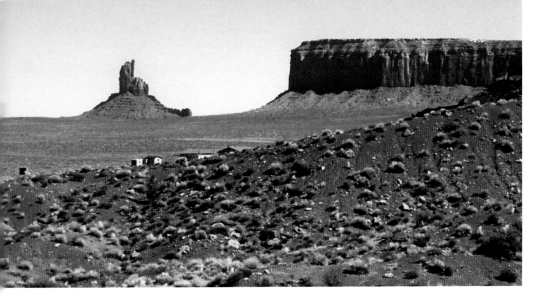

◄ INTO THE VALLEY

The photo-stitching technique comes into its own with wide open spaces. This composite shot of Monument Valley, Arizona, is made up from four different shots, taken in quick succession. Each overlaps the other, to help ensure that the different sections blend together successfully.

monochromatic moods

THERE ARE MANY DIFFERENT TYPES of landscape photography—but two styles dominate the genre. First, there is the romantic view that aims to capture bucolic scenes, in great lighting, with strong colors, looking at their most idyllic. The other style is dramatic, and creates a moodier, more somber view of the scenery by deliberately restricting colors.

This monochromatic approach can simply mean creating an image that is black and white. Shots taken on overcast days suit this particularly well, since the clouds can be made to look dark and dramatic if shot first in color and converted to black and white in postproduction (see pages 62–65). This technique can rescue shots taken in uninspiring, dull light.

But the approach can be applied more subtly if you keep the pictures in color. By using a carefully thought-out viewpoint and avoiding direct lighting conditions, a landscape image can be constructed using only gentle blues or greens. Such a restricted palette (see pages 48–57) can create a restfulness and harmony that often suits the natural subject matter.

▼ WINDING ROAD
An overcast day mutes the greens of the fencerow and surrounding countryside. **This creates a low-contrast background and attracts the eye immediately to the snaking route of the light-toned tracks.**

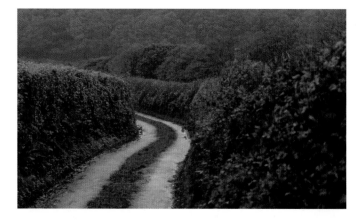

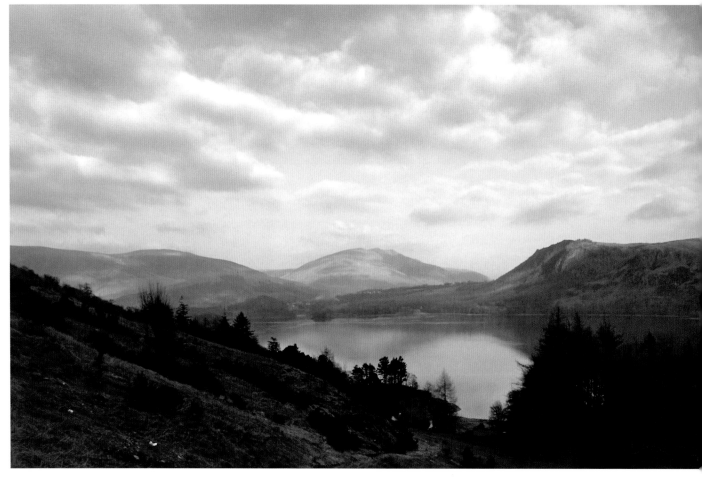

► BLUE RINSE
Shot late in the day, most of this scene is lit indirectly by light reflecting off the sky. This gives a characteristic blue cast. The only highlights are provided by the setting sun catching the low clouds.

▼ BEST IN BLACK
This mountainscape was shot in less-than-perfect light for color photography. However, by converting it to black and white on the computer, a more successful image was created. The depth of tone was controlled so that the hills retain some detail, and the sky is as dark and threatening as possible.

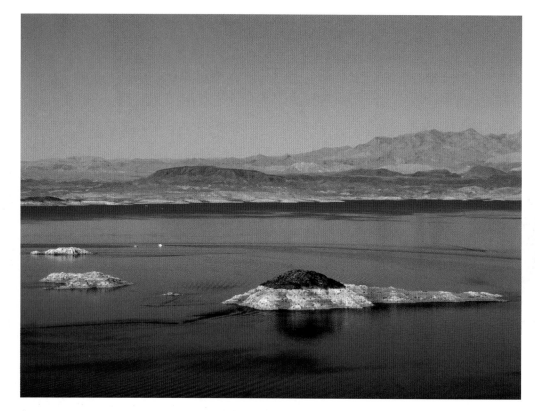

▲ WATERY ISLES

The all-blue panoramic view over Lake Mead, Arizona, is broken only by the green of small islands that poke their heads above the water surface when the level of the reservoir gets low.

▼ SEEING RED

This view of the Grand Canyon was taken from a sightseeing plane. The ancient river valley has a monochrome reddish hue, and the variations in tone reveal the strange texture of the landscape.

► PLAN VIEW

Here, a network of streets in the suburbs of Las Vegas is seen from an aerial viewpoint. By converting the image to black and white, the organic, veinlike pattern of roads is made more obvious.

parks and gardens

MANY OF US THINK OF GARDENS as being just about plants. But although you can concentrate on photographing close-ups of the flowers (see pages 254–57), gardens are deliberately designed to form a series of stunning scenes, full of interest on a much larger scale.

Great gardens and public parks are painstakingly planned so that every corner you turn offers something new to look at. And because gardens should retain some pleasing aspects whatever the season, much of the visual interest comes from the hard landscaping rather than the planting. It is the statues, ponds, fountains, bridges, patios, paths, and gazebos that form the backbone of a great garden.

These features should also be used to create the focal points for your pictures. Don't try to fit everything in—choose a single feature and build up a composition around it. Use steps to lead the eye, for instance, or make a fountain the main focus of your shot. You will often find that some of the best pictures are those that do not include a riot of color, but show the beauty of the garden with a more restricted palette.

MOVING WATER

Water is a vital ingredient in garden design. It adds sound, attracts wildlife, gives a home to different plants, and provides reflections. But moving water is difficult to photograph. It is tempting to shoot fountains and waterfalls with a fast shutter speed to freeze the movement—but if you do so, the water flow often looks insubstantial. It is better to use a slow shutter speed, with a tripod, to create some blur. A fountain needs a shutter speed of 1/15 sec or slower. A stream bubbling over boulders may need a shutter speed of 20 seconds or more.

► WATERFALLS
The intensity of a natural waterfall will vary—usually it is at its most impressive when the stream or river is in flood. Manmade waterfalls are more predictable, but in either case, the impression of moving water is helped by using a slow shutter speed. Here, an exposure of 1/8 sec was used.

◄ GREENERY
Simple color combinations often work best when framing garden pictures. This all-green shot of Longwood Gardens, near Philadelphia, could hardly be more harmonious. This ensures that the picture concentrates on the elaborate forms of the topiary.

► WATER FEATURE

Look out for details as well as general views when shooting gardens. This close-up is of a carved head that feeds water into the rectangular ponds at Château de Courances, France.

► LEADING THE EYE

Just as with other forms of landscape photography, look for lines that give a strong feeling of perspective and depth. This tranquil courtyard in the Generalife gardens in Granada, Spain, is framed symmetrically to make the most of the converging lines created by the flower borders and long pond.

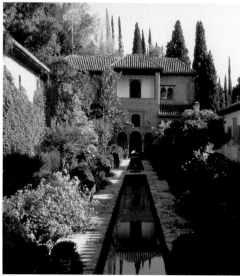

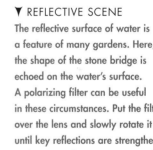

◄ OUTSTANDING FEATURE
This garden has obviously been constructed around this spectacular tree. Using the diagonal lines of the hedges as visual pointers, the tree creates an impressive focal point for the camera.

▼ REFLECTIVE SCENE
The reflective surface of water is a feature of many gardens. Here, the shape of the stone bridge is echoed on the water's surface. A polarizing filter can be useful in these circumstances. Put the filter over the lens and slowly rotate it until key reflections are strengthened and unwanted ones are removed.

◄ SEEDS OF TIME

Plants don't need to be exotic, or even in flower, to make interesting pictures. A dandelion is a common weed in many countries, and a pernicious problem to many gardeners. However, its seedhead creates a great close-up study. Soft, almost shadowless, light helps to reveal its complex structure and delicate outer texture.

► BUTTERFLY HEAVEN

Local knowledge and an understanding of animal behavior will greatly increase your success rate. When in full bloom, sedum plants become a magnet for a number of different species of butterflies. If you wait in the right place, it doesn't take long to get a picture. Here, four small tortoiseshell butterflies are feeding on the pink flowers.

NATURE

Nature photography can prove to be one of the most challenging of all photographic subjects. Success is not just a matter of having the right equipment and the right lighting. You also have to hunt out the subject, and often, especially where animals are concerned, wait until the subject moves into a pleasing position in good light.

In truth, finding the ideal opportunities is as much about luck and patience as it is about specialist knowledge. However, being in the right place at the right time means doing your homework—or relying on the expertise of others. For example, the local knowledge of a safari guide will be crucial to your success in shooting big game. The Internet can be invaluable for gathering information about your local wildlife. And friends, neighbors, and fellow enthusiasts can keep you informed about the wild creatures that visit their yards. Whether you are interested in plants, animals, or bugs, the best place to hone your skills often proves to be your own backyard. If you can successfully photograph the cats, caterpillars, robins, and roses found there, then you will have learned the techniques that will help you get great pictures of less common species. Being on your doorstep, you can keep practicing until you get results you are happy with.

The gear that you need for nature photography varies depending on exactly what you are shooting. Some creatures are more demanding than others and will require a lot of special equipment and skills to photograph successfully. Fish and marine plant life, for example, require an underwater camera or a special watertight housing. While photographing from the surface of the water is fairly easy, the deeper you go, the better your diving skills will need to be—and the darker it gets, so you will also need waterproof lighting. Some subjects are almost impossible to capture without highly specialized equipment—for very high magnification images of tiny insects or pollen grains, for example, an electron microscope is essential.

However, many plants and animals can be tackled with an ordinary camera, although to increase the range of species that you can photograph, a super-telephoto lens and some form of serious macro accessory are worth investing in. The length of telephoto lens that you require depends not only on the size of subject you are hoping to capture, but also on how close you can get to it. Most wild creatures are timid—so you need a narrow angle of view, and to approach stealthily, to get a reasonably sized image. With some subjects, there is a limit to how close you can go—dangerous animals should be given a wide berth, and if you get too close to tiny subjects, you could throw them into shadow. The solution is to combine image magnification with a sensible working distance.

▲ THREE LITTLE PIGS
Some animals look naturally cute in front of the camera. The younger they are and the more humanlike their behavior, the more appealing the animal tends to appear. The way these piglets seem to be jostling to get in the picture makes an irresistible portrait.

► HOME VISIT
The puffin is one of the most photogenic of seabirds. Because these birds are usually found in remote places, you will probably have to travel off the beaten track if you want to photograph them. But when you visit their habitat, it is surprising how easy they are to locate and get close to.

plants

PLANTS AND FLOWERS are an integral part of landscape photography—but their natural beauty, and diversity in color and form, make them a particularly rewarding subject in their own right. Creating an image in which they are the sole focus means getting in close, and this is not always easy.

Although camera manufacturers and photographers alike are obsessed with the focal length of zoom lenses, an equally important part of the specification is how close they will allow you to get to the subject. This minimum focusing distance varies enormously from lens to lens, but it is essential to determine the maximum magnification that your optics are capable of. A telephoto lens makes a subject look bigger in the viewfinder, but because you have to stand farther back before you can actually get it to focus on a nearby subject, this advantage is negated.

The built-in zooms found on many digital compact cameras usually have special close-up modes that are designed to be used when you need to focus a bit closer than normal—and these are particularly useful for full-frame shots of plants.

▼ WINDBREAK
A slight breeze can prove a problem with flower close-ups—increasing the chance of a blurred image. If conditions are not ideal, you can use a windbreak, or support unseen stems using wire.

► FILLING THE FIELD
You don't always need high magnifications to get tight close-up shots. This spectacular fungus formed a large clump that could easily be photographed with an ordinary zoom lens.

The lenses most often used with digital SLRs do not focus as closely, or offer as much magnification, as the built-in zooms found on compact cameras. However, the SLR's advantage is that it is a system camera, so the lens setup can be changed to suit the shot you are trying to achieve. There are several ways in which to get any SLR lens to focus closer than usual (see page 262). However, the best all-around solution is to invest in a macro lens.

A macro lens is a non-zoom, or "prime," lens with a fixed focal length that extends the lens optics farther away from the sensor to allow you to focus on the subject far more closely. The amount of magnification is variable—typically these lenses produce an image on the sensor that is either life-size (known as 1:1 magnification), or an image on the sensor that is half life-size (1:2 magnification). However, the actual image you see on the camera's LCD is larger than that recorded by the sensor, so can be significantly larger than life-size. Various focal lengths are also available and your choice affects your minimum working distance. The most popular models offer an effective focal length of between 90 mm and 150 mm. Macro lenses can also be used successfully for distant subjects.

DEPTH OF FIELD

One of the main difficulties with close-up photography is keeping enough of the image in focus. The closer the lens focuses, the less depth of field you have to play with for a particular focal length and aperture (see pages 82–85). When using a macro lens at its maximum magnification, depth of field may only extend a fraction of an inch. With floral close-ups, a small aperture is almost always needed, but even so, it is important that the lens focuses on a key focal point in the composition (the anthers and stigma in this study of a poppy flower), since not all of the frame will be sharp.

◄ BEARING FRUIT
The best time to photograph a plant depends on the season and the species. This rugosa rose looks great when in full flower throughout the summer, but its rose hips in fall look even more spectacular caught in close-up using a macro lens.

▲ IN THE BACKGROUND
Finding a plain background for flowers can be difficult. Sometimes you need to add your own, using a sheet of black paper behind the bloom. There is no such problem with a waterlily—the pond's surface creates a dark backdrop. If you are using an SLR, a polarizing filter can be useful for controlling reflections.

◄ MAKING A SPLASH
Flowers usually look their best in indirect sunlight. The lack of strong shadows gives an even intensity of color. Drops of dew or rain can be an attractive finishing touch—but these can be added at any time with a hand-held water sprayer.

birds

IT IS A COMMON MISCONCEPTION that professional wildlife photographers get great pictures only by using huge telephoto lenses. Long focal lengths are only part of the answer, particularly when photographing birds.

On most occasions, to have any chance of getting a tightly-composed shot of birds, an effective focal length of 400 mm is a bare minimum—and 600 mm is preferable. However, even if you are photographing pigeons in the park, you will have to get within a few paces of the bird for it to fill the frame using a 400-mm lens. Few birds in the wild will consciously allow you to get this close. And then there is the additional problem that most are smaller, and more secretive, than a pigeon. Stealth, therefore, is just as important as equipment.

◄ SITTING IN THE SUN
Parks and nature reserves allow you to get close to many different birds with little need for stealth. These pelicans were photographed in Valencia's Oceanografic park, Spain.

▼ SUBJECT SIZE
Large birds, and those used to humans, can be photographed without long telephoto lenses. A zoom set at an effective focal length of 200 mm was used for this swan.

▲ FLASH EXPOSURE
Even if you can find wild birds, they often hide in trees or undergrowth— making well-lit shots difficult. This scarlet ibis was photographed using fill-in flash.

Long telephoto lenses do not have to be expensive. Compact cameras with built-in zooms with a maximum effective focal length of 400 mm are available—or you can extend their range using screw-in teleconverters. Digital SLRs have more flexibility with long zooms, slot-in teleconverters, and specialty super-telephoto lenses being available to extend effective focal length to 600 mm and beyond.

Once you have a suitable lens, you then need to get close enough to the birds. In gardens, you can find a good hidden vantage point, then attract birds with food. Elsewhere you might need a blind—hutlike blinds are found on nature reserves, and portable ones can be bought. But patiently sitting, or lying, in long grass or behind some foliage, quietly and out of sight, can be an equally effective stalking technique.

▶ FAMILY PORTRAIT
A mother swan with her young cygnets makes a charming picture. When photographing young birds, make sure that you are not putting the chicks at risk—do not touch the nest or cause stress to the adults. Note that some rare species are protected by special laws—you may even need a license to photograph them in some countries.

◀ STEP IN TIME
A different style of image can be created if you try to include something of a bird's behavior when photographing them—even if this means using looser framing. The two cormorants in this image appear to be performing a synchronized dance on the protruding rock.

BIRDS IN FLIGHT

When trying to photograph flying birds, choosing a fast enough shutter speed and panning and focusing accurately are problems. However, the biggest difficulty is often one of exposure. Taken against a bright sky, the bird can turn into a silhouette. Direct frontal lighting, with the sun behind you, usually provides the best results—as in this shot of a gliding gull against a deep blue sky.

▶ AMONG THE LILIES
Showing something of the habitat is a good reason not to zoom in so close that the birds fill the frame. These white ducks are resting on the water—but including the yellow lilies not only adds color to the scene, it also provides information about the tranquil location.

bugs

JUST AS WITH FLOWERS, to photograph close-ups of insects and other creepy-crawlies, a camera setup that allows you to shoot from just a few inches away is usually required. A macro lens is a good flexible solution (see page 256), but there are other, less expensive, options.

▼ FINDING FOCUS
When focusing on macro subjects, it is often better not to make the fine, final adjustments using lens controls. Simply move the camera back and forth slightly until the key area is sharp, as in this shot of a harlequin ladybug.

Close-up lenses have the advantage that they can be used on many cameras with built-in lenses, as well as on SLRs. These devices screw into the filter thread at the end of the lens, essentially working like a magnifying glass. They are available in different strengths, measured in diopters. A +4 diopter is a good choice for insect photography. However, optical quality is not as good as you would get with a macro lens.

Digital SLRs can also accept extension tubes. These are sold in sets of three—and when used singly, in pairs, or all together, the different-sized tubes provide seven degrees of magnification. Fitting between any existing lens and the camera body, they lack the flexibility and ease of use of a macro lens. However, they offer similar quality and are capable of providing life-size reproduction on the image sensor.

BACKGROUNDS

Because insects are so small and often concealed by foliage, it can be best to carefully move them from their hiding places to somewhere where they can be photographed more clearly and in better light. Normally, it is best to put them in a naturalistic setting—a leaf or piece of stone (below) can be used to create a background. For scientific or identification purposes, however, a plain white board is a better choice (bottom).

▲ FEEDING TIME
Knowing what different bugs feed on will help you find them—and to photograph them where they will not be easily disturbed. Any bird-damaged apple becomes a magnet for wasps in late summer.

► BLENDING IN
Not all insects are brightly colored. Some have a more subtle coloration that often makes it difficult to spot them. But this close-up shot allows you to see the stag beetle clearly against the pale bark of the tree.

pets

PETS ARE EASIER TO PHOTOGRAPH than wild animals because they are used to humans. But they can still prove surprisingly challenging—even for accomplished wildlife photographers.

The first problem is that you cannot rely on your pet for any cooperation. This is compounded by the fact that its natural habitat is your own household—and clean, uncluttered, candid shots are often hard to come by in a family home. If you can, take photographs outdoors, where you have more space to maneuver and the advantage of natural light. Alternatively, create a simple studio setup—and then use family members and food treats to help get, and keep, the animal in position.

▲ STANDING TO ATTENTION
If your dog is obedient, it can be easily photographed in a studio environment. To get this pose, the Weimaraner's owner stood to the left of the camera to get its attention. The studio flash light was also placed on the left to provide diffused sidelighting.

▲ BEAUTIFUL BABIES
Young animals are particularly appealing to photograph. This Haflinger foal was photographed using a telephoto lens. By changing vantage points, it was possible to make sure the mother was out of the frame, and use the grass as a simple natural backdrop. The diffused light from the cloudy sky shows the soft texture of its coat.

◀ SELECTION PACK
Dogs are happiest when they are photographed at play. A fast shutter speed was used to freeze the movement of these dogs as they dashed back to their owner. The two closest to the camera are not completely sharp—but this helps create a feeling of depth and action.

► ALL EARS

Unlike dogs, cats aren't obedient, and it can be tricky to persuade them to sit still—let alone in the position you want them in—so you have to work quickly. However, when they do lie down, it is easy to get their attention—ask the owner to call their name so they look up toward the camera.

animals

IN COMPARISON WITH the number of birds,
bugs, and plants that surround us, wild animals
are relatively scarce—in most areas there is
only a handful of species that can easily be
photographed. Zoos and wildlife parks give you
the opportunity to see and photograph animals
from all over the world in one location.

Many safari parks, rescue centers, and zoos house a rich selection
of species in large enclosures carefully designed to mimic their
natural habitats. This makes it possible to get shots of lots of
different animals that look like they were taken in the wild.

However, the need for safety and security means that there
is usually some form of barrier between the enclosure and the
public. Whether this is a glass window or a wire fence, the
obstruction can be a problem when trying to take clear
photographs. The wires, surface dirt, or reflections may not
be in focus, but their blurred presence in the frame can ruin
resolution and detail. Setting the widest aperture possible to
restrict depth of field is only part of the solution. You must also
get the front of the lens right up close, so that it is actually
touching the obstacle you are trying to photograph through,
before firing the shutter.

◄ FOCUS OF ATTENTION
With a wide aperture and the lens
pressed against the viewing window,
you cannot tell this chimp is captive.
With limited depth of field, it was
crucial to focus on the eyes.

▲ VIEW FROM ABOVE
Look for vantage points that
suit the photograph—the viewing
platform over this enclosure gives
a great view of the body shape and
skin texture of the alligators below.

▲ TAKING A DIP
It is tempting to concentrate on getting classic poster shots of animals—
shots that show the identity and the features clearly. However, as with other
photographic subjects, it is also possible to adopt a more artistic approach.
This late-afternoon study is as much about the rippling reflections as it is
about the outline and whiskers of the swimming seal.

Even captive animals are easier to photograph at certain times than at others. They may sleep in the middle of the day, or retire to their dens in poor weather, making it hard to find unobscured views. Often it is simply a matter of patience and persistence that gets the perfect pose. However, it is worth finding out the feeding times of different animals—you will frequently discover that the creatures will instinctively know these and will pace around expectantly in advance of their keeper's arrival with the food. This is an excellent time to take pictures—before the crowds assemble for the feeding time itself.

When you are trying to photograph wild animals, stalking skills are as important as local knowledge. Most mammals have a heightened sense of smell, so creeping up slowly, or using a blind, is not sufficient to guarantee you will get close to the creatures. You also need to disguise your presence by staying downwind from your photographic prey.

▼ NOT SO WILD

This close-up of a fox looks as if it involved the use of a blind or a remote camera. In fact, the fox was practically tame, having been reared by humans since it was a cub, so it was easy to approach. It was simply a matter of taking a pet portrait (see pages 264–65).

► OFF THE SCENT

Deer are easily startled by sudden movement, and will keep their distance from humans. However, with care, you can get near enough to get a good close-up without a particularly long telephoto lens. Simply approach very slowly, with the wind blowing toward you.

▲ SOAKING UP THE RAYS

With any animal, it pays to know something about their behavior to increase your chances of finding them. Cold-blooded reptiles like basking in the sun—so quiet, sunny spots are the ideal places to find snakes or lizards to photograph.

◄ ANIMALS IN THE STUDIO

Some small species can be carefully captured, then photographed in a vivarium or pen—but don't harm them, and release them later exactly where you found them. These toads produced an entertaining sequence of studio shots, swimming in a bowl of water.

SPORTS

Sports comes in many different forms. It can be relaxing, exhilarating, exhausting, or nerve-shattering. Some sports are an excuse to get away from it all, while others are all about being part of a crowd. But despite all these different forms, action is nearly always the key. The movement and drama that are an integral part of most sports make them ideal photographic subjects, but they also present unique challenges. A crucial goal is scored in a flash, and cannot be repeated, so both you and the camera need to be able to keep up.

As with wildlife, a telephoto lens is a must. There are exceptions, but you are usually forced to shoot from a safe distance. For most sports, a zoom offering an effective focal length of around 300 mm will be sufficient. Longer lenses may be needed for close-ups of sports played on extra-large fields, such as baseball. Unlike many other subjects, where you want to crop in as closely as possible before you press the shutter, with sports it is often better not to zoom in too tightly. A loose border around the shot allows you a degree of compositional safety, and will produce a greater success rate. Use the top resolution and quality recording settings to allow for postproduction trimming.

◄ HAND IN GLOVE
Some sports images don't require a long telephoto lens. In this posed boxing shot, depth of field is restricted to give an opponent's view of a punch.

► SURF'S UP
If you are going to shoot from dry land, capturing surfing and sailboard action requires a very long lens—an effective focal length of 600 mm is ideal.

▲ HANGING AROUND
Hang-gliding is a spectacular sport without crowds of spectators. You will get the best shots from the launch site—so you are close to people taking off and landing.

▶ CATCH OF THE DAY
Some sports involve sporadic, or even almost no action. Fishing is immensely popular, but is best shot using landscape techniques to show the picturesque locations.

At top sporting events, your view will almost always be restricted to one position, its location dependent on your ticket and the crowds. At some events, photography may not even be allowed without prior arrangements or credentials. However, there are plenty of events where you can get as close to the action as any professional. Furthermore, with fewer spectators, you will be able to change your vantage point as often as you like, in order to get a variety of different shots. Look for junior championships of popular sports and top competitions in minor sports—since these often offer the perfect combination of high-quality action with few crowd restrictions. Try to get to the venue early, so that you can work out where the best vantage points are. But be prepared to shoot a lot of pictures—since however skillful you are, only a percentage of your shots will be in focus, let alone well-composed. You should try to anticipate your next shot and be ready when a dramatic moment comes along.

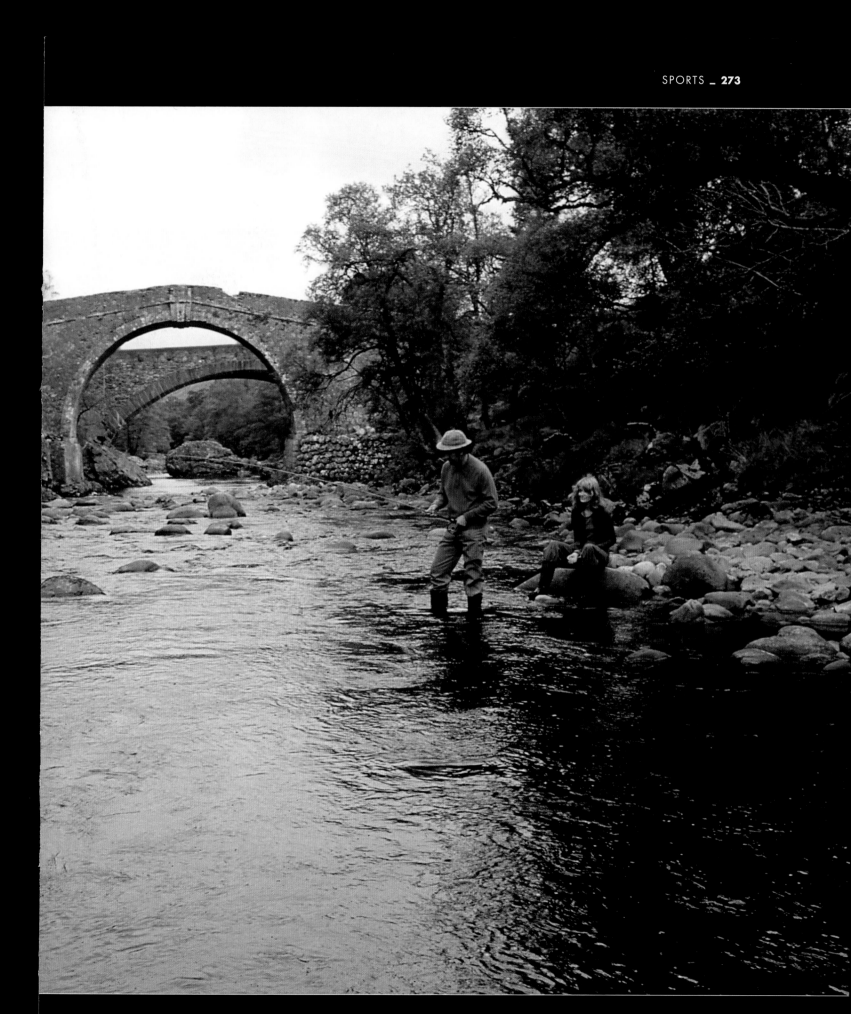

freezing the action

ALTHOUGH IT IS POSSIBLE to shoot sports pictures with a deliberately slow shutter speed so that the movement is an artistic blur, it is more common to freeze the action with a fast shutter speed.

Shutter speed selection is not just dependant on the speed of the subject—it is the speed of the image itself that counts. You will find that image speed increases the closer a subject is—and the more of the composition it occupies. Image speed is also affected by the direction of movement. For example, a shot of a sprinter running toward, or away from, the camera requires a shutter speed of at least 1/250 sec. But sprinting across the field of view, a speed four times faster is necessary (1/1000 sec). Diagonal movement needs a shutter speed in between.

▼ CAUGHT IN MIDAIR

Composing this image so the man on the jet ski is moving across the frame, and zooming in tightly, created a really fast image speed. A shutter speed of 1/2000 sec was necessary to freeze the action.

CHOOSING THE MOMENT

In low light, it isn't always possible to use a fast shutter speed, even if you use the widest aperture and increase the ISO. However, in any sport there are moments when the action slows down that present ideal opportunities. For example, a race car negotiating a tight bend will be traveling much more slowly than when at full throttle on the straight; and a trampolinist pauses in midair at the apex of each jump. In the soccer shots below, the kickoff and a goal kick imply movement and action, but could be captured with relatively long shutter speeds.

◄ HURDLING ALONG
If an athlete is heading toward you, rather than across the frame, you can use a slower shutter speed and get a sharp image. Here, a shutter speed of 1/250 sec was used.

FLASH TRICKS

If you can get within a few yards of the action, you can use flash to help freeze movement. Electronic flash has a duration that can be as short 1/20,000 sec, and if it is the main light source, it will effectively freeze movement in the foreground. However, unless you are shooting in darkness, the actual shot will effectively have a double exposure—the brief flash, and the longer ambient light exposure, which lasts as long as the shutter is open. This combination can create a ghostlike halo around fast-moving areas of the subject—which can be seen in the boxing shots below.

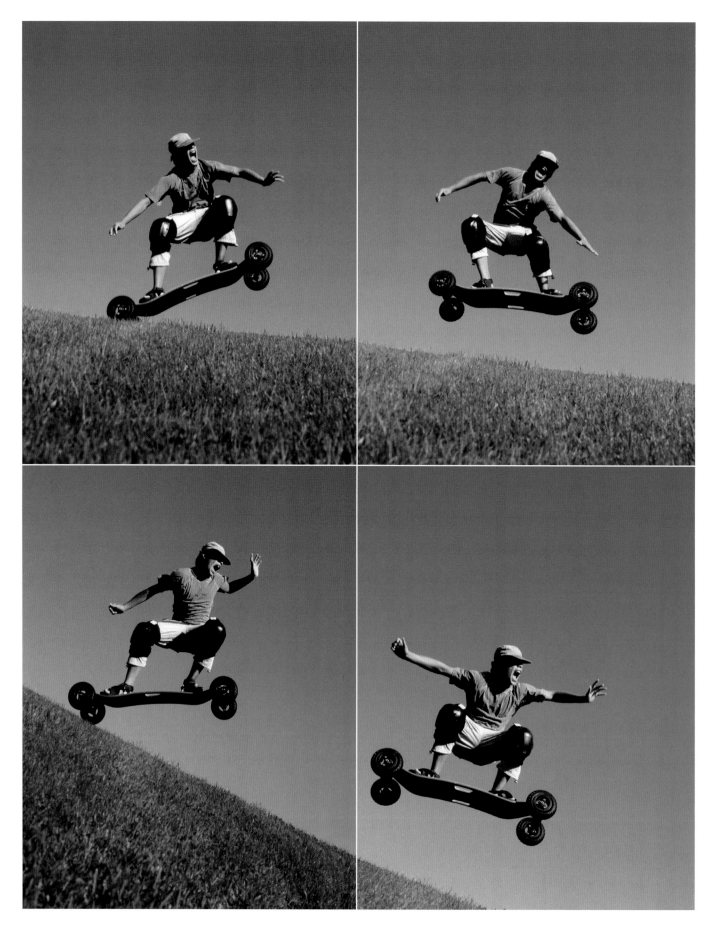

prefocusing

A BIG CHALLENGE in sports photography is accurate focusing. Subjects often move so fast that autofocus systems fail to lock on quickly enough in most frames. One solution is to set the focus before the subject even comes into view—known as prefocusing.

In many sports, every competitor follows the same route around a course. When you prefocus, rather than waiting for a horse to reach a fence, for example, then focusing on it, you focus on the fence in advance. You can then adjust the lens to precisely the right position—either by using manual focus control, or using autofocus and then locking the focus in that position. When the subject reaches the right point in the frame, you press the shutter—and a sharp picture is taken instantly.

PREDICTIVE AF

Most digital SLR cameras have a focus mode that tracks fast-moving subjects. "Predictive autofocus" adjusts the lens even after the shutter has been pressed to predict where the subject has moved during the short delay before the exposure actually starts.

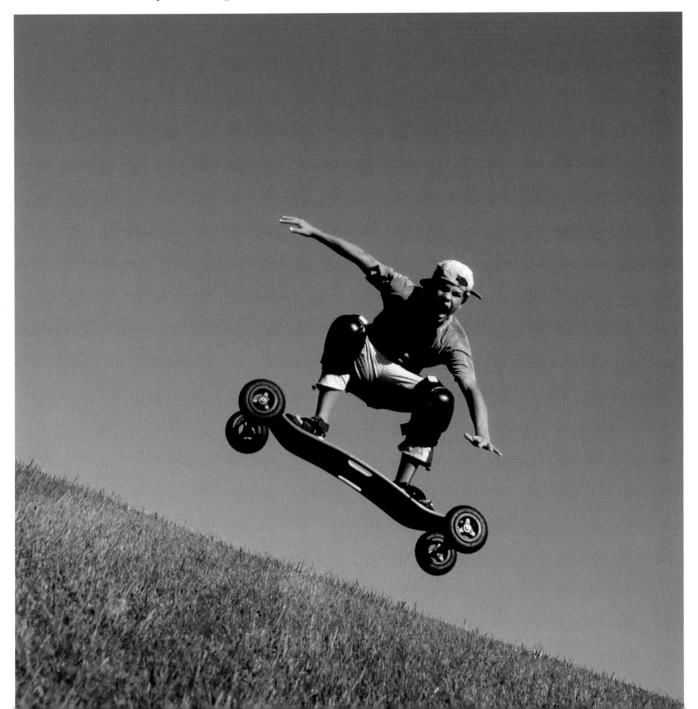

▲ PANNING
If subjects are moving across the frame, swing the camera around to follow the action. This panning action keeps the subject sharp, and offers the added benefit of slightly blurring the background.

▼ CHOOSING A SPOT
The best skiers on this downhill run followed a similar line to take advantage of the jump. By prefocusing the lens on the right spot, I simply waited for the next skier to enter the frame.

► TRY, TRY AGAIN
For this shot I prefocused the camera on the hill the snowboarders were jumping from. They repeated the trick again and again, so I had plenty of opportunities to capture the perfect shot.

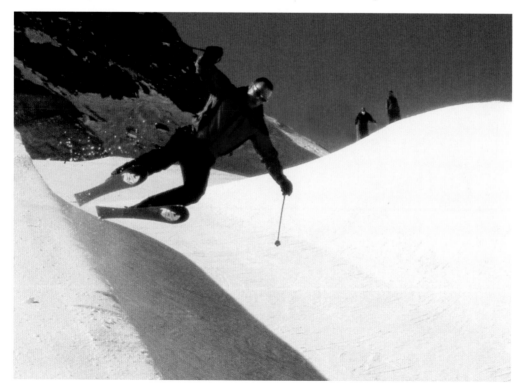

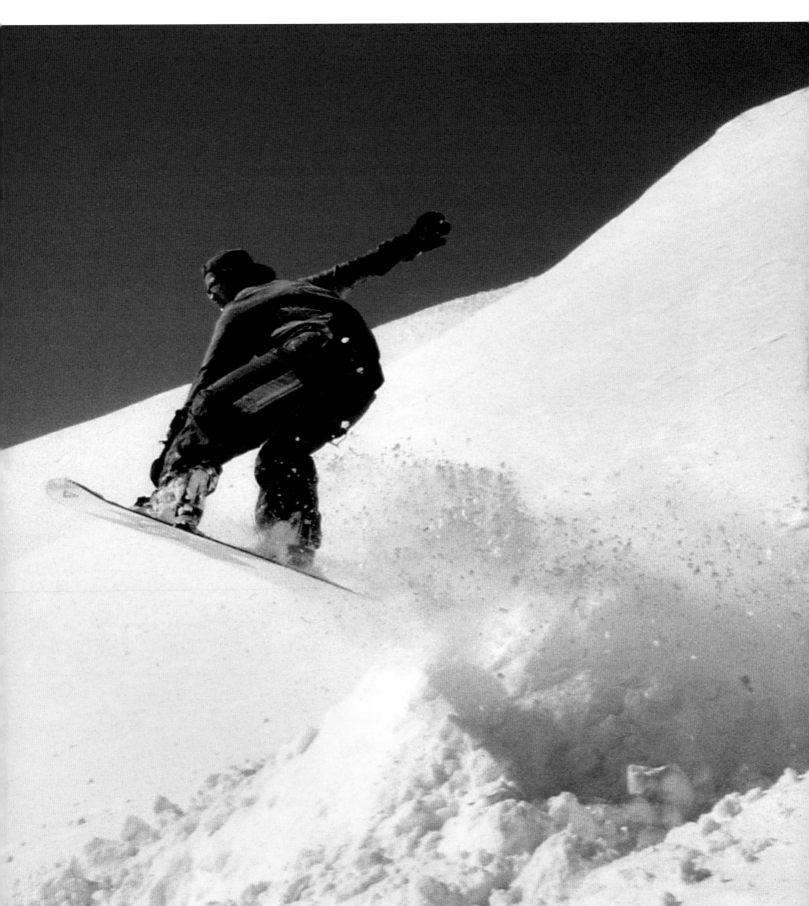

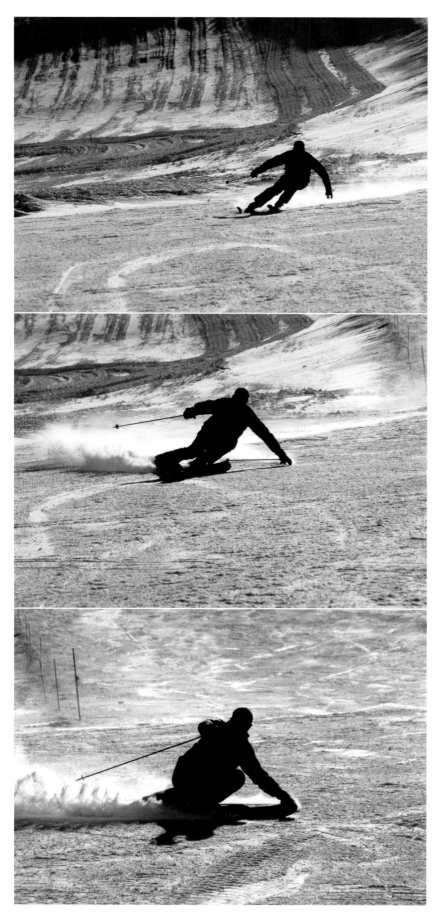

burst rates

TAKING A SERIES OF SHOTS in rapid succession can help increase your chance of capturing that crucial moment in a sporting event. Furthermore, such continuous sequences can tell their own stories that help you to analyze the motion and show the intricacies of a sport in a way that is impossible with the naked eye.

In the days of film, the number of frames per second that could be shot automatically depended on the capabilities of your camera's motorwind. The maximum shooting speed of a digital camera relies more on processing power than on precision engineering. A digital camera is a computer, and the information recorded by the sensor needs to be digitized, processed, and stored—and this can lead to a noticeable wait before you can take your next shot. The slower the shutter speed, and the higher the resolution used, the longer the delay.

Many cameras have a continuous shooting mode for action photography that uses a buffer memory—a temporary store that holds the unprocessed data as the sequence is being shot. The number of shots that can be taken per second at this "burst rate," and the total number of shots that can be taken before the camera needs to stop and catch up, varies significantly from camera to camera. The file format and file size are also important—the rate will be sustained longer if you shoot in JPEG format, rather than in RAW (see page 23). With a good SLR, expect a burst rate of three frames per second or more.

◄ DOWNHILL RUSH
A sequence of just three shots gives a much better view of a skier turning at high speed on the snow than a single picture. The burst rate here was limited to two frames per second by the speed of the autofocus.

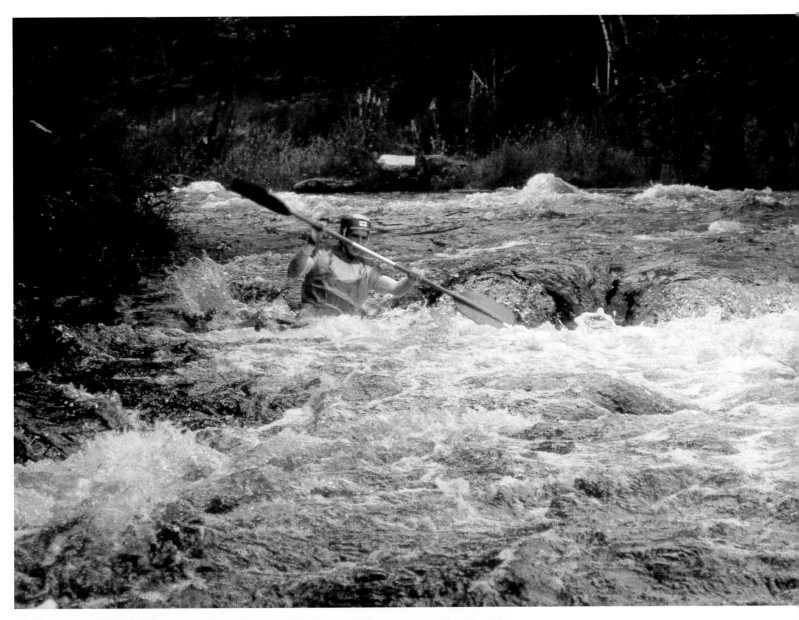

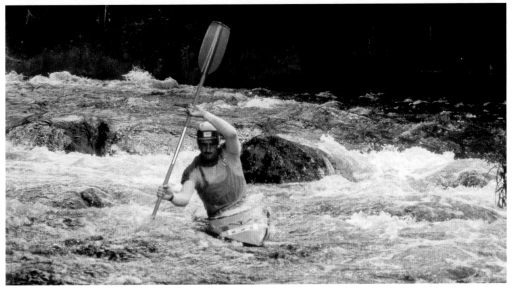

◄ ▲ TIMING YOUR MOVE
Unfortunately, using a camera's burst rate facility cannot guarantee catching a picture. Even if you are shooting at five frames per second with a shutter speed of 1/500 sec, this amounts to capturing only one percent of the action. Due to the limited capacity of the camera's memory, and the maximum duration of the burst rate, you need to use the continuous shooting facility prudently. Wait for the moment when you are most likely to get a good shot—here, when the canoeist was maneuvering through the white water and rocks of the mountain river.

capturing the spirit

ALTHOUGH ACTION IS KEY to sports, it is not this alone that produces the drama. It is the people who compete, and those who spectate, that create the feeling of theater. Their expressions and body language can tell you as much as any scoreboard or high-speed photograph.

Sports is about the passion and the endeavor of the people involved. Shots that capture these emotions are essentially portraits—and the approach you use depends on what you are trying to communicate. For example, a long telephoto lens is useful for close-ups showing the determination in an athlete's face. A wider lens is better for showing the participant within the setting for a particular sport—which can make a refreshing change to action close-ups. Don't forget those at the fringes—the referees, coaches, and fans all have their role to play.

▼ TEAMWORK
There are always moments when action takes a back seat, and emotion takes over to sum up the sport. Scenes such as this young soccer team celebrating a victory are always going to be worth trying to capture on camera.

▲ NEW RECRUIT
Try to show people interacting. Here, the instructor is absorbed in helping this child balance on skis for the first time.

► A STONE AT A TIME
Even gentle sports like curling have moments of action. This wide-angle portrait gives a great idea of what this ancient game is all about.

glossary

AERIAL PERSPECTIVE The impression of depth in an image created by particles in the atmosphere. The further an object is from the camera, the more air scatters the light as it passes through, so distant subjects appear less distinct and paler in colour.

AMBIENT LIGHT Existing light in the scene, excluding any light source added.

ANGLE OF VIEW How much of a scene a lens can capture from a particular position, usually measured in degrees. The longer the focal length, the smaller the angle of view.

APERTURE The opening in the lens that helps restrict how much light reaches the image sensor. In all but the most basic cameras, the size of the aperture is adjustable. The aperture setting used has an important role to play in both exposure and depth of field.

ASPECT RATIO The relationship between the width and height of an image.

AUTOFOCUS A system in which the lens is adjusted automatically by the camera to bring the image into sharp focus.

B Abbreviation of Bulb. A shutter speed setting that allows you to keep the shutter open for as long as the trigger release is held down. Used for exposures lasting seconds or minutes.

BRACKETING A way of increasing the chances of getting the right exposure by taking a sequence of pictures with a slightly different exposure setting for each. Some cameras have automatic bracketing systems.

BUFFER Temporary memory used by a camera or a computer. The size of the buffer on a camera dictates its maximum burst rate, and how many exposures it can be used for.

BURST RATE Continuous shooting speed of a digital camera, which allows a sequence of images to be taken in rapid succession – measured in frames per second (fps).

CATCHLIGHT White highlight in the eye of a subject that is a reflection of the light source.

CAMERA SHAKE Blurring of the image caused by movement of the camera during exposure.

CCD Charge Coupled Device. One of the types of imaging sensor used in digital cameras. It is found at the focal plane, and converts the focused image into an electrical signal.

CHANNEL MIXER Photoshop function that allows you to adjust the opacity of red, green, and blue channels independently. Useful when converting a colour image to black and white.

CLONE TOOL Facility in image manipulation programs that allows you to copy an area of an image and apply it onto another part of the image. Extensively used for removing blemishes, dust marks, and unwanted areas.

CMOS Complementary Metal Oxide Semiconductor. One of the types of imaging sensor used in digital cameras. It is found at the focal plane, and converts the focused image into an electrical signal. Similar in function to the alternative CCD sensor.

CMYK Cyan, Magenta, Yellow, and Black – the four primary inks used to print full-colour images. Digital photographs and scans are recorded in RGB (Red, Green, and Blue), however they can be converted to CMYK using imaging editing software, although it is not necessary to convert before printing.

COLOUR BALANCE The matching of film or imaging chip settings to ensure that white and grey tones appear as they would to the human eye. Digital cameras change the colour balance electronically using the white-balance system.

COLOUR CAST Unwanted colour tint to an image usually created either by incorrect colour balance, or by a reflection from a strongly coloured object.

COLOUR GAMUT The range of colours that can be displayed by a computer screen, or printed by a printer. The range of colours may well be different for both – and different from those recorded in the digital file.

COLOUR MANAGEMENT A system that warns you of colour gamut problems, and helps ensure that the pictures you print look the same as those you see on screen.

COLOUR TEMPERATURE Measurement of the colour of light, often expressed in Kelvin (K). Digital cameras make electronic adjustments using the white-balance system to match colours to those seen by the human eye, to prevent or reduce colour casts.

COMPACT A type of camera that has a shutter mechanism built into the lens. Compacts are usually point-and-shoot designs.

COVE Curved studio background that ensures there is no visible join between the backdrop and the surface the subject is sitting on.

CROPPING Removing unwanted parts of an image by enlarging only part of the frame either during printing, or digital manipulation.

CURVES Powerful tonal adjustment facility found in some image manipulation software.

DEPTH OF FIELD A measure of how much of a picture is in focus, from the nearest point in the scene to the furthest point. Depth of field is dependent on the aperture used, the distance that the lens is focused at, and the real focal length of the lens.

EFFECTIVE FOCAL LENGTH Measure that allows you to compare the angle of view and magnification of different lenses and lens settings, whatever the size of imaging chip used. The actual focal length is converted to the equivalent focal length that would give the same angle of view on a camera using 35mm film (or a sensor measuring 36 x 24mm). See also focal length.

EXPOSURE The total amount of light used to create the image. The exposure is a product of the intensity of the light, the aperture setting, and the shutter speed.

FILE FORMAT The way in which a digital file is saved. There are a wide variety of different file formats – the most commonly used being JPEG and RAW. The format dictates the programs that will be able to read and open the file. It also dictates the amount of information and the detail that is stored.

F-NUMBER The aperture setting. The number is the focal length of the lens divided by the diameter of the aperture; because of this, larger

f-numbers represent smaller aperture sizes. Exposure settings for a particular scene can be expressed using f-numbers without having to know the focal length actually used.

FOCAL LENGTH A measure of the magnification and angle of view of a given lens or zoom setting. It is usually measured in millimetres. However, its usefulness as a way of comparing different lenses is diminished by the fact that the exact focal length required to give a particular angle of view will depend on the size of the imaging chip used by the camera in question.

F/STOP Alternative name for f-number.

GAUSSIAN BLUR Image manipulation effect that allows you to blur parts of an image.

HIGH KEY An image with dominant light tones.

HISTOGRAM Graphical display used as a way of depicting and manipulating the brightness, tonal range, and contrast in a digital image.

HUE/SATURATION Adjustment commonly used in image manipulation software to alter selected colours within an image.

ISO International Standards Organisation. Scale used for measuring the sensitivity of an image sensor. In many cameras, the ISO setting can be altered for each individual exposure. Used to help ensure a particular shutter speed or aperture in a range of lighting conditions.

JPEG Joint Photographic Experts Group. The file format used by most digital cameras that allows a variable amount of compression to be used to change both the detail stored and the resulting size of the file. RAW or TIFF file formats may also be available for the highest resolution capture settings.

LAYER Feature available in some digital manipulation software that allows you lay different versions or elements of an image, or images, on top of each other. The original image can be protected as the background layer, whilst alterations are made to copy layers.

LEVELS Exposure, contrast, and colour balance adjustment commonly used in digital image manipulation. Histograms are used as a guide to the corrections that need to be made.

LOW KEY An image with dominant dark tones.

MACRO Equipment or facility that allows you to take pictures at a closer shooting distance than usual, to provide a high magnification image of a small subject.

MAGNIFICATION RATIO Relationship between the width of the focused image and the width of the subject. If the image is life-size the magnification ratio is described as 1:1.

MEGAPIXEL Unit used to measure the maximum resolution of a digital camera, equal to one million pixels.

NEUTRAL DENSITY Optical or electronic filter that reduces the amount of light reaching the image sensor equally across the whole field of view to allow longer shutter speeds or wider apertures to be used. Can be abbreviated to ND.

PIXEL Abbreviation of picture element. A single light-sensitive cell in a digital camera's image sensor. The basic unit used to measure the maximum resolution of a digital camera or a digital image.

POLARIZER A filter that only lets through light vibrating in one plane. It can be used to deepen the colour of part of a picture, such as the sky, or to reduce reflections form non-metallic surfaces, such as water or glass. The filter is rotated to get the desired effect.

PREDICTIVE AUTOFOCUS Autofocus setting where the focus continues to be adjusted during the delay between firing the shutter and the shutter actually opening. Allows a camera to track and focus on moving subjects accurately. A common feature on digital SLRs.

PRIME Lens with a fixed angle of view.

RAW A high-quality proprietary file format offered by some digital cameras. Image data is stored in a semi-processed state and needs to be fully processed on a computer. This allows exposure compensation, colour balance, and other settings to be altered after camera exposure without image degradation.

RED EYE Effect often caused by flash where light reflects from the retina illuminating blood vessels in the subjects eye.

RESOLUTION The ability of a lens or imaging device to record fine detail. Digital cameras usually offer several resolution settings. A low resolution can be used for recording to conserve memory when a high resolution is not necessary.

RGB Red, Green, and Blue. The three colours used by digital cameras, scanners, and computer monitors to display or record images. They can be converted to other colour models (such as CMYK) using suitable software.

SCANNER Device that converts a physical image into a digital one.

SLOW SYNC FLASH Technique where a slow shutter speed is combined with a burst of flash. The flash provides the main illumination, but the ambient light creates a secondary image that can be useful in suggesting movement. The technique can also be used to ensure that the background receives more exposure than it would otherwise have done.

SLR Single lens reflex. A camera in which the viewfinder image shows the subject through the same lens as is used to expose the imaging chip. It typically uses a mirror to reflect the image to the viewfinder, which is lifted out of the way when the picture is taken. Unlike compact cameras, lenses are usually interchangeable.

TELEPHOTO A lens, or zoom setting, with a focal length that gives a narrow angle of view – making objects appear larger than they would appear to the human eye. A telephoto lens has an effective focal length of 70mm or greater.

TIFF Tagged Image File Format. Digital image format - used to record files with maximum available detail.

UNSHARP MASK A facility provided in image manipulation programs that allows you to sharpen a digital image by increasing edge contrast. Sometimes abbreviated to USM.

WHITE BALANCE System by which a digital camera measures the colour temperature of a light source. The automatic white-balance system tries to correct the recorded colours so that the whites, and therefore all the other colours, appear normally to the human eye.

ZOOM A lens with an adjustable angle of view.

index

acknowledgments

author's acknowledgments

John Hedgecoe would particularly like to thank these people for their long-term support and advice over the period of this book; Jenny Hedgecoe, Karen Self, Chris George, Sebastian Hedgecoe, and photography assistant Kate Anderson.

Also, many thanks to the following individuals and organizations for their help in the preparation of this book:
Karin Schmid—Zermatt Tourism
Paroz Optik and Sport-Boutique Natascha—Zermatt
Abbeyglen Castle Hotel—Co. Galway
Angus Mackintosh
Aylsham Wanderers—under 9's (soccer)
Circus Gerbola
Connemara Smokehouse
Kelso Hawk Walks
Norwich Lads A.B.C (boxing)
The German Riding School—Warendorf
The Ice Factor—Kinlochleven
The Government Tourist Offices of the following countries: Germany, Ireland, Mexico, Netherlands, Switzerland and Spain. The China Photographers Association.

And, of course, thanks to all the models.

publisher's acknowledgments

Dorling Kindersley would like to thank the following individuals for their contributions to this project: Ted Kinsey and Sarah Rock for design, Christine Heilman for Americanization, Margaret McCormack for the index, and Nicky Munro for editorial help and advice.

Most pictures in this book were taken on the Hasselblad H1D and the Olympus E–300